Renaissance Art

Renaissance Art

Edited by
CREIGHTON GILBERT

Icon Editions

Harper & Row, Publishers
New York, Hagerstown, San Francisco, London

First published in 1970 as a Harper Torchbook in The CONTEMPORARY ESSAYS
Series, Leonard W. Levy, General Editor. First Icon Edition published in 1973.

STANDARD BOOK NUMBER: 06-430033-1

LIBRARY OF CONGRESS CATALOG CARD NUMBER: 70-92848

81 10 9 8 7 6 5 4 3

Contents

v

Illustrations

Introduction: Renaissance Art
and the Styles of Its Scholars

by CREIGHTON GILBERT

NO MATTER whether this book is opened by a student in a course or by a curious "general reader," I hope it is his *second* book on this topic. Its plan assumes that the first was a general account of Renaissance art that provided a balanced summary of the many important phenomena of the period. But all general accounts oversimplify all the particulars—and so need to be compensated by deeper inspections of some of them at least. This anthology assembles special studies of that kind.

The assumed precedence of another book might excuse this one from attempting to define Renaissance art. Specialists dislike the task anyway, as the following essays will confirm. This is partly because so many early attempts have been shown up as ludicrous; partly because a habitual involvement with the works of art reinforces a preference for the particular, concrete, and visible as against generalized abstraction; and partly because when we do attempt a definition, one of the chief factors paradoxically turns out to be the Renaissance dislike of large principles and organizations. Yet perhaps there is an obligation to suggest some speculative formulas at the beginning of a set of detailed studies, even if they only stimulate rebuttal.

A natural point of departure would be to compare the history of Renaissance art with other kinds of history and with what seems very different in our own experience of history and art. Very soon we notice that other historians divide their descriptions of the Western world into ancient, medieval, and modern, but the art historian divides his into ancient, medieval, Renaissance, and modern. Therefore "Renaissance art" corresponds in time to "early modern history;" and so this art so unlike our

modern art was developed by and for people who were also developing our familiar social institutions. Indeed the Renaissance centuries replaced the feudal social structure with the capitalist, made cities the centers of energy, made the national state the chief political entity, and rejected basic psychological loyalty to the church (though a similar loyalty to religion was not rejected until centuries later, creating a distinction both from the Middle Ages and from us that is easy to blur). The new man of the Renaissance is a townsman, a manufacturer or trader or financier, pious but secular, in a word he is the bourgeois.

The change is often described as from a status society to a contract society, and this involves a decrease in stability. A life is not fixed by birth into a class, but is affected by individual capacity. One can be born poor and die rich, or the opposite; character is important, and each citizen must study the character of other citizens as a matter of survival, to see whether the others are honest or skilled or not, in the way a banker does, and must also study the physical qualities of things bought or sold as a craftsman or merchant does. In the feudal age right decisions on such matters had no effect on the rest of one's life. The behavior was not new, but was newly the concern of those who set the tone of the age. Today we are still concerned with human character and with physical materials, but we think of them in conflict when we often talk of man and thing, human rights and property rights, the organic and the mechanical. The Renaissance developed both concerns and each depended on the other for strength, their values were reciprocally supporting. The collecting of things aided the free development of human character and vice versa. Perhaps this Renaissance success makes the age worth study by analysts of our social ills.

An attractive formula about the nature of the Middle Ages (which typically lend themselves more easily to formulas) offers a nice analogy between feudal society, scholastic philosophy, and Gothic architecture. All three are tight, closed systems of interacting parts with hierarchic rank. (To be sure, they all really belong to just one small part of the Middle Ages, near the year 1200 and northern France.) Some degree of system must

appear in any social activity, but the Renaissance seems to choose small, competing or limited-purpose ones. It produced no Holy Roman Empire but city councils, not the *Summa Theologica* of St. Thomas but the sermons of Savonarola and Erasmus' guides for lay piety, no crusade against the infidel but Protestantism, no encyclopedic *Specula* but groups of biographies, no *Divine Comedy* but sonnets, picaresque novels, and the Elizabethan tragedy with its mixed plots and tone, no cathedrals but many churches for parishes and the mendicant orders.

In the High Gothic, architecture clearly dominates the other visual arts, conditioning (often literally) what is done by sculpture, glass painting, even manuscript painting and metal crafts. If there is a vanguard art in Renaissance Italy (typically the point is debatable), it is painting. This painting articulates the interlocking importance of human character and physical materials when it realistically reports the visible world and makes human circumstances its main concern, both new emphases. It does not specially emphasize the individual human being. It is true that the portrait is the paradigm of Renaissance innovation in art, since it offers humanity through the vehicle of physical facts and vice versa, but it is secondary in the work of all but some minor Renaissance artists, and only becomes primary for later artists like Velazquez, Hals, Goya, or Ingres. Renaissance individualism was probably exaggerated by nineteenth-century individualists when they noticed how the Renaissance had removed medieval barriers to individual development. The main human concern of Renaissance painting is the small group. In the first book on art with a Renaissance viewpoint, Alberti points out that the painter's chief work is the *storia,* the narrative. From Giotto to Tintoretto and beyond, painters are most interested in portraying with sharp characterization or gesture a cluster of people at key moments in their lives, tableaux, in short. (The main figural concern of the Middle Ages was the divine image, immobile and to be venerated.) As we call Gothic art architecture-dominated, and modern art has been truly said to reflect the conditions of music, we may say Renaissance art alludes to the conditions of drama. The transcripts of

Renaissance town council meetings, Boccaccio's stories and the art form of the prose anecdote that descended from them, the realistic new history writing that makes events depend on confrontations of character between leaders, seem to confirm that this is a life style.

The physically real people of the dramas move on a physically real stage, and this depends on the invention of the technique of perspective. It allows visible objects (including people) to be drawn smaller on the wall or panel or canvas in proportion as they are supposed to be farther away from the front. The Renaissance artists who worked out this mathematical device regarded it entirely as a way to match reality, while to us its qualities of patterned design seem conspicuous. The frequent idea that perspective is a key to Renaissance art is not wrong but is much overemphasized; it appeals because it is technical and tangible and does indeed point out an innovation, so that it is a satisfying way to explain the big alteration between medieval and Renaissance art. Yet it is revealing that writers with this approach must repeatedly turn, without realizing it, to the same few exceptional Renaissance images to support the point, in which perspective appears with emphasis or for its own sake, and call these typical of the age. (Thus only one painting by Masaccio, the greatest painter of the first generation to use perspective, has this quality.) It seems truer to follow Alberti, who restricts perspective to the first ("Rudiments") of the three sections of his book, while the second deals with human figures, their motions, their inferred emotions, and the story. Similarly perspective in most Renaissance paintings is an underpinning for the chief concern—human events.

Social research also seems a Renaissance innovation, if we trace realistic political analysis to Machiavelli, family sociology to Alberti's *On the Family*, history writing (after a thousand-year gap) to a host of writers, Guicciardini being the greatest. A result of the energetic attention to contemporary history is that the Renaissance is the first epoch to call itself an epoch in contrast with a preceding one (except for the traditional opposition of pre-Christian and Christian ages). Artists share this antimedieval attitude, beginning with architects. This, along

with the other innovation of conceiving of artistic style as an isolatable concept, helped a feeling of alliance with the classical past, and thus the idea of rebirth that gave the Renaissance its name. A few Renaissance buildings and other works literally illustrate a passion for antiquity reborn, but they are also admittedly eccentric ones. Antiquity appears more often as a small quotation, or through admiration of the evidence that ancient Rome, too, admired the human and the material, or as a polemical lever, the kind of citation of the respectable past to legitimize the controversial modern that is familiar today. A greater influence on Renaissance architecture than Roman lines and shapes is the Roman notion that a building should imitate the human body—thus relating the human, the physical, and the mathematical—startling to us but fundamental to the period, as discussed in Millon's essay. Likewise the awareness of being in an epoch distinct from the Middle Ages is most keenly realized not in attacks on it but by letting medieval elements appear in a way that makes their foreignness clear, a procedure discussed in the first three essays.

In selecting the essays for this book, no attempt was made to represent all aspects of the Renaissance; thus, there is nothing on sculpture. This decision, which may accidentally make the unsystematic quality of Renaissance studies seem still more marked than it is, was reached because I wanted to take the best essays in the whole field and hence those aspects of the period appear which have been most favored by recent investigators. To add the further criterion of representing all aspects would have made selection difficult. Quite old studies had to be excluded on the ground that their results were now either obsolete or had been absorbed into general introductory books. A natural watershed between old and new research is World War II, when there were several years of severely reduced work; the classic essay by Panofsky is the only earlier one included. On the other hand many of the best studies seem to have appeared just after the war ended, perhaps because meditation on basic questions had been stimulated. Very long articles were also excluded, since they would have reduced the number in the book too much; this ruled out, for example, Wittkower's epochmak-

ing treatment of Michelangelo's Laurentian library. Articles
that have already been reprinted somewhere were excluded,
because the value of the book is to remove things from inacces-
sibility; this ruled out all papers by Ernst Gombrich, which are
being reissued in collected volumes. Finally, even fine studies
on unimportant subjects are excluded, so that the book can
have meaning to a nonspecialized audience.

The essays chosen reflect the now active methods and schools
of art history, which in general have hardly been analyzed by
their practitioners. They assume habits of thought for which the
reader should have some preparation. One of the most effective
(and one of the few to have been somewhat self-analytical) is
iconology—or the Warburg method, after its promulgator, Aby
Warburg, who provided an institute and publications for its
diffusion. This method in simple essence is to study the work of
art as a concentrated carrier of the interests of its culture and its
social myths. Iconologists show and define the attitudes in a
work of art by analyzing its technique, its design and style, and
most obviously its subject matter, or iconography, and further
those details in which this work varies from earlier and later
presentations of the same subject matter. This last has been the
most triumphant and illuminating Warburg technique, while
the least developed area has been design and style, the exclusive
interest of another group of art historians. The help in portray-
ing a culture that is had from contrasting the details of its
images with another culture's treatment of the same images
puts a premium on persistent themes. Thus Panofsky, the
greatest Warburgian, wrote a book on the history of tombs,
studied the evolving representations of Father Time and Cupid
through millennia, and in the essay here reprinted investigated
the forms of weddings. All these subjects have a striking likeness
with an unexpected relative, anthropology, when it uses the
comparison of customs as a basic tool. In fact Aby Warburg's
first essay was on Hopi ritual. The difference is that iconological
art history deals with the customs of those cultures most often
neglected by anthropology's "study of man"—Western history
after the beginning of recorded history and before the present.
Thus the official aim of Warburg's institute was to study the

survival of the classics, in itself apparently an oddly narrow topic. Iconology is constantly interested in intersections between custom or tradition and the creative or original individual or group. Hence Panofsky writes on what may be called mythically stabilized treatments of the relation of individuals to moral codes, such as the persistent story of the choice of Hercules between vice and virtue, the evolving idea of melancholy and especially its shift from a medical to a psychological context, the Arcadian or pastoral idea of the afterlife, the fable of Pandora's box, Platonic love. All this suggests why northern Renaissance Europe was his favorite theme, on which he wrote his two weightiest books. Unlike Italy at the same period, more concerned to innovate and reject, the north interweaves religious and feudal traditions with the special inventions of modern artists and intellectuals. Panofsky's favorite artist was Dürer, whom he saw as an intellectual artist able to nourish a folk background, rather like Panofsky himself but no less vividly perceived for that, the heir of a pattern of behavior that Jan van Eyck had first fully articulated.

The virtues of the Warburg method are suggested by its utility to scholars who do not adhere to it as members but can apply it effectively to their different approaches. Thus Meyer Schapiro studying a northern Renaissance theme applies psychoanalytical material, in which continuity is also valued, to a generally Warburgian context. But he further blends it with a Marxian technique, so that the discontinuous factors are the critical ones in the work of art as a carrier of its culture, in this case the new ways in which bourgeois social concerns change an image.

A more surprising cross-fertilization with a Warburg procedure appears in Meiss's essay. Much influenced by Panofsky, Meiss had had his training with Richard Offner, one of the outstanding practitioners of an utterly different approach based on "attribution." It is comparable to that part of traditional biology called taxonomy, which simply seeks to recognize to what subclassification every object considered belongs, and thus to label it properly. In art history that means attributing it to the right artist, or grouping works by the same artist who

happens to be unknown to our records. It is more frustrating than taxonomy and more similar to medical diagnosis in that it is empirical, with no checkbacks to confirm or deny correctness available afterward, and with significant differences in each example. The only test of work well done is the gradual consensus of other specialists on the same material. Such work is necessary in studying the Renaissance, because most works of art were not signed or documented, and their authorship can be worked out only in this way. This book contains no pure examples of this type of study. They tend to be unreadable, either listing features for comparison or briefly asserting a similarity among works, which the specialized reader may then judge. This research and Warburg studies go separate ways, but Meiss's study is an unexpectedly perfect blend: the carrier of the culture is not found in traditional symbols or social reporting, but in things mainly visual, the natural light and the artist's representation of older works of art in his work. The author shows that the artist and public responded to these purely aesthetic stimuli in the same way, although less frequently, as they did to the accepted symbols, turning them into "anthropological" terms of communication within the culture. Such demonstrations are necessarily rare, but evoke in a concentrated way the artist's Schapiro-like modernity of life style and his Panofsky-like intellectual probing of the world.

The social context of art is also built up by documentary research. Scholars in this specialty are usually seeking records of authorship to support or form the base for attributions, and the public often supposes that many firm statements derive from agreeably objective data such as documents. But things are rarely so simple; it is rare to have a batch of documents on a great work of art—for example, there are none to speak of on the frescoes of Giotto, Masaccio, and Michelangelo. Even when there are some, they often do not settle arguments but shift the arguments to the meaning of the documents. They usually can be interpreted in more than one way, like X rays, another tool that the public supposes gives firm answers. The immediate value of such documents is to enrich our awareness of the circumstances, often in unexpected ways. Thus Rigoni's study,

which was chosen because it is one of the very few cases of a long set of documents on a great work of art, incidentally records better than almost any other source data on the early age when an artist would have his own shop independent of his master, and on the seasonal limitations of painters' work, two significant matters often disregarded in analysis. When it suggests that artists led exciting lives, it is correct, of course, but we may give it a weight out of proportion to the frequency of such events; one must keep reminding oneself that police court records have a higher chance of survival than other records, skewing our sense of the character of citizens. Archive study is discouraging work, often yielding no return on months of application, and persisted in chiefly because it seems to hold the promise that any finds will be genuinely new. It may therefore be good to call attention to another specialty more often practiced than recognized, the rediscovery of published documents. Wilde's and Ackerman's essays here demonstrate it, in part exploiting materials unearthed long ago and lying fallow in books of past generations, but more vividly in bringing the significant detail to nail down an unsuspected synthesis, so that our understanding is much widened.

Millon's essay can be read as a blend of the Warburg method with still another, in this case engineering knowledge, and opens up one of the Renaissance notions furthest away from our conventions, the idea that buildings are imitations of nature. More broadly, this study—like those of Ackerman, Rearick, and Wilde—assumes that a big accumulation of data adds up to a convincing conclusion. This scientific method of induction, normal in American thinking, evidently is based on the Newtonian philosophical postulates of the eighteenth-century British empiricists, who, as good Newtonians, effectively insisted that all reliable knowledge derives from sense impressions. Their view was disputed of course by Kant, who pointed to the laws of mathematics to claim that knowledge exists prior to the people who know things. As F. S. C. Northrop pointed out, Kant's influence in German education has let German and other idealistic thinkers regard various systems of knowledge not built on experience (such as the whole range of socialisms from Marxist

to national) as more scientific and solid than Jeffersonian libertarianism (which continues to be ignorant of Kant). Americans, on the other hand, are bewildered to understand how socialist systems can continue to be accepted when battered by empirical evidence. And although the later emergence of new kinds of mathematics like non-Euclidean geometry has undercut Kant's view that standard mathematics was absolute truth waiting for us to know it, Kantians and socialists have remained ignorant of this development.

All this is by way of introduction to the essay by Argan, whose language and procedures are difficult for readers unaware that German idealistic philosophy has fundamentally influenced a leading Italian approach to art criticism. The goal in this approach is to distill a definition of whatever is being studied—for example, the whole work of an artist. The definition is not to be accumulated from observations, but is a real datum that antedates observers and must be found. The critic must get to it with minimal reliance on particular visible objects, by intuiting concepts that will match reality if he is finely attuned. To be sure, much Italian writing on art history is quite remote from this approach; a great deal consists of attributions. The least successful work occurs when an attempt is made to present attributions as if they were incidental to an idealistic critical essay, which has higher prestige. But an excellent example like Argan's essay works out to the conclusion that Palladio as an artist was much like an idealistic critic; he intuited pure form and brushed circumstances aside. That is no reason to reject its findings, for we may suppose that Argan, like Panofsky and Meiss, is naturally drawn to discuss most effectively what is most congruent to his own interests.

It is rarely possible for a short essay to survey effectively the style or self-awareness of a whole movement or generation, which is one of the reasons for welcoming Shearman's. In its important second half it essentially operates in the tradition set up by Heinrich Woelfflin about 1890, which holds that the most effective way of tracing the history of art from an earlier to a later point is by isolating the continuous small changes and the larger stabilities in the methods of painting shapes, that is, the

styles of the forms. Today most art historians are too timid to try to originate such large analyses of the arts of a period, but the method and older examples of it are the standard ones in courses and textbooks, and thus are easy to understand in this original example.

All these methods suggest that art historians need to have vast experience, so that the best essays rarely have young authors. But since I wanted to exemplify the newest generation, Rearick's essay seemed to show how the difficulty of youth can be short-circuited by dealing intensely with a narrow subject. It also touches on segments of the Renaissance not otherwise noticed in this book, the study of drawings, and a great painter nearly always neglected because he comes at the end of a series. It is commended to those readers of this book who will soon begin to produce the materials of another.

Part I

Appearances and Meaning in Early Flemish Painting

1

Jan van Eyck's Arnolfini Portrait

by ERWIN PANOFSKY

EDITORIAL NOTE: *The painting discussed in this essay had been recognized much earlier as one of the greatest works of the Flemish Renaissance, and as an exceptional and peculiar image. Panofsky's article is a classic in the explanation of lost symbols but is still more notable in demonstrating the ways, pictorial and psychological, in which these symbols are absorbed into the artist's language and become an element in its unified aesthetic effect on us. When it was published it introduced the theory of "disguised symbolism," now a standard tool of art history. Panofsky's later book,* Early Netherlandish Painting, *includes an elaborated statement of the theory with numerous examples and a very brief summary of this article in the context of the other works mentioned.*

FOR ABOUT three-quarters of a century Jan van Eyck's full-length portrait of a newly married couple (or, to speak more exactly, a man and a woman represented in the act of contract-

ing matrimony) [1] has been almost unanimously acknowledged to be the portrait of Giovanni Arnolfini, a native of Lucca, who settled at Bruges before 1421 and later attained the rank of a Conseiller du Duc de Bourgogne and Général des Finances en Normandie, and his wife, Jeanne de Cename (or, in Italian, Cenami), whose father, Guillaume de Cename, also came from Lucca, but lived in Paris from the beginning of the fifteenth century until his death.[2] But owing to certain circumstances which require some investigation, this identification has been disputed from time to time.

The "orthodox theory" is based on the assumption that the London portrait (fig. 1) is identical with a picture acquired by Don Diego de Guevara, a Spanish grandee, and presented by him to Margaret of Austria, Governor of the Netherlands, by whom it was bequeathed to her successor, Queen Mary of Hungary. This picture is mentioned in two inventories of Lady Margaret's collection (one made in 1516, the other in 1523), which give the name of the gentleman portrayed as "Hernoul le fin" and "Arnoult fin" respectively, as well as in the inventory of Queen Mary's property made after her death in 1558.[3] From this we must conclude that she brought it with her to Spain when she left the Netherlands in 1555, and in 1789 it is still mentioned among the works of art adorning the palace of Charles III, at Madrid.[4] As for the London portrait, we only know that it was discovered at Brussels in 1815 by an English Major General called Hay and subsequently taken to England, where it was purchased by the National Gallery in 1842.

1. W. H. James Weale, "Hubert and John van Eyck," 1908 ("Weale, I"), p. 69 ff.; W. H. James Weale, and M. W. Brockwell, "The van Eycks and their Art," 1912 ("Weale, II"), p. 114 ff. Both with bibliography.
2. For the Cename family and the personality of Giovanni Arnolfini, see L. Mirot, "Etudes Lucquoises," Bibl. de l'Ecole des Chartes, 91 (1930): 100 ff., especially p. 114.
3. These inventories are reprinted in Weale, I, p. 70 and Weale, II, p. 114. In Weale, II a third inventory of Lady Margaret's collection, made in 1524, is also quoted. This is said to contain a similar description of the picture. As for Queen Mary's inventory, see F. Beer: "Jahrb. d. Kunstslgn. d. Allerh. Kaiserh.," 12 (1891): 158, Nr. 85.
4. K. Justi, "Zeitschrift für bildende Kunst," 12 (1887): "Otra pintura vara de alto y tres quartos de ancho; Hombre y muger agarrados de las manos. Juan de Encina, Imbentor de la pintura al oleo."

As the subject matter of the picture described in the inventories (a man and a woman standing in a room and joining hands) is absolutely unique in northern fifteenth-century panel painting, its identity with the London portrait seems to be fairly well established; moreover, considering that the picture formerly belonging to the Hapsburg princesses disappeared after 1789, and the London portrait appeared in 1815, it seems safe to assume that the latter is identical with the former and was carried off during the Napoleonic wars. In addition, the London portrait corresponds to the descriptions in several respects, particularly the date (1434) and the mirror reflecting the couple from behind.[5]

There are only two circumstances which periodically give rise to discussion and recently led Monsieur Louis Dimier[6] to the conclusion that the picture in the National Gallery cannot be identical with the picture mentioned in the inventories: firstly, the enigmatical inscription on the London portrait: "Johannes de Eyck fuit hic"; secondly, the fact that, in Carel Vermander's biography of Jan van Eyck (published in 1604), the "Hapsburg picture" is described in the following manner: ". . . in een Tafereelken twee Conterfeytsels van Oly-Verwe, van een Man en een Vrouwe, die malcander de rechter handt gaven als in Houwelijck vergaderende, en *worden ghetrouwt van Fides, die se t'samengaf.*"[7] Translated into English, the passage reads: "On a small panel two portraits in oils, of a man and woman taking each other by the right hand, [note that, in reality, the man grasps the woman's right hand with his *left*] as if they were

5. The fact that the picture is called a large one in the inventories (while, in reality, it is not larger than 0.845 by 0.624 cm.) is no obstacle. Mr. Weale is obviously right in pointing out that "large" and "small" are relative terms, and that the panel is set down as "large" in comparison with those preceding it in the inventory of 1516. In addition a picture which was "small" for a late-sixteenth-century writer like Vermander, was "large" when judged by the standards of about 1400. As for the inventory of 1555/58, it is obviously based on an earlier one.

6. *Revue de l'Art,* 36 (1932): 18 ff. and also November, 1932. Monsieur Dimier's statements were already contradicted, though not properly disproved, by Mr. M. Jirmounsky, *Gazette des Beaux-Arts,* 74 (1932): 423, and also December, 1932.

7. Carel Vermander, "Het Leven der doorluchtighe Nederlandtsche en Hooghduytsche Schilders, ed. H. Floerke" (1906), I, p. 44.

contracting a marriage; and *they were married by Fides who joined them to each other."*

From this Monsieur Dimier infers that the "Hapsburg picture" not only showed a bridal pair as in the London panel, but also a *Personification of Faith,* who fulfilled the same office as, for instance, the priest in the versions of the Sposalizio, and he confirms this conclusion by quoting Joachim von Sandrart who, in 1675, qualifies Vermander's description by adding the statement that "Fides" appeared as an actual female ("Frau Fides" as the German version puts it) : "Par quoddam novorum coniugum, quos *muliebri habitu adstans* desponsare videbatur Fides."[8]

Now, Monsieur Dimier is perfectly right in pointing out that Vermander's "Fides" cannot possibly be identified (as was conjectured by some scholars)[9] with the little griffin terrier or Bolognese dog seen in the foreground of the London picture. For although a dog occurs fairly often as an attribute or symbol of Faith,[10] the Flemish word "tesamengeven" is a technical term equivalent to what "desponsare" or "copulare" means in Latin—a term denoting the action of the person entitled to hand over the bride to the bridegroom. Thus it is beyond doubt that not only Sandrart, but also Vermander actually meant to say that the couple portrayed in the "Hapsburg picture" were united by a *human figure embodying Faith.* The only question is whether or not Vermander is reliable. And this question must be answered in the negative.

Apart from the fact that a description as thorough as that in Queen Mary's inventory, where even the mirror is mentioned, would hardly omit a full-size figure, we must inquire from

8. Joachim von Sandrart, Acad. Germ., 1683, p. 203. In the German edition (Teutsche Akademie, 1675, ed. R. Peltzer: 1926, p. 55) the passage reads as follows: "Ein Mann und Weibsbild, so sich durch Darreichung der rechten Hand verheurathen und von der *darbey stehenden Frau Fides* vermählet werden."
9. See, for instance, Weale, "Notes sur les van Eyck," 1861, p. 26 ff., and Floerke, p. 408.
10. Cf. Barbier de Montault, "Traité d'Iconographie Chrétienne," 1890, p. 196, or Cesare Ripa: "Iconologia," s.v. "Fedeltà." In the "Repertorium Morale," by Petrus Berchorius (middle of the fourteenth century, printed Nürnberg, 1489) the dog is interpreted as "vir fidelis" (s.v. "canis") .

whom Vermander gleaned his information about a picture which, as mentioned above, he had never seen. Now it is a well-known fact (although entirely disregarded by Monsieur Dimier) that Vermander's statements as to the van Eycks are mostly derived from Marcus van Vaernewyck's "Spieghel der Nederlantscher Audtheyt," published in 1569 and (as "Historie van Belgis") in 1574. This was also the case with Vermander's description of the "Hapsburg picture," which is proved by the fact that he repeats Vaernewyck's absurd tale that Queen Mary had acquired the picture from a barber whom she had remunerated with an appointment worth a hundred florins a year—a tale which Sandrart took over from Vermander as credulously as the latter had taken it over from Vaernewyck. Thus Vaernewyck is the ultimate source from which both Vermander and Sandrart obtained their information, and his description of the "Hapsburg picture" reads as follows: "een cleen tafereelkin . . . waerin gheschildert was/een trauwinghe van eenen man ende vrauwe/*die van Fides ghetraut worden.*"[11] That is, in English: "a small panel on which was depicted the wedding of a man and a woman *who were married by Fides.*"

It is self-evident that Vermander's description is nothing but an amplification of this text, and we can easily see that he amplified it rather at haphazard. Since he was familiar with the usual form of a wedding ceremony, he ventured the statement that the two people took each other by the *right* hand (whereas, in the London portrait, the man proffers his *left*) ; and since, in his opinion, Vaernewyck's sentence "die van Fides ghetraut worden" (who were married by Fides) was lacking in precision he *arbitrarily added the adjectival clause "die se t'samengaf"* (who joined them to each other) . So this adjectival clause, so much emphasized by Monsieur Dimier, turns out to be a mere invention of Vermander's.

But what did Vaernewyck mean by his mysterious sentence? In my opinion he meant nothing at all, but simply repeated (or rather translated) information which in all probability puzzled him as much as his translation puzzles his readers. We should not forget that Vaernewyck had not seen the picture either, for

11. Weale: I, p. lxxxv. In the "Histoire van Belgis" of 1574 the passage is to be found on fol. 119 verso.

it had been brought to Spain by Queen Mary, and it is a signifi-
cant fact that in his earlier writings he does not mention it at
all.[12] Thus his description must be based on information
gleaned from an unknown source, most probably a letter from
Spain; and when we retranslate his sentence into Latin (using
the passage of Sandrart as a model), we can easily understand
how the confusion arose. This hypothetical text might have
read: "Tabella, in qua depicta erant sponsalia viri cuiusdam et
feminae *qui desponsari videbantur per fidem,*" and a sentence
like this would have been an absolutely correct description of
the London picture. Only, it could easily give rise to a misinter-
pretation because, to an uninitiated mind, the expression "per
fidem" might easily suggest a personification, while in reality it
was a *law term.*

According to Catholic dogma, marriage is a sacrament which
is immediately accomplished by the mutual consent of the
persons to be married when this consent is expressed by words
and actions: "Actus exteriores et verba exprimentia consensum
directe faciunt nexum quendam qui est sacramentum matri-
monii," as Thomas Aquinas puts it.[13] Even after the Council of
Trent has prescribed the presence of two or three witnesses and
the cooperation of a priest, the latter is not held to dispense the
"sacramental grace" as is the case in the baptism of a child or
the ordination of a priest, but is regarded as a mere "testis
qualificatus" whose cooperation has a mere formal value: ". . .
sacerdotis benedictio non requiritur in matrimonio quasi de
materia sacramenti." Thus, even now, the sacerdotal benedic-
tion and the presence of witnesses does not affect the sacra-
mental validity of marriage but is only required for its formal
legalization. Before the Council of Trent, however, even this
principle was not yet acknowledged. Although the Church did
its very best to caution the faithful against marrying secretly,
there was no proper "impedimentum clandestinitatis" until

12. Cf. Weale, I, p. lxxvi ff.
13. As for the theory of matrimony in Catholic theology, see Wetzer und
Welte, "Kirchenlexikon," s.v. "Ehe," "Eheverlöbnis," "Ehehindernis." Also
F. Cabrol and H. Leclercq, *Dictionnaire d'Archéologie Chrétienne et de
Liturgie,* s.v. "Marriage"; same authors: *Dictionnaire de Théologie
Catholique,* s.v. "Marriage" (very thorough).

1563; that is to say, two people could contract a perfectly valid and legitimate marriage whenever and wherever they liked, without any witness and independently of any ecclesiastical rite, provided that the essential condition of a "mutual consent expressed by words and actions" had been fulfilled. Consequently in those days the formal procedure of a wedding scarcely differed from that of a betrothal and both these ceremonies could be called by the same name "sponsalia," with the only difference that a marriage was called "sponsalia de præsenti" while a betrothal was called "sponsalia de futuro."

Now, what were those "words and actions" required for a legitimate marriage? Firstly, an appropriate formula solemnly pronounced by the bride as well as by the bridegroom, which the latter confirmed by raising his hand. Secondly, the tradition of a pledge ("arrha"), generally a ring placed on the finger of the bride. Thirdly, which was most important, the *"joining of hands,"* which had always formed an integral part of Jewish marriage ceremonies as well as those of Greece and Rome ("dextrarum iunctio"). (fig. 2) Since all these "words and actions" (comprehensively depicted in the London portrait) fundamentally meant nothing but a *solemn promise of Faith,* not only the whole procedure was called by a term derived from "Treue" in the Germanic languages ("Trauung" in German, "Trouwinghe" in Dutch and Flemish, whereby originally "Trouwinghe" could mean both "sponsalia de præsenti" and "sponsalia de futuro"), but also the various parts of the ceremony were called by expressions emphasizing their relation to faith. The forearm raised in confirmation of the matrimonial oath was called *fides levata;*[14] the wedding ring is called *la fede* in Italy up to our own times; and the *dextrarum iunctio* was called *fides manualis* or even *fides* without further connotation,[15] because it was held to be the essential feature of the ritual. Also in heraldry a pair of joined hands is simply called *une foi.*[16]

Thus in medieval Latin the word *fides* could be used as a

14. Du Cange, "Glossarium mediæ et infimæ latinitatis," s.v. "Fides."
15. Cabrol-Leclercq, *Dict. d'Archéol. Chrét.,* l.c., col. 1895. Du Cange, l.c.
16. Didron, *Annales Archéologiques,* 20 (1860): 245. See also Andrea Alciati's famous "Emblemata," no. 9 ("Fidei symbolum").

synonym of "Marital oath," more particularly *dextrarum iunc-
tio*. Consequently Jan van Eyck's London portrait could not be
described more briefly or more appropriately than by calling it
the representation of a couple "qui desponsari videbantur per
fidem," that is to say: "who were contracting their marriage by
a marital oath, more particularly by joining hands."

It is both amusing and instructive to observe how, in the
writings of sixteenth- and seventeenth-century biographers, this
abstract law term gradually developed into a living, though
allegorical, female figure. Vaernewyck opened the way to the
misinterpretation by inserting the Latin word *fides* into his
Flemish text and writing it with a capital F, but shrank from
any further explanation. Vermander emphasized the personality
of this rather enigmatical *Fides* by adding the adjectival clause
"who joined them to each other," and finally Sandrart explicitly
asserted that she was present as an actual woman, "habitu
muliebri adstans." It is not difficult to understand the mental
processes of those humanistic authors. To the contemporaries of
Cesare Ripa, personifications and allegories were more familiar
than to others, and they had in their minds all those Roman
sarcophagi where the people to be married are united by a
"Juno pronuba" (fig. 2). But the case should be a lesson to us
not to attempt to use literary sources for the interpretation of
pictures, before we have interpreted the literary sources them-
selves.

To the modern mind it seems almost inconceivable that, up
to the Council of Trent, the Catholic Church could acknowl-
edge a marriage contracted in the absence of any priest or
witness. Still this seeming laxity logically follows from the
orthodox conception of matrimony—a conception according to
which the binding force of a sacrament fulfilled by a spiritual
"coniunctio animarum" did not depend upon any accessory
circumstances. On the other hand, it is obvious that the lack of
any legal or ecclesiastical evidence was bound to lead to the
most serious inconveniences and could cause actual tragedies.
Medieval literature and papers dealing with law suits are full of
cases, partly tragic, partly rather burlesque, in which the valid-
ity of a marriage could be neither proved nor disproved for

want of reliable witnesses,[17] so that people who honestly believed themselves to be married found out that they were not, and vice versa. The most preposterous things could happen when the depositions of the people concerned contradicted each other, as they often did; for example, in the case of a young lady who was to become the mother of no less illustrious a person than Willibald Pirckheimer. This young lady was originally on fairly intimate terms with a young patrician of Nürnberg, called Sigmund Stromer, but wanted to get rid of him when she had made the acquaintance of Dr. Hans Pirckheimer. Now the unfortunate lover asserted that she was his legitimate wife, owing to the fact that they had secretly performed the ceremony of "joining hands"; but this was exactly what she denied. So the bishop of Bamberg, to whom the case was submitted, could not but decide that the marriage was not proved, and she was allowed to become the mother of Willibald Pirckheimer while poor Stromer remained a bachelor all his life.[18]

Now, this state of affairs perfectly explains the curious inscription on the London portrait: "Johannes de Eyck fuit hic. 1434." In Monsieur Dimier's opinion, this sentence which, according to the rules of Latin grammar, cannot but mean "Jan van Eyck has been here," would make no sense if it was not translated by "this was Jan van Eyck," thereby proving that the persons portrayed were the artist and his wife. Setting aside the grammatical problem, Monsieur Dimier's interpretation (which, by the way, was suggested by several other scholars, but was emphatically opposed by Mr. Salomon Reinach some fourteen years ago) [19] is contradicted by the simple fact that a child of Jan van Eyck had been baptized before June 30, 1434. Thus, discarding suspicions which must be regarded as groundless by the fact that this child was held over the font by Pierre de Beffremont in the name of the Duke of Burgundy,[20] we must

17. Plenty of Literature in Cabrol-Leclercq. *Dictionnaire de Théologie Catholique,* l.c., col. 2223.
18. E. Reicke, *Willibald Pirckheimer,* 1930, p. 10 ff.
19. Sal. Reinach, *Bulletin archéologique du Comité des travaux historiques et scientifiques,* 1918, p. 85.
20. Weale, I, p. xl; Weale, II, p. xxxvi.

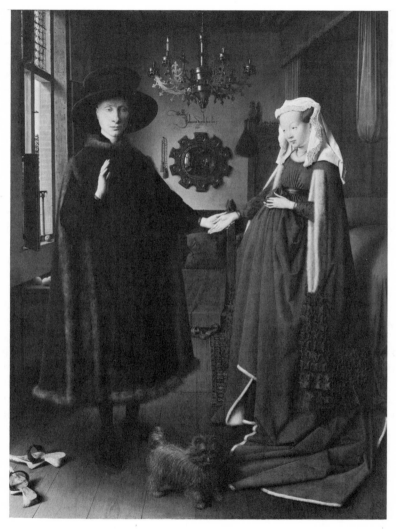

1. **Giovanni Arnolfini and His Bride,** Jan van Eyck. London, National Gallery
Courtesy of the Trustees, National Gallery, London

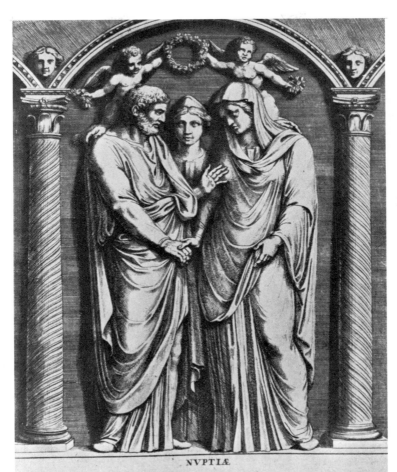

NVPTIÆ.

SPONSVS, ac SPONSA uicissim dexteras iúgunt, maritalis fidei argumentum. PRONVBA IVNO
in medio stat, ac utrumque amplectens, coniugio iúgit. AMORES GEMINI hinc inde uolitantes cor-
nam altera manu tenent, altera flores et frondes effundit, quorum sertis postes ædium nouę Nuptę
exornare consueuerunt.

In Ædibus Iustinianis

Romę ex Typographia Dominici de Rubeis Hæres Io: Iacobi de Rubeis ad Templ. S. Mariæ de Pace cum Priu. S. Pont. et Super. perm.

2. A Roman Marriage Ceremony, sarcophagus. Engraving published by
Pietro Santi Bartoli, 1693. Rome, Palazzo Giustiniani

assume that Jan van Eyck and his wife were married in the
autumn of 1433 at the very latest, so that they cannot be identi-
cal with the bridal pair represented in the London picture.
Furthermore, the phrase "Jan van Eyck was here" makes per-
fectly good sense when we consider the legal situation as de-
scribed in the preceding paragraphs. Since the two people
portrayed were married merely "per fidem" the portrait meant
no less than a "pictorial marriage certificate" in which the
statement that "Jan van Eyck had been there" had the same
importance and implied the same legal consequences as an
"affidavit" deposed by a witness at a modern registrar's office.

Thus there is no reason whatever to doubt the identity of the
London portrait with the panel mentioned in the inventories:
we can safely adopt the "orthodox theory" according to which
the two people portrayed are Giovanni Arnolfini and Jeanne de
Cename,[21] all the more so because the circumstances of their
marriage are peculiarly consistent with the unusual conception
of the "artistic marriage certificate." Both of them had abso-
lutely no relatives at Bruges (Arnolfini being an only child
whose property finally went to a nephew of his wife, and Jeanne
de Cename's family living in Paris),[22] so that we can under-
stand the original idea of a picture which was a memorial
portrait and a document at the same time, and in which a well-
known gentleman painter signed his name both as artist and as
witness.

Dr. Max J. Friedländer (who, by the way, already divined
the meaning of the inscription without investigating the mat-
ter)[23] rightly points out that the Arnolfini portrait is almost a

21. As for the apparent family likeness between Jeanne de Cename and
the wife of Jan van Eyck as portrayed by her husband in the famous
picture of 1439 (a family likeness from which Monsieur Dimier concludes
that the two portraits represent the same person, while Mr. Weale rather
believes Jeanne de Cename to be the sister of Margaret van Eyck), we
must bear in mind that in Jan van Eyck's pictures the women are much
less "individualized" than the men, adapted as they are to a typical ideal
of loveliness. As far as we can learn from documents, Jeanne de Cename
had only one sister named "Acarde" (Mirot: l.c., p. 107 and stemma p.
168).
22. Mirot, l.c., p. 114.
23. *Die Altniederländische Malerei,* I, 1924, p. 18.

miracle of composition: "In it a problem has been solved which no fifteenth-century painter was destined to take up again: two persons standing side by side, and portrayed full length within a richly furnished room . . . a glorious document of the sovereign power of genius."[24] In fact, to find an analogous composition in northern painting we must go forward to Holbein's *Ambassadors.* However, taking into consideration the fact that the London picture is both a portrait of two individual persons and a representation of a sacramental rite, we can explain its compositional scheme by comparing it not only with specimens of portrait painting but also with representations of marriage ceremonies to be found, for example, in the Bibles Moralisées[25] or, even more apropos, in a French Psalter of about 1323 (Munich, cod. gall. 16, fol. 35; fig. 4).[26] In it, the marriage of David and Michal, the daughter of Saul, is represented in a very similar way as that of Giovanni Arnolfini and Jeanne de Cename, only the bride does not act of her own accord, but is given away by her father, who is accompanied by a courtier and carries a glove as a symbol of his tutelary authority.

Apart from this difference, the two scenes resemble each other in that the ceremony takes place in absence of a priest and is accomplished by raising the forearm and joining hands, "fide levata" and "per fidem manualem." Thus the precocious apparition of a full-length double portrait can be explained by Jan van Eyck's adopting a compositional scheme not uncommon in the iconography of marriage pictures. But this adoption of a traditional scheme means anything but a lack of "originality." When the Arnolfini portrait is compared with the fourteenth-century miniature, we are struck by the amount of tender personal feeling with which the artist has invested the conventional gesture and, on the other hand, by the solemn rigidity of the figures, particularly that of the bridegroom. Van Eyck took the liberty of joining the *right hand* of the *bride* with the *left* of the *bridegroom,* contrary to ritual and contrary, also, to all the other representations of a marriage ceremony. He endeavored to avoid the overlapping of the right arm as well as the *contra-*

24. *Van Eyck bis Breughel,* 2d ed., 1921, p. 18.
25. Laborde, *Les Bibles Moralisées,* 1911, pl. 86 and 154.
26. Published by Hans Fehr, *Das Recht im Bilde,* 1923, fig. 191.

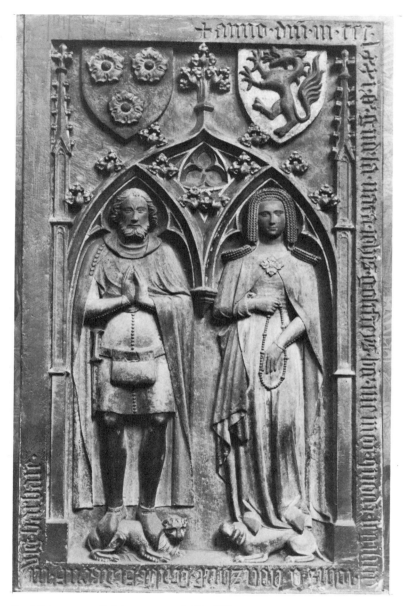

3. Johann von Hotzhausen and His Wife, sarcophagus. Frankfurt-am-Main, Cathedral
Courtesy of Marburg——Art Reference Bureau

posto movement automatically caused by the "dextrarum iunc-
tio" in the true sense of the term. Thus he contrived to build
up the group symmetrically and to subdue the actual movement
in such a way that the "fides levata" gesture of the bridegroom
seems to be invested with the confident humility of a pious
prayer. In fact the position of Arnolfini's right arm would make
a perfect attitude of prayer if the other arm moved with a
corresponding gesture. There is something statuesque about
these two figures, and I cannot help feeling that the whole
arrangement is, to some extent, reminiscent of those slab tombs
which show the full-length figures of a man and a woman in
similar attitudes, and where the woman is usually made to stand
upon a dog, here indubitably used as a symbol of marital faith
(fig. 3) .[27] It would be an attractive idea to explain the peculiarly
hieratic character of the Eyckian composition by an influence of
those quiet devout portrayals of the deceased, such as may be
seen on innumerable monuments of that period; all the more so

27. This type of medieval slab tomb is the result of an interesting process
which can be observed in a good many instances. The Bible is full of what
we may call, "involuntary descriptions" of ancient oriental images, such as,
for instance, the scapegoat tied to the Holy Tree as recently discovered in
the Royal tombs of Ur which was the model of Abraham's ram caught in
the bush, or the Babylonian astral divinity resuscitated as the "apocalyptic
woman." Now the thirteenth verse of the 90th Psalm says "super aspidem
et basiliscum ambulabis et conculcabis leonem et draconem," thus describ-
ing the Babylonian type of a god or hero triumphing over an animal or a
couple of animals (a type which also gave rise to the representations of St.
Michael fighting the Dragon, the Virtues conquering Evil and so forth) .
We can observe how this motive which originally was used exclusively for
the representations of Christ was gradually transferred to the Virgin, the
Saints and finally to the slab tombs, such as the monument of Bishop
Siegfried von Epstein in Mainz Cathedral or that of Heinrich von Sayn in
the Germanisches Museum, Nuremberg. From this we must conclude that
the animals forming the "foot rest" of the knights and princes portrayed
on great medieval slab tombs were originally no attributes denoting the
praiseworthy qualities of the deceased, but symbols of Evil conquered by
the immortal soul. Later on, however, the Lion which originally was meant
to be the "leo conculcatus" described in the 90th Psalm was interpreted as
a symbol of Fortitude, and when the statues of a married couple were to
be placed on the same monument (so that the women, too, had to be
provided with an animal) she was usually made to stand upon a Dog,
conceived as a symbol of Marital Faith (see note 10) .

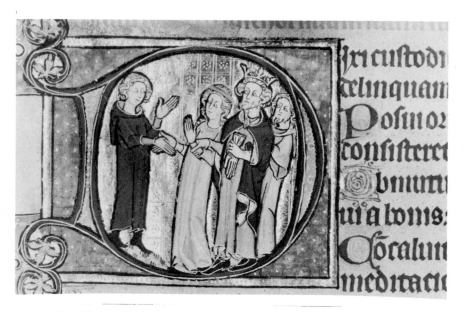

4. The Marriage of David and Michal, in a French psalter ca. 1323.
Munich, Staatsbibliothek
Courtesy of Bayerische Staatsbibliothek

because the inherent connection between the incunabula of early Flemish painting and sculpture is proved by many an instance.

In the London picture, however, these statuesque figures are placed in an interior suffused with a dim though colored light, which shows up the peculiar tactual values of such materials as brass, velvet, wood, and fur, so that they appear interwoven with each other within a homogeneous chiaroscuro atmosphere. Small wonder then that the Arnolfini portrait has always been praised as a masterpiece of "realistic" interior, or even genre, painting. But the question arises whether the patient enthusiasm bestowed upon this marvelous interior anticipates the modern principle of "l'art pour l'art," so to speak, or is still rooted to some extent in the medieval tendency of investing visible objects with an allegorical or symbolical meaning.

First of all we must bear in mind that what Mr. Weale simply calls "a Flemish interior" is by no means an ordinary living room, but a nuptial chamber in the strict sense of the term, that is to say, a room hallowed by sacramental associations and which even used to be consecrated by a special "Benedictio thalami."[28] This is proved by the fact that in the beautiful chandelier hanging from the ceiling, only one candle is burning. For since this candle cannot possibly serve for practical purposes (in view of the fact that the room is flooded with daylight) , it must needs bear upon the marriage ceremony. In fact a burning candle—symbol of the all-seeing wisdom of God—not only was and often is, required for the ceremony of taking an oath in general,[29] but also had a special reference to weddings. The "marriage candle"—a substitute for the classical "tæda" which had been so essential a feature of Greek and Roman marriage ceremonies that the word became synonymous with "wedding"—was either carried to church before the bridal procession, or solemnly given to the bride by the bridegroom, or lit in the home of the

28. See Ildefons Herweghen, "Germanische Rechtssymbolik in der römischen Liturgie," *Deutschrechtliche Beiträge,* 8 (1913) : 312 ff.
29. "Jurare super Candelam," "Testimonium in Cereo." See Wetzer-Welte, l.c., s.v. "Eid" and Jac. Grimm, "Deutsche Rechtsaltertümer," 4th ed., 1899, II, p. 546.

newly married couple; we even know of a custom according to which the friends of the couple called on them in the evening "et petierunt Candelam per sponsum et sponsam . . . sibi dari."[30] Thus we learn from the one burning candle that the "Flemish interior" is to be interpreted as a "thalamus," to speak in medieval terms, and we comprehend at once its unusual features. It is not by chance that the scene takes place in a bedroom instead of a sitting room (this applies also to a considerable number of fifteenth- and sixteenth-century *Annunciations,* in which the interior is characterized as the "Thalamus Virginis," as a liturgical text puts it), nor is it by accident that the back of the armchair standing by the bed is crowned by a carved wooden figure of *St. Margaret triumphing over the Dragon,* for this Saint was especially invoked by women in expectation of a child[31]; thus the small sculpture is connected with the bride in the same way as the burning candle is connected with the bridegroom.

Now the significance of these motives is an attributive, rather than a symbolical one, inasmuch as they actually "belong" to a nuptial chamber and to a marriage ceremony in the same way that a club belongs to Hercules or a knife to St. Bartholomew. Still, the very fact that these significant attributes are not emphasized as what they actually are, but are *disguised,* so to speak, as ordinary pieces of furniture (while, on the other hand, the general arrangement of the various objects has something solemn about it, placed as they are according to the rules of symmetry and in correct relationship with the statuesque figures) impresses the beholder with a kind of mystery and makes him inclined to suspect a hidden significance in all and every object, even when they are not immediately connected with the sacramental performance. And this applied in a much higher degree to the medieval spectator who was wont to conceive the whole of the visible world as a symbol. To him, the little griffin

30. Du Cange, l.c., s.v. "Candela." See Wetzer-Welte, l.c., s.v. "Hochzeit" and "Brautkerze."
31. Weale, I, p. 20 and Weale, II, p. 17. This belief has even led some scholars to suppose that St. Margaret is to be regarded as a substitute for the classical Lucina (F. Soleil: "La vierge Marguérite substituée à la Lucine antique," 1885).

terrier as well as the candle were familiar as typical symbols of faith,[32] and even the pattens of white wood so conspicuously placed in the foreground of the picture would probably impress him with a feeling of sacredness: "Loose thy shoe from off thy foot, for the place whereon thou standest is holy.''

Now, I would not dare to assert that the observer is expected to realize such notions consciously. On the contrary, the supreme charm of the picture—and this applies to the creations of Jan van Eyck in general—is essentially based on the fact that the spectator is not irritated by a mass of complicated hieroglyphs, but is allowed to abandon himself to the quiet fascination of what I might call a transfigured reality. Jan van Eyck's landscapes and interiors are built up in such a way that what is possibly meant to be a mere realistic motive can, at the same time, be conceived as a symbol, or, to put it another way, his attributes and symbols are chosen and placed in such a way that what is possibly meant to express an allegorical meaning at the same time perfectly "fits" into a landscape or an interior apparently taken from life. In this respect the Arnolfini portrait is entirely analogous to Jan van Eyck's religious paintings, such as the marvelous *Virgin of Lucca,* where many a symbol of virginity (the "living waters," the candlestick, the glass carafe, and even the "throne of Solomon") [33] is "disguised" in a similar way; or the image of *St. Barbara,* whose tower (characterized by

32. With regard to the dog, see notes 10 and 27; with regard to the candle, see Didron, l.c., p. 206 ff. and plate facing p. 237. Also E. Mâle, "L'Art religieux de la fin du moyen-âge en France," 2d ed., 1922, p. 334, and Ripa, l.c., s.v. "Fede Cattolica," where the motive is explained by a passage of St. Augustin which says "Cæcitas est infidelitas et illuminatio fides." Needless to say that "Fides" could always mean both "True Belief" and "Faithfulness," especially of wife and husband. Fides conceived as a theological virtue explicitly prescribes "serva fidem coniugum" (Didron: l.c., p. 244) .

33. As for the "aquæ viventes" W. Molsdorf, "Führer durch den symbol. und typol. Bilderkreis," 1920, nr. 795. The comparison of the Virgin with a "candelabrum" is to be found in the "Speculum Humanæ Salvationis" (quoted by E. Beitz, "Grünewalds Isenheimer Menschwerdungsbild und seine Quellen," 1924, p. 25) ; in Berchorius' "Repertorium morale" the "candelabrum" is adduced as a symbol of Virtue and, quite logically, as "basis fidei," because the candle itself stands for Faith as mentioned in the preceding note) . As for the carafe, which also occurs in Grünewald's Isenheim altar, see Beitz: l.c., p. 47.

the three windows alluding to the Holy Trinity) has been transformed into what seems to be a realistic Gothic church in course of erection;[34] but, thanks to the formal symmetry of the composition, this building impresses us as even more "symbolical" that if the tower had been attached to the figure in the usual form of an attribute.

Thus our question whether or not the still life-like accessories in our picture are invested with a symbolical meaning turns out to be no true alternative. In it, as in the other works by Jan van Eyck, medieval symbolism and modern realism are so perfectly reconciled that the former has become inherent in the latter. The symbolical significance is neither abolished nor does it contradict the naturalistic tendencies; it is so completely absorbed by reality that reality itself gives rise to a flow of preternatural associations, the direction of which is secretly determined by the vital forces of medieval iconography.[35]

34. This is the reason why the picture was sometimes described as St. Agnes (Weale, I, p. 89; Weale, II, p. 129).

35. Thus, it is little surprising that a little dog, very similar to that in the Arnolfini portrait, occurred also in the famous picture of a naked woman taking her bath described by Bartholomaeus Facius and apparently analogous to a painting which was formerly in the collection of Cornelius van der Geest (Weale, I, p. 175; Weale, II, p. 196 ff.), where the motive has obviously nothing to do with marital Faith. Iconographical symbols, especially in medieval art, are almost always "ambivalent" (the snake can mean Evil as well as Prudence, and golden sandals can be an attribute of Luxury as well as Magnanimity, see Panofsky, *Münchner Jahrbuch der Bild. Kunst,* N. F., 9 (1932) : 285 ff. Thus, the equation dog = faith does not preclude the equation dog = animality, as shown on the reverse of the well-known Constantine-medal, where a little dog characterizes the personification of Nature in contradistinction to Grace. Consequently the griffin terrier "fits" into the bathroom picture as well as into the Arnolfini portrait, whether we regard it as a "symbol" or as a mere "genremotif." When this article was in print, K. von Tolnai published a paper (*Münchner Jahrbuch* l.c., p. 320 ff.) in which, I am glad to say, the problem of symbolism in Early Flemish art is approached in a similar way.

2

"Muscipula Diaboli," the Symbolism

of the Mérode Altarpiece

by MEYER SCHAPIRO

EDITORIAL NOTE: *The "Master of Flémalle" is a name invented by art historians of the late nineteenth century, at an early stage of the systematic study of Flemish Renaissance painting, when they were able to agree that a group of paintings was by the same important artist although none of them was signed or connected with documents. It is now accepted by most specialists that he is the painter who appears in records as Robert Campin, since the profile of a career deduced from the paintings matches the profile of the known events of Campin's life. But since there is no absolute proof, the name Master of Flémalle continues to be used. He is a contemporary of Jan van Eyck, a little older and a little less sophisticated—for example, in his spatial forms and in the representation of light in interiors. But for the purposes of the present essay, both artists share a group style of their place and time. Schapiro is therefore able to use the same approach as Panofsky in studying the disguised symbolism, while exploiting some other methods as well.*

I

IN THE MÉRODE ALTARPIECE by the Master of Flémalle, the figure of Joseph appears in a wing beside the *Annunciation* as an artisan who fashions mousetraps (fig. 5) .[1] Not only is the

1. For an illustration of the *Annunciation* see the accompanying article by Millard Meiss (fig. 10) .

presence of Joseph in the context of the *Annunciation* excep-
tional in Christian art; we are surprised also that his craft of
carpentry should be applied to something so piquant and mar-
ginal in his métier. The writers on Flemish painting have seen
in this singular detail the mind of the author, who shows in
other parts of his work an unmistakable disposition to the
domestic, the intimate, and the tiny; his pictures represent a
cozy, well-kept bourgeois world in which the chief actors are
comfortably at home. He has been called the "Master with the
Mousetrap,"[2] and a recent critic has regretted the now accepted
name, since the former one is "prettier and more character-
istic."[3]

I believe that this detail of the mousetrap is more than a
whimsical invention of the artist, suggested by Joseph's occupa-
tion. It has also a theological meaning that was present to the
minds of Christians in the Middle Ages, and could be related by
them to the sense of the main image of the triptych. St. Augus-
tine, considering the redemption of man by Christ's sacrifice,
employs the metaphor of the mousetrap to explain the necessity
of the incarnation. The human flesh of Christ is a bait for the
devil, who, in seizing it, brings about his own ruin. "The devil
exulted when Christ died, but by this very death of Christ the
devil was vanquished, as if he had swallowed the bait in the
mousetrap. He rejoiced in Christ's death, like a bailiff of death.
What he rejoiced in was then his own undoing. The cross of the
Lord was the devil's mousetrap; the bait by which he was
caught was the Lord's death."[4]

This metaphor appealed to St. Augustine as an especially
happy figure of the redemption; it occurs no less than three
times in his writings.[5] In another sermon he says: "We fell into

2. By Bode, *Gazette des Beaux-Arts,* 2d ser., 32 (1887) : 218.
3. Fierens-Gevaert, *Histoire de la peinture flamande,* Paris, Brussels, 1928,
II, p. 8.
4. "Exsultavit diabolus quando mortuus est Christus, et ipsa morte Christi
est diabolus victus, tanquam in muscipula escam accepit. Gaudebat ad
mortem, quasi praepositus mortis. Ad quod gaudebat, inde illi tensum est.
Muscipula diaboli, crux Domini: esca qua caperetur, mors Domini." Sermo
CCLXIII, "De ascensione Domini," Migne, *Pat. Lat.,* XXXVIII, col. 1210.
5. See also Sermo CXXX, *ibid.,* col. 726 (on John 5:5–14) , and Sermo CXXXIV,
ibid., col. 745 (on John 8:31–34) .

the hands of the prince of this world, who seduced Adam, and made him his servant, and began to possess us as his slaves. But the Redeemer came, and the seducer was overcome. And what did our Redeemer to him who held us captive? For our ransom he held out His Cross as a trap; he placed in it as a bait His own Blood."[6]

The image of the mousetrap was only one of several metaphors of deception by which the theologians attempted to justify Christ's incarnation and sacrifice as the payment of a ransom owed to the devil, who held man prisoner because of the sin of Adam and Eve.[7] The conception of Christ's body as a bait on a divine fishhook which lures the demon to destroy himself was an older and more common figure, already used by Gregory of Nyssa and Cyril,[8] but was questioned by some writers as immoral. Anselm replaced the commercial transaction between God and the devil by the feudal idea of a wrong done by man to the honor of his superior, God, for which man as a finite creature was incapable of rendering due satisfaction (since the insult to God was infinite and required an infinite yet human penalty) ; and hence God in his infinite mercy offered his own incarnate Son as a voluntary sacrifice to atone for man's sin. Abelard, shortly after, devised a more ethical account of the sacrifice on the pattern of personal love, as a spontaneous, ultimate manifestation of Christ's love of man, which inspires the latter to a corresponding goodness and love. But the older view, with the authority of Augustine and Gregory the Great, persisted throughout the Middle Ages. Peter Lombard in his

6. "Sed venit Redemptor, et victus est deceptor. Et quid fecit Redemptor noster captivatori nostro? Ad pretium nostrum tetendit muscipulam crucem suam: posuit ibi quasi escam sanguinem suum," *ibid.,* Sermo cxxx, col. 726.

7. On these doctrines see Hastings Rashdall, *The Idea of the Atonement in Christian Theology,* London, 1920, and Jean Rivière, *Le dogme de la rédemption au début du moyen âge,* Bibliothèque Thomiste, Section historique, xvi (Paris, 1934) .

8. "The Deity was hidden under the veil of our nature, that so, as is done by greedy fish, the hook of Deity might be gulped down along with the bait of the flesh"—Gregory of Nyssa, *Oratio catechetica magna,* 24, cited by Rashdall, *op. cit.,* p. 305; for Cyril, see *ibid.,* p. 311, n. 3; for Augustine, *ibid.,* pp. 330 ff.; and on these metaphors in the West, see Rivière, *op. cit.,* pp. 39, 40.

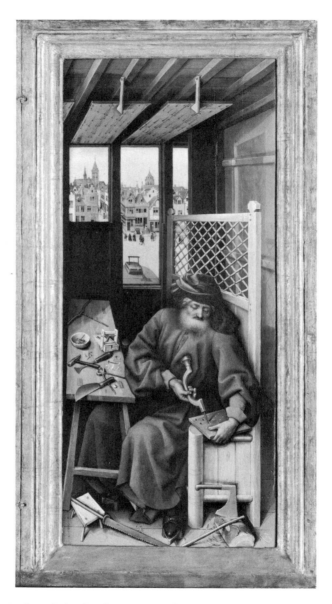

5. **Joseph in the Carpenter's Shop,** from the Mérode Altarpiece, Master of Flémalle. New York, Metropolitan Museum of Art, The Cloisters Collection

6. **Incarnation,** in the **Hours of Catherine of Cleves.** New York, A. B. Martin, Guennol Collection

widely read *Sentences* repeats almost word for word Augustine's fable of the mousetrap and the deceiver deceived.[9] In the time of the Mérode altarpiece, the metaphor of the fishhook still appears in the writings of John Gerson expounding the Redemption.[10]

The connection of the mousetrap in the picture with the theological metaphor is strengthened by the extraordinary way in which the artist has rendered the *Annunciation* in the neighboring panel (fig. 10). Instead of the Holy Spirit in the form of a dove, usual in images of the subject, he has represented a tiny naked figure of a child bearing a cross and descending toward the Virgin along beams of light which have just passed through a window. This homunculus Christ with the cross is fairly common in later medieval art,[11] although it appears to be contrary to dogma in showing the substantial human form of Christ before the moment of incarnation; it was criticized as unorthodox,[12] but the child was probably understood by the pious spectator as a symbol of the incarnation to come, just as the cross carried by this figure symbolized the crucifixion and redemption.[13] Here, too, as in the Joseph scene, doctrine, metaphor and reality are condensed in a single object. The beams of light penetrating the window are not simply a phenomenal detail of everyday life, which later Dutch artists were to represent more subtly and picturesquely in their genre paintings of a woman reading or sewing in her room; the passage of the rays through the glass is a characteristic medieval image of the miraculous insemination. In medieval poetry, in mystical literature, in hymns and mystery plays, in Latin and the vernacular, this metaphor recurs.

9. Lib. III, Dist. XIX, I, Migne, *Pat. Lat.*, CXCII, col. 796; he repeats Augustine, Sermo CXXX, Migne, *Pat. Lat.*, XXXVIII, col. 726.
10. John Gerson, *Opera omnia* (Antwerp, 1706), III, col. 1199. See also below, p. 33 and note 28 for the text.
11. See David M. Robb, "The Iconography of the Annunciation in the Fourteenth and Fifteenth Centuries," *Art Bulletin*, 18 (1936) : 523.
12. By St. Antoninus of Florence (1389–1459) ; for the text, see Robb, *op. cit.*, p. 526.
13. See Charles de Tolnay, *Le Maître de Flémalle et les frères van Eyck* (Brussels, 1939), p. 15.

> As a ray of the sun
> Through a window can pass,
> And yet no hurt is done
> The translucent glass,
>
> So, but more subtly,
> Of a mother untried,
> God, the son of God,
> Comes forth from his bride.[14]

In the Mérode panel, the mystery that takes place within the Virgin's body is symbolized in the space of the house; the various objects, all so familiar and tangible, the door, the win-

14.
> Sicut vitrum radio
> solis penetratur,
> inde tamen laesio
> nulla vitro datur,
>
> Sic, immo subtilius,
> matre non corrupta,
> deus, dei filius,
> sua prodit nupta.

Mone, *Lateinische Hymnen des Mittelalters,* Freiburg i. Br., 1853, II, no. 370, p. 63 ("Sequentia de virgine Maria"). See also the poem by a Spanish writer of the twelfth century, Peter of Compostela, which I have cited elsewhere in a parallel context ["From Mozarabic to Romanesque in Silos," *Art Bulletin,* 21 (1939) : 349, note 122]:

> Ut propriis solis radiis lux vitra subintrat,
> Sic uterum rector superum mox virginis intrat.

(see P. B. Soto, "Petri Compostellani De consolatione rationis libri duo," *Beiträge zur Geschichte der Philosophie des Mittelalters,* 8 (1912) : 122).

Another example is published by Mone, *op. cit.,* I, p. 63, in the hymn, "Dies est laetitiae in ortu regali . . ."; its special significance will be discussed in the accompanying article by Millard Meiss, whose questions about the motif of the light passing through the window in the *Annunciation* have been the occasion of my own consideration of the symbolism. Further examples are cited in the valuable book by Georges Duriez, *La Théologie dans le drame religieux en Allemagne au moyen âge* (Paris, 1914), p. 209 (German mystery plays; Amadeus; and St. Bridget, who seems to paraphrase the poems published by Mone), and by K. Smits, *De Iconografie van de Nederlandsche primitieven* (Amsterdam, 1933), p. 46, who connects this detail in Flemish painting with a corresponding medieval Netherlandish text.

dow, the towel, the basin, the pot of lilies, the lighted candle, and perhaps others, possess a hidden religious meaning, focused in the central human figure. The theological sense of the mousetrap becomes more credible as an element of this symbolic whole. The imaging of the incarnation through the movement of the tiny soul-homunculus passing through glass along the rays of light belongs to the same mode of fantasy as the metaphorical mousetrap with its fleshly bait for the devil. Together they mark the poles of the human career of Christ.

II

The image of the mousetrap depends, of course, on the presence of Joseph, who is a most unusual figure beside the *Annunciation*. In the two other examples that I know—a painting by Giovanni di Paolo,[15] contemporary with the Mérode panel, and a tapestry in Reims of about 1530[16]—the mousetrap is not rendered. In the first, Joseph simply warms himself by the fire; in the second, he is shown as a carpenter cutting wood and is part of an elaborate typological composition that includes *Isaiah,* the *Temptation of Eve,* and *Gideon's Fleece.* It is possible that in both works Joseph and Mary were understood as counterparts of Adam and Eve; in the Italian work, the *Expulsion* adjoins the *Annunciation.*

In the Mérode triptych, which was probably made in the 1420's, the introduction of Joseph is peculiarly timely and local. This is a moment of strong propaganda for the cult of Joseph, which is undeveloped before the end of the fourteenth century.[17] In 1399, the feast of Joseph (March 19) was adopted by the Franciscan order, and a little later by the Dominicans, but it did not enter the Roman breviary until 1479 and became

15. Now in the National Gallery in Washington; see *Art Quarterly,* 5 (1942) : 316, fig. 2.
16. Ch. Loriquet, *Tapisseries de la Cathédrale de Reims,* Paris, Reims, 1882, pl. ix. These tapestries are now in the Municipal Museum.
17. On the history of the cult of Joseph, see O. Pfülf, "Die Verehrung des heiligen Joseph," *Stimmen aus Maria-Laach,* 38 (1890): 137–61, 282–302, and the articles on St. Joseph in *The Catholic Encyclopedia* and the *Dictionnaire de Théologie Catholique.*

obligatory for the entire Church only in 1621. In the first decades of the fifteenth century, the leaders in the movement for the cult of Joseph were two eminent conservative reformers of the Church who had held important religious posts in Flanders, the Cardinal Peter d'Ailly (1350–1425), bishop of Cambrai, a diocese that embraced Hainaut, Brabant, and Namur, and his pupil, John Gerson (1363–1429), who for a time after 1397 was dean of St. Donatian in Bruges. At the Council of Constance in 1416, they proposed that Joseph be elevated to a rank above that of the apostles and next to the Virgin's; they argued also for the institution of a universal feast of the Marriage of Mary and Joseph. Their effort was unsuccessful, but it contributed, no doubt, to the growth of the cult of Joseph. In the early fifteenth century, his feast appears in service books of churches in Louvain, Liège, and Utrecht, and the feast of the Marriage is adopted toward 1430 in Bruges, Douai, and Arras. Gerson composed a number of works in honor of Joseph, including a sermon and a mass;[18] in his writings on the Annunciation and the Nativity, he dwells on the virtues of Mary's husband, whom he calls the "lord and master of the mother of the lord and Master of all."[19] He pictures with great feeling the ideal relationship of the couple, their mutual trust, their chaste marriage, and, employing arguments that had been offered by an earlier theologian, Simon of Tournai, he justifies their relation as a true marriage, in spite of the perpetual virginity of the couple.[20]

It would be interesting to know why the cult of Joseph should spread at this time, and why the two men who were

18. *Opera omnia*, Antwerp, 1706, III, cols. 842 ff. ("Considerations sur saint Joseph"), cols. 1352 ff. ("Sermo de annuntiatione B.M.V."), cols. 729 ff. ("Exhortatio facta . . . Anno Domini 1413. Ut solemnizetur Festum Sancti Joseph virginalis sponsi beatae Mariae"), cols. 736 ff. ("Sequuntur quaedam quae opportune dicerentur in Festo s. Joseph"), cols. 740 ff. ("Officium Missae s. Joseph, etc."), cols. 743–83 ("Josephina carmine heroico decantata"). The date of the heroic poem is given by the text as 1417.

19. *Ibid.*, III, col. 844.

20. *Ibid.*, III, cols. 851 ff.; IV, col. 764.

especially active in the unification and reform of the divided Church should be its chief proponents. Here it is enough to observe that the cult of Joseph, when considered beside the worship of the apostles and the local saints, who represent the authority and miracle-working powers of the church, places the human family of Christ in the foreground of devotion. It is essentially domestic and bourgeois, and celebrates the moral, familial virtues of the Saint, rather than a supernatural accomplishment. Joseph belongs to the world as a husband and artisan, but he is also a model of continence. These aspects of his cult are in harmony with Gerson's nominalism and warm, emotional piety, his vernacular style, his concern with moral questions and desire for a simple faith freed from formal theological elaborations and subtlety. He turns from the mysterious, incomprehensible Trinity of dogma to the "divinissima Trinitas Jesu, Joseph et Mariae."[21]

Although there is nothing about the mousetrap in his writings, Gerson's account of Joseph is not irrelevant to this detail of the Mérode panel. In the first place, he stresses Joseph's occupation as a carpenter (he calls him a "charlier"—interesting for his personal enthusiasm for Joseph, since Charlier was Gerson's family name), and he disserts at length on the virtue of this humble craft, which, together with the Virgin's labor as a weaver, assures his humility, his moral dignity, and his livelihood.

> O what a marvel of deep humility—thus God's graciousness and humanity was such that he willed to be subject to a carpenter, a *charlier* or woodcutter, and to a poor weaver or silk worker. [Joseph] devoted himself to work and toil, so as to be busied well and earn a just and honest living, and gain the blessing the Prophet speaks of when he says: "Because you eat the toil of your hands (that is, what your hands earn) you are blessed and it will go well with you" (Psalm 127). Thus Joseph in youth took to carpentry, to making carts or sheds or windows or ships or houses, though he was of an honorable and noble line in Nazareth, which is against the men and women who don't want to work and think

21. *Ibid.*, III, col. 844.

it shameful or slavery, and so are often poor and evil in the world and more to God, for such persons are commonly slaves to all the vices. . . .[22]

These arguments, it may be said in passing, anticipate the ascetic Protestant concept of the vocation and the religious value of industriousness, and should be taken into account in the problem of the origins of the Protestant ethic and bourgeois morality.

If this praise of Joseph as an artisan helps us to understand the pictures of the Saint plying his craft, there is another aspect of the Saint discussed by Gerson, which refers to the theological concepts behind the metaphor of the mousetrap. He is deeply concerned with Joseph's role in the deception of the devil in the divine plan of redemption, and in treating the question he alludes more than once to the artistic images of the Saint. He observes that in ancient paintings Joseph is represented as a very old man with a big beard, and he attempts, like a modern student of iconography, to account for this type by historical considerations.[23] In the early period of Christianity, when the doctrine of the perpetual virginity of Mary had not yet taken firm root in the hearts of the faithful, it was necessary to combat heretics, who pointed to the Gospel passage about the brothers and sisters of Christ. The artists therefore rendered Joseph as an old man at the moment of Christ's birth, in order to indicate his incapacity for begetting a child. But Gerson remarked also that in more recent art, especially in Germany (where he had spent some time after the Council of Constance), Joseph was represented as a young man. The painters have a certain liberty, he says, quoting Horace:

> . . . Pictoribus atque poetis
> quidlibet audendi semper fuit aequa potestas.[24]

22. *Ibid.*, III, col. 850. See also IV, col. 755.
23. *Ibid.*, III, cols. 848, 1352.
24. *Ibid.*, III, col. 1352: ". . . Depictum tamen invenimus Joseph velut in aetate juvenili, qualem praediximus, sicut in hac Alemania crebro notavi. Vel dic illud Horatii . . ."

This newer version Gerson believes to be more in keeping with
the divine plan. For if Joseph were too old, the devil would
suspect the supernatural cause of the birth of Christ and there-
fore not be deceived by the bait of the man-God.[25] On this
question of the devil's awareness of the incarnation, theologians
were divided.[26] Some, basing themselves on passages in the
Gospels (Mark 1:24 and Luke 4:34, 41), believed that the
devil, from the beginning, recognized the divine paternity of
Mary's child; others, following Ignatius, whose opinion was
read in the office of Christmas Eve in the Roman breviary, held
that the Virgin was married to Joseph precisely in order to
conceal the birth of Christ from the devil, who thought the
child was begotten by Joseph. This last interpretation was wide-
spread in the later Middle Ages, and occurs in the writings of
Bernard, Bonaventure, and Thomas, in the mystery plays, and
the *Speculum humanae salvationis.*

The role of Joseph in the deception of the devil was therefore
perfectly familiar in the time of the Mérode altarpiece. It may
appear surprising then that Joseph is so often represented as an
old man; but the theologians themselves were not strict in this
whole matter. The same author, Jerome, or Thomas Aquinas,
or Bridget of Sweden,[27] could give contradictory opinions on
the question of the devil's knowledge of the incarnation, accord-
ing to the context treated. By either type of Joseph, old or
young, the spectator would be led to recall the homiletic truths
about Mary's virginity and the virtue of her chaste spouse.
Local tradition undoubtedly had much to do with the type
chosen, which, once established, became the vehicle of a grow-
ing mass of legend and belief implicit for the spectator in the
mere presence of the customary image, however scant or incon-
sistent the attributes might be.

In the present case, what matters is the fact that Joseph was
for the religious fantasy of the later Middle Ages the guardian
of the mystery of the incarnation and one of the main figures in

25. *Ibid.,* III, col. 851; IV, col. 761.
26. The opinions are collected by Duriez, *op. cit.,* pp. 73, 74. See also
Dictionnaire de théologie catholique, VIII, col. 1513.
27. Duriez, *loc. cit.*

the divine plot to deceive the devil. Gerson, in meditating on the redemption, does not employ the figure of the mousetrap. Instead, the fishhook and bait are the instruments, as I have remarked already. In his "Exposition on the Passion of the Lord," he addresses the devil as Leviathan who tried to bite the precious flesh of Jesus Christ with the bite of death. "But the hook of divinity that was concealed within and joined to the flesh, tore open the devil's jaws and liberated the prey, which you would imagine he held and devoured."[28]

III

The double character of the mousetrap in the painting, as domestic object and theological symbol, suggests the following reflections on the art. In the early Middle Ages the notion that the things of the physical world are an allegory of the spiritual did not entail the representation of these things as the signs of a hidden truth. The symbolism of art was largely confined to personifications and to the figures and episodes derived from the holy books; if animals were represented as symbols, they were most often the creatures named in the Bible, like the four beasts of John's and Ezekiel's visions, or the half-fabulous beings described and interpreted in the *Physiologus*. The introduction of nature and, with it, of the domestic human surroundings into painting can hardly be credited to a religious purpose. The mousetrap, like the other household objects, had first to be interesting as a part of the extended visible world, before its theological significance could justify its presence in a religious picture. But even as a piece of still life, the mousetrap is more than just an object in a home; it takes its place beside the towel and the basin of water as an instrument of cleanliness or wholeness, and may therefore be regarded as an overt symbol of the Virgin's purity in the same sense as the others and, like them, independent of a theological text. The artist who inserts this object among the others feels its qualitative connection

28. *Op. cit.*, iii, col. 1199 ("Expositio in Passionem Domini") : ". . . sed occultabatur intus et jungebatur divinitatis hamus, qui aperuit maxillas, et liberavit praedam quam opiniabaris tenere atque devorare."

with them and creates a poetic unity, based on his love for the quality that attracts him. This love need not be religious in character, but a primary personal (or social) fact, which the religion absorbs and with which the artist himself may color the religious world.

If, now, we look at the mousetrap in this poetic manner as an attribute of Joseph or of Joseph and Mary together, we are led to another result. We have to consider then its significance in relation to the human peculiarities of these two figures, who are man and woman, old and young, married yet chaste, in the context of a miraculous conception. In a poem about a beautiful maiden beside a pious old husband who is making a mousetrap, we would sense a vague, suggestive aptness in his activity, as if his nature and a secret relation to the girl were symbolized in his craft. The painter, in imagining a milieu for the Virgin and her guardian, Joseph, is unconsciously attracted by objects that project in some feature essential characters of the figures and vaguely resemble the hidden elements of the action. As we meditate on the labor of old Joseph who bores tiny holes with his drill, as we regard the objects in both rooms, the pair of mousetraps and the tools, the candles, the pot of lilies, the towel, the basin of water, the windows, the open books and the fireplace, they are drawn together in our minds as symbols of the masculine and feminine. The objects which are unified as fixtures and implements of the home and on another level as theological emblems are also coherent as metaphors of the human situation. The religious symbolism itself depends largely on the same basic properties of objects which make them relevant as psychological signs; the vessel, the window, or the door, for example, is common to dreams and to religious fantasy as an equivalent of the woman. It is difficult, of course, to fix precisely the meaning of a group of such sexual symbols in a painting. They are often ambiguous, and we lack, moreover, all knowledge of the life history of both the artist and the donor, who dictated perhaps the presence of Joseph and his task. But the process of symbolization is a general one and may be adduced within limits in the deciphering of single works.

If the theological texts are an evidence for the religious

meaning of the mousetrap in the Mérode panel, there exist documents no less explicit that point to a sexual significance. In popular magic and folklore, the mouse is a creature of most concentrated erotic and diabolical meaning.[29] It is the womb, the unchaste female, the prostitute, the devil; it is believed to arise by spontaneous generation from excrement or whirlwind; its liver grows and wanes with the moon; it is important for human pregnancy; it is a love instrument; its feces are an aphrodisiac; the white mouse is also the incarnation of the souls of unborn children. For aid against mice, Christians appeal to the Belgian virgin, St. Gertrude, a spinner and patron of spinners, and also to the Virgin Mary. This conception of the mouse as evil and erotic is shared by the folk and by learned men. In the Renaissance, scholars like Erasmus and Alciati write of the mouse as the image of the lascivious and the destructive.[30] To see the mousetrap of Joseph as an instrument of a latent sexual meaning in this context of chastity and a mysterious fecundation is therefore hardly arbitrary. What is most interesting is how the different layers of meaning sustain each other: the domestic world furnishes the objects for the poetic and theological symbols of Mary's purity and the miraculous presence of God; the religious-social conception of the family provides the ascetic figure and occupation of Joseph; the theologian's metaphor of redemption, the mousetrap, is, at the same time, a rich condensation of symbols of the diabolical and the erotic and their repression; the trap is both a female object and the means of destroying sexual temptation.

These symbols, whether religious or secular, presuppose the development of realism, that is, the imaging of the world for its own sake, as a beautiful, fascinating spectacle in which man

29. I follow here the article "Maus," by R. Riegler in the *Handwörterbuch des deutschen Aberglaubens,* ed. Bächtold-Stäubli (Berlin-Leipzig, 1934–35), VI, pp. 31–59.
30. Erasmus, *Adagiorum epitome* (Leipzig, 1678) ("In deliciis"); A. Alciati, *Emblemata* (Leyden, 1591), pp. 306, 307, Emblema LXXIX ("Lascivia"); cf. also I. P. Valerianus, *Hieroglyphica* (Cologne, 1631), pp. 161, 162 (cap. xxx–xxxv—note that the white mouse which is lascivious in cap. xxxiv is also "intaminata munditia" and a symbol of "intemerata castitas" in cap. xxxv).

discovers his own horizons and freedom of movement. The devoted rendering of the objects of the home and the vocation foretells the disengagement of still life as a fully secular sphere of the intimate and the manipulable. Religious thought tries to appropriate all this for itself; it seeks to stamp the freshly discovered world with its own categories, to spiritualize it and incorporate it within a scheme of otherworldly values, just as earlier, the Church took over the dangerous critical method of dialectical reasoning for the demonstration of its dogmas. On the other side, the enlarged scope of individual vision makes this art increasingly a vehicle of personal life and hence of subconscious demands, which are projected on the newly admitted realm of objects in a vaguely symbolic and innocent manner. The domestic still life is claimed as a symbolic field by both the ascetic ideals and the repressed desires. The iconographic program of the period, in response to the social trend, favors this double process by placing in the foreground of art themes like the Virgin and Child, the Annunciation, the Incarnation, and the Nativity, which pertain to the intimate and hidden in private life and call into play this complex, emotional sphere. The religion tries to master the feelings by displacement to the imaginary holy persons, and in this it is aided by the realism of art, which is able to give to its figures a compelling vividness and familiarity. But in shaping a semblance of the real world about a religious theme of the utmost mysteriousness, like the Incarnation, the objects of the setting become significant of the unacknowledged physical realities that the religion aims to transcend through its legend of a supernatural birth. At the time of the Mérode panel appear also the first secular paintings of the naked female body, a clear sign of the new place of art in the contending, affective life of the individual.

It is interesting to recall that the same Gerson who spoke so knowingly of the proper rendering of Joseph (and criticized the allegorical *Roman de la rose* as a lascivious, though beautiful poem) condemned the painting of the nude. He warned against the current confusion of mystical and erotic love and saw a danger even in contemplating the nudity of the crucified Christ.[31]

31. *Op. cit.,* III, col. 610.

The new art thus appears as a latent battlefield for the religious conceptions, the new secular values, and the underground wishes of men, who have become more aware of themselves and of nature. Jan van Eyck's portrait of Arnolfini and his wife as a marriage document[32]—a significant theme at the time of the propagation of the cult of Joseph and the feast of his wedding with Mary—is a revealing example of this combat in which conflicting attitudes are made to coincide through the hidden allusions in the objects and through the reflection of the figures (including the painter) in a mirror. The latter is a beautiful, luminous, polished eye, encircled by tiny scenes of the life of Christ; it is both a symbol of the Virgin and a model of painting as a perfect image of the visible world. In accepting the realistic vision of nature, religious art runs the risk of receding to a marginal position, of becoming in turn the border element that secular reality had been. In the Arnolfini portrait, it maintains itself in the background and as a secret language in the small objects, in contrast to their ostensible domestic meaning and material charm; the more complete scenes of the life of Christ are a representation within a representation, a secondary reality forming a border around the reflecting glass.

At the end of the century this opposition comes out into the open and assumes a terrifying and melancholy form in the fantasies of Bosch, a master capable of enchanting tenderness in the painting of landscape. His works are a counteroffensive of the unhappy religious conscience against the prevailing worldliness in a period of the decay of the Church. The formerly marginal grotesques of Gothic art, minutely rendered embodiments of the aggressive and the erotic, invade the entire field, and are elaborated as monstrous symbols of the desires, thrown together under the heading of the religious conception of sin. In these visions of a frightfully exasperated asceticism, more conscious of man than of God, there is neither the assurance of faith nor the refreshing beauty of the world. The mousetraps of the sidewing of the Mérode altarpiece, automatic mechanisms fashioned by the Virgin's bourgeois husband to catch the devil

32. Erwin Panofsky, "Jan van Eyck's Arnolfini Portrait," *Burlington Magazine*, 64 (1934): pp. 117–27. [Article reprinted in this volume, pp. 1–20.]

and overcome the passions, are forerunners of the ubiquitous Boschian instruments in which the diabolical, the ingenious, and the sinfully erotic are combined.

A Note on the Mérode Altarpiece

In writing on the symbolism of the Mérode altarpiece in 1945,[1] I left unexplained the wooden board in which Joseph is drilling holes (fig. 5). I could not relate it to the mousetraps that he has already made, which I had interpreted through a sermon of St. Augustine: "The devil exulted when Christ died, but by this very death of Christ the devil was vanquished, as if he had swallowed the bait in the mousetrap. . . . The cross of the Lord was the devil's mousetrap; the bait by which he was caught was the Lord's death."[2]

Since then Professor Panofsky has supposed that the board is the perforated cover of a foot warmer,[3] and Margaret Freeman has seen in it the tormenting spike block that hangs from Christ's waist in certain images of the Via Crucis.[4]

Another explanation is suggested by a painting in a Netherlandish manuscript of about 1440: the Hours of Catherine of Cleves, formerly in the collection of the Duke of Arenberg and now belonging to Alastair B. Martin (fig. 6).[5] In a miniature at the bottom of page 171, a scene representing the trapping of

1. " 'Muscipula Diaboli,' The Symbolism of the Mérode Altarpiece," *Art Bulletin,* 28 (1945) : 182–87. [See preceding.]
2. Migne, *Patr. lat.,* xxxviii, col. 1210 (Sermo cclxiii—De ascensione Domini). On this metaphor in Augustine's writing and its history, see J. Rivière, *Le dogme de la rédemption chez saint Augustin* (Paris, 1933), pp. 117 ff., 320–338. This book was not available to me in 1945.
3. *Early Netherlandish Painting, Its Origins and Character* (Cambridge, Mass., 1953), p. 164.
4. "The Iconography of the Mérode Altarpiece," *The Metropolitan Museum of Art Bulletin,* December, 1957, p. 138. The same interpretation is now proposed by Charles de Tolnay, "L'autel Mérode du Maître de Flémalle," *Gazette des Beaux-Arts,* VIe période, 53 (1959) : 75.
5. The manuscript has been described by A. W. Byvanck, *La Miniature dans les Pays-Bas septentrionaux* (Paris, 1937), pp. 65, 117, 118. See also Panofsky, *op. cit.,* p. 398, note to p. 103. I wish to thank Mr. Martin for kindly permitting me to study this manuscript and to reproduce the page.

fish, there appears a boatlike contrivance of which the upper surface is a perforated board of almond shape; the holes are no doubt a means of ventilation. The device is apparently a box for storing live fish as bait; it is attached by a cord to a stake on the shore. Nearby are other instruments of the fisherman: an openwork trap and two wicker baskets for preserving the caught fish in the water.

What makes the bait box especially relevant to the picture by Robert Campin is the scene in the miniature above. The Incarnation is represented there, with God the Father sending forth the naked Christ Child, who bears the cross in his arms; behind him flies the dove. The action is set on a starry Eastern sky at early dawn above a rocky landscape; Christ and the dove descend toward a pond that fills the foreground. The absent Mary is perhaps implied in the star-filled Eastern sky at dawn, a current metaphor of the Virgin.[6]

Here, as in the Mérode altarpiece, the Incarnation is associated with a marginal image in which appear devices for trapping. The painter of the manuscript evidently knew the art of the Flémalle Master, since the latter's compositions for the Crucifixion and the Descent from the Cross are copied faithfully in this book.[7] As the Christ Child, with the bird of the Holy Spirit behind him, descends to the closed womb of the Virgin, bearing the cross with which to trap the devil, the fisherman below manipulates a long-handled net to draw the trapped fishes out of a round wicker basket floating in the pond. In representing an ordinary fishing scene, the miniaturist still holds to the connotation of the mousetrap. In the Middle Ages, in comments on Job 40:19, 20 (Vulgate) —"Canst thou draw out Leviathan with a hook?"—Christ's body was described as a bait on a divine fishhook which lures the demon to destroy himself.[8]

In the Mérode altarpiece the perforated board is rectangular,

6. Yrjö Hirn, *The Sacred Shrine* (London, 1912), pp. 465, 468.

7. For the dependence of the Cleves master on Robert Campin, see Panofsky, *op. cit.*, pp. 104, 176, 177 and figs. 129, 130.

8. Cf. Gregory, Moralia in Job, xxxiii, vii, 14; ix, 17 (*Patr. lat.*, lxxvi, cols. 680, 682); and see Rivière, *op. cit.*, p. 336, n. 2, for other references.

to be sure, rather than rounded as in the miniature. The rectangular bait box is common in our day and we may assume that it was known in the fifteenth century. The context of the miniature, as of the altarpiece, and the other connections between the two works lead us to believe that in the Mérode picture, too, the board on which Joseph is at work belongs to the same complex of trapping and bait associated with the Redemption.[9]

It may be objected that the genre scene in the manuscript is innocent of religious or other symbolism; as a representation of rural life on the lower margin of a page it is like hundreds of other images of daily work in later medieval manuscripts—images that have no apparent connection with the content of the larger religious pictures on the same pages. Yet in some marginal scenes one does notice a more or less obvious allusion to the major biblical theme, as a parallel or parody drawn from the profane world. I have cited elsewhere a miniature of Cain killing Abel with a jawbone above which a monkey shoots a bird with a bow and arrow; the bestiality of man is compared with the cunning artifice of the beast.[10] Such spontaneous poetic transpositions of the main idea into a marginal image, unsupported by a text, are not infrequent, and one may therefore look for a metaphorical content in the correspondences between the Incarnation above and the genre picture below in the page of the Book of Hours. The interpretation is, of course, only a plausible conjecture which owes what cogency it has to the relationships of the miniature with the Mérode altarpiece, where so many small elements are at the same time parts of a domestic world and mute symbols of a theological design. In the manuscript few of the miniatures are accompanied by marginal paintings—perhaps a half dozen of the sixty or more. Among these at least one alludes clearly to the religious scene above: on

9. That mousetrap and fishing could be cited together as metaphors in an account of the Redemption is shown by a sermon in a breviary of the fourteenth century in Monte Cassino (Cod. xxxiv, p. 284). See Rivière, *op. cit.*, p. 321 n.
10. "Cain's Jawbone that Did the First Murder," *Art Bulletin,* 24 (1942): 211 and fig. 6.

page 63 the painting underneath the *Visitation* represents the naked infant Christ in a net manipulated like a bird trap by another naked infant, undoubtedly John, who sits on the ground within a wicker enclosure.[11] On page 215, beneath a huge hell mouth where an angel comes to release the naked souls, a rustic suspends a wire between a post and a tree; two birds hover at the post and two others are caught in a cage, a reference perhaps to the state of man in purgatory and hell, although the image may be no more than a vaguely allusive genre scene inspired by the theme of enclosure and liberation in the miniature above.

By the fifteenth century the painter of manuscripts included in his repertoire many scenes of daily life suitable for the illustration of the calendars of psalters, breviaries, and books of hours, which could also serve him for the margins of other leaves. The image of fishing and baiting is not strictly an invention of the artist designed for the context of the Incarnation above. We suspect that it was based on a picture of the labors of a month. In the Grimani Breviary, a scene of night fishing, with similar devices, illustrates the calendar page for March.[12] Since the Incarnation took place in that month, the choice of subject in the Hours of Catherine of Cleves seems altogether apt. A figure drawing eels (or fish) out of a weir or wicker basket is represented earlier on Romanesque capitals of Cluny[13] and Vézelay.[14] In Vézelay an accompanying figure blowing a bellows, a personification of the wind, indicates that the scene

11. The bird hunter's net is also a symbol of the Crucifixion. Cf. Gregory, Moralia in Job, XL, 24 (*Patr. lat.*, LXXVI, cols. 691–692) —cited by Rivière, *op. cit.*, p. 337.

12. *Le Bréviare Grimani de la Bibliothèque Saint Marc à Vénise, avec une introduction de Giulio Coggiola* (Leyden, 1903–1908) , fol. 4 (cf. also fol. 7) . It is reproduced also by Paul Brandt, *Schaffende Arbeit und bildende Kunst* (Leipzig, 1927) , II, fig. 5, p. 21.

13. Brandt, *op. cit.*, I, fig. 242.

14. *Ibid.*, fig. 243, and pp. 193 ff. The action and instrument of these figures were first recognized by Brandt. They are still misinterpreted in a recent description by J. Adhémar, in Francis Salet, *La Madeleine de Vézelay* (Melun, 1948), p. 184, no. 23 (Étude Iconographique par J. Adhémar) .

represents a month, probably March,[15] or at least has been
copied from a cycle of the months—the wind is a common
illustration of March in the early Middle Ages.[16] But for a
closer parallel to our miniature in the representation of the
months one must turn to the poem of Wandalbert of Prüm in
the early ninth century (*De mensium duodecim nominibus,
signis,* etc.) . In December, he writes:

> All kinds of water fowl are caught in nets;
> Here, too, in the fish-laden waters
> Wickerwork baskets are set
> And enclosures of faggots fixed at the banks
> Where the fords slacken the flow of the shallow stream
> And the nets capture an easy prey.[17]

I have not found this scene in Gothic calendars. But my
knowledge of these is very incomplete. The images of the
months in the later Middle Ages have yet to be collected and
studied like those of the earlier period.

15. Brandt was puzzled by the figure with the bellows, and Adhémar, who
recognized him as a wind, failed to see the connection with the month (*op.
cit.,* p. 162 n. 1) .
16. On the Wind as March, see J. C. Webster, *The Labors of the Months
in Antique and Mediaeval Arts to the End of the Twelfth Century*
(Princeton, 1938) , p. 51, and my remarks in *Speculum,* XVI, 1941, pp. 135,
136.
17. Retibus hinc varias pelagi prensare volucres,
 Amnibus hinc etiam piscosis ponere crates
 Vimineas, densosque ad litora figere fasces,
 Qua vada demisso tranquillant flumine cursum
 Inventum, facilem capiant ut retia praedam.

3

Light as Form and Symbol

in Some Fifteenth-Century Paintings

by MILLARD MEISS

EDITORIAL NOTE: *This essay was originally published together with Schapiro's in the same issue of a quarterly. It employs the now familiar tool of revealing the "hidden symbols," with a larger sweep among several works of art but focusing on one by Jan van Eyck. The author's finding that the windows represented in these paintings allude to theologians' arguments for the Virgin Birth has become accepted and familiar. His final point, suggesting the interconnections of this symbolism with van Eyck's modern style and his self-consciousness of it, has been less noticed, and to be sure was less worked out in detail in the article, but is potentially more important as a concept.*

IN ACCOUNTS OF the development of naturalism in fifteenth-century painting linear perspective is usually given first consideration. This modern emphasis on perspective has been influenced, no doubt, by the writings of the fifteenth-century artists themselves. Discussions of it occupy a prominent place in the treatises of Alberti and Piero della Francesca. These discussions were, however, motivated not only by a sense of the importance of perspective for painting but also by a desire to raise the status of the craft and a corresponding insistence on the theoretical and mathematical modes of thought necessary to it.

There is no question, of course, that the fifteenth century extended the use of perspective in painting beyond earlier periods, and that it created the theory of focus perspective together with consistent methods of applying it. But basic innovations in pictorial composition were made early in the fourteenth century in both Siena and Florence. Duccio, Giotto, Simone Martini, and the Lorenzetti succeeded in creating the illusion of space and solidity and of a world seen through a frame from a more or less fixed position. If we compare with their work the paintings of the leading masters of the first half of the fifteenth century, the advances in the rendering of light impress us scarcely less than the consequences of the application of systematic focus perspective. In the compositions of Masaccio, Domenico Veneziano, Piero, or Campin and the van Eycks, things are largely what they appear to be from a certain point of view and under certain conditions of light. The objects of painting thus acquire a new dimension, and they approximate more closely the objects of the world, the portrayal of which was a major concern of the painters of the time. Light contributes, too, a new subtlety to the personalities that appear in painting. Moving over the features of Giovanni Arnolfini or the apostles in the *Tribute Money,* it extends and deepens consciousness. Mobile and intangible, light has always seemed the natural counterpart of the mind. In nature as in art, it stirs feelings and sustains moods.

Painters of the second quarter of the fifteenth century, like those of the early seventeenth, showed a certain predilection for subjects or motifs involving light. The *Miracle of Peter Healing by His Shadow,* seldom represented in earlier art, has a special poignancy in the Brancacci chapel. Artists delighted in painting the generation of light as one of the most enchanting of natural phenomena. In Fra Filippo Lippi's painting of the *Annunciation of the Death of the Virgin* the angel brings, as a symbol of death, a burning taper instead of the traditional palm (fig. 7).[1]

1. Both Mrs. Jameson [*Legends of the Madonna,* 2d ed. (London, n.d.), p. 311] and H. Mendelsohn [*Fra Filippo Lippi* (Berlin, 1909), p. 88] have commented on Fra Filippo's innovation. In most paintings of this rare subject the angel gives the Virgin a palm, following the Golden Legend (August 15, Assumption of the Virgin). But the Golden Legend

The compositions of Jan van Eyck and the Master of Flémalle frequently include a fire: on the hearth in the *Madonna* in Leningrad and the *St. Barbara* in the Prado, and burning candles in the Arnolfini portrait, the Paele altarpiece, the *Virgin in the Church* (Berlin), *Joseph and the Suitors* (Prado), and the *Nativity* at Dijon. In the last-named painting the sun itself is introduced.

Most of these forms appear as perfectly normal elements of a familiar setting, whether bourgeois rooms, churches, or landscapes. Almost all of them have, however, an additional connotation derived from the chief figures or action of the painting. Christian mysteries were from the very beginning explained by metaphors of light. Painters of the fifteenth century were aware of the rich repertory of religious associations investing all the familiar sources of light, and with which they might develop and extend the religious meaning of their works. Some of these images were not represented in medieval art. Others, such as the sun, appeared as graphic signs; only in the art of the fifteenth century did they assume the vivid form which had originally inspired their selection as symbols.

Warm sunlight, together with evidence of life, growth, and fertility, distinguishes the New World from the cool, gray Old World in the moralized landscapes of Mantegna (*Madonna,* Uffizi) and Giovanni Bellini (*Man of Sorrows,* London). Similar symbolic contrasts appear in Fra Filippo's paintings of the Madonna adoring the newborn Christ Child (Berlin and Uffizi). Panofsky and Tolnay, to whom we owe our present insight into the religious symbolism of early Flemish painting, have discussed the symbolic content of the candles, and of the sun in the Dijon *Nativity*.[2] It seems possible too that the fire on

tells that after the angel returned to heaven, the palm held by the Virgin "shone with a great brilliance. It was a green branch, but with leaves as luminous as the morning star." In the representation of this scene in the *Maestà,* Duccio added small stars to the leaves of the palm. The luminous palm branch may have suggested to Fra Filippo the use of a burning candle, a symbol customarily presented to a dying person.

2. Erwin Panofsky, "Jan van Eyck's Arnolfini Portrait," (reprinted in these *Essays,* see pp. 1–20); *idem,* "The Friedsam Annunciation and the Problem of the Ghent Altarpiece," *Art Bulletin,* 17 (1935): 433–473; *idem,* "Once More the Friedsam Annunciation . . .," *Art Bulletin,* 20

the hearth has likewise a religious meaning, particularly in the
panel of *St. Barbara* in the Prado. In this painting, which shows
the Saint piously reading before a fire in a neat and cozy room,
all the objects above the fireplace, the statue of the Trinity, the
candle, the carafe, and, farther along the wall, the towel and
water jug refer in one way or another to her sanctity. Of fire
Berchorius (†1362) says:

> Since fire is the most noble element, its virtue is wonderfully
> diffused. For fire lurks secretly in all things, as is evident when

(1938) : 419–424; Charles de Tolnay, "Zur Herkunft des Stiles der van
Eyck," *Münchner Jahrbuch,* 9 (1932) : 320 ff.; *idem, Le Maître de Flé-
malle et les Frères van Eyck* (Brussels, 1939) .

Tolnay's interpretation of the growth and meaning of naturalism in
early fifteenth-century painting is different from that suggested above.
Instead of regarding the interest in nature or reality as primary (and
connected with the secular trends of the period) he believes it originated
in, and was sustained by, late medieval religious conceptions. Of light he
says (in his book, p. 16) : ". . . the vision of interior (spiritual) light led
the mystics to the contemplation of natural light, of which they—for
example, Suso—sometimes give enchanting descriptions, and in this way
they are the direct precursors of the painters called realists." For a point of
view similar to mine, see Meyer Schapiro, in these *Essays,* pp. 27–28.

Tolnay (p. 14) bases his interpretation of the Dijon *Nativity,* which
includes both the sun and the candle, on the Golden Legend, where the
two midwives appear (and speak the phrases written on the scrolls in the
painting) and on a Christmas sermon of St. Ambrose or St. Maximus, in
which Christmas Day is called the day of the New Sun, which shone more
brilliantly than the sun on any other day of the year. The candle is not
mentioned in the Golden Legend, and apparently not in the sermon, but
it does appear, along with a reference to the sun, in St. Bridget's vision of
the Nativity (1370) : ". . . And while she (the Virgin) was standing there
in prayer, I saw the child in her womb move and suddenly in a moment
she gave birth to her son, from whom radiated such an ineffable light and
splendor that the sun was not comparable to it, nor did the candle, that St.
Joseph had put there, give any light at all, the divine light totally annihi-
lating the material light of the candle." (Quoted from the translation by
H. Cornell, *Iconography of the Nativity of Christ* (Uppsala, 1924) , pp.
21–22.) It seems probable that the Master of Flémalle had in mind this
text, or paintings influenced by it, when painting the Dijon *Nativity.* In
many representations of the *Nativity* influenced by the vision of Bridget
Joseph holds a candle, as Cornell has shown.

two solid bodies are struck together, for then the fire breaks out, though it was not at all believed to be hidden there. Thus God is truly in all things, though invisible. . . . Indeed, we may well speak of the fire of charity, or the fire of the Holy Spirit, and especially of the fire of divine love, which is in many people who are not believed to possess it.[3]

Fascinated by light, some of the leading Flemish painters of the late fourteenth and early fifteenth centuries adopted a striking symbolic image that was current in medieval thought. Theologians and poets often explained the mystery of the incarnation by comparing the miraculous conception and birth of Christ with the passage of sunlight through a glass window:

> Just as the brilliance of the sun fills and penetrates a glass window without damaging it, and pierces its solid form with imperceptible subtlety, neither hurting it when entering nor destroying it when emerging: thus the word of God, the splendor of the Father, entered the virgin chamber and then came forth from the closed womb (St. Bernard).[4]

Very little is told in the Gospels of the way in which the Virgin conceived and gave birth to Christ. St. John said "the Word was made flesh," and Matthew and Luke said that Mary was impregnated by the Holy Ghost. The Fathers felt it necessary to describe the miracle in greater detail, partly in order to combat heretical ideas, and partly in order to satisfy the curios-

3. "Cum ignis sit nobilissimum elementum, virtutem habet mirabiliter sui diffusivam. In omnibus enim rebus occulte latet ignis, sicut manifeste videtur, cum duo solida corpora invicem colliduntur, exinde enim solet ignis egredi, qui tame ibi credebatur minime occultari. Sic vere Deus invisibiliter est in omnibus. . . . Vel potest dici, de igne caritatis, scilicet spiritus sancti, vel divini amoris, qui in multis est, in quibus non creditur esse." P. Berchorius, "Reductorium morale," *Opera omnia* (Antwerp, 1609), Lib. vi, Cap. iv.
4. "Sicut splendor solis vitrum absque laesione perfundit et penetrat eiusque soliditatem insensibili subtilitate pertraicit nec cum ingreditur, violat nec, cum egreditur, dissipat: sic Dei verbum, splendor Patris, virginum habitaculum adiit et inde clauso utero prodiit. . . ." Quoted by A. Salzer, *Die Sinnbilder und Beiworte Mariens in der deutschen Literatur und lateinischen Hymnenpoesie des Mittelalters* (Linz, 1893), p. 74.

ity of the faithful about these central Christian events. They declared that Mary had received, through her ear, the Word of God in the form of a divine aspiration transmitted by the Holy Ghost. Her virginity was not affected by this miraculous insemination and she remained intact even when giving birth to Christ and forever after. Christ incarnate possessed the power of passing through material things, a power which He showed also when He rose from a closed tomb and when He moved to the apostles through closed doors. These supernatural occurrences were difficult to understand; the Fathers and their successors had recourse to metaphors and symbols. The conception was illustrated by reference to Gideon's fleece or Aaron's rod, and the birth was compared with the closed gates of Ezekiel through which only the Lord could pass.[5] Along with these similes they spoke of Christ as a light, or sometimes fire,[6] which the Virgin received and bore. The Virgin was regarded as a window through which the spirit of God passed to earth.[7] From these metaphors there was developed, in the ninth century or earlier,[8]

5. For the patristic and medieval doctrine of the conception and birth of Christ, see G. Herzog, *La Sainte Vierge dans l'histoire* (Paris, 1908), chaps. 1–3; Y. Hirn, *The Sacred Shrine* (London, 1912), chaps. 14, 15, 17; Th. Livius, *The Blessed Virgin in the Fathers of the First Six Centuries* (London, 1893), pp. 117 ff. Ernest Jones, *Essays in Applied Psychoanalysis* (London, 1923), pp. 261 ff., has studied the medieval idea of the Madonna's conception through the ear from a psychoanalytic point of view.

6. For example, St. Epiphanius (Livius, *op. cit.,* p. 128); St. Fulgentius (*ibid.,* p. 138); St. Ephrem (*ibid.,* pp. 407, 426).

7. St. Fulgentius, quoted by Livius, *op. cit.,* p. 138.

8. Hirn, *op. cit.,* p. 343, refers to the use of the image in the ninth century, but cites no examples of so early a date. Salzer, *loc. cit.,* quotes as the work of Athanasius (†373) an unusually lengthy example of the simile. It appears in a text, originally Greek, entitled Questiones aliae, which was included in the collected writings of Athanasius (*Opera omnia,* Paris, 1727, II, p. 446). The text was rejected by Migne (*Pat. Gr.,* XXVIII, 1857, col. 790), who does not, however, assign it a date. Its interest is great enough, I think, to warrant full quotation:

"Audi mysterium: Sicut domus circumsepta undique, quae habet orientem versus vitream puram et tenuissimam fenestellam, oriente sole, radii eius penetrantes vitrum et ingredientes domum totam collustrant, et rursus transeunte sole et egredientibus radiis vitrum non confringitur, sed ab ingredientibus et egredientibus repercussionibus radiorum solarium

the image of the sunlight and the glass. It possessed the advantage of symbolizing both stages of the miracle, the conception as well as the birth. In the *Biblia pauperum,* for instance, it is introduced in connection with both the Annunciation and the Nativity.[9] Its wide diffusion, if not its origin, was probably due to the prominence and the beauty of the glazed windows of medieval churches. The earlier symbols, created by agricultural peoples and inspired by natural forces such as rain, dew, and florescence, were partly replaced in the Middle Ages by an image dependent upon art.

During the eleventh and twelfth centuries the simile was used by Peter Damian, Hildebert, William of Champeaux, and St. Bernard.[10] Frequently it was interpreted to emphasize the virginity of Mary rather than the ghostly power of Christ. Thus St. Bridget, whose vision of the Nativity influenced the representation of that scene throughout Europe in the late fourteenth and fifteenth centuries, is addressed by Christ in her first revelation:

manet illaesum: ita intellegas de semper Virgine Maria. Illa enim castissima, ut domus quaedam circumsepta cum sit, filius et verbum Dei ut radius divinus ex sole iustitiae Patre descendens, qui per vitream fenestellam aurium illius ingressus sanctissimam domum eius illustravit et rursus, . . . exivit, ne minime quidem foedata virginitate illius, sed sicut ante partum etiam in partu et post partum Virginem castam conservavit."

(Hear the mystery: Just as a house enclosed on all sides which has toward the east a clean thin glass window and, when the sun rises, its rays penetrating and passing through the glass brighten the whole house, and again with the passing of the sun and the withdrawal of the rays the glass is not shattered, but remains undamaged by the incoming and outgoing vibrations of the solar rays: thus you may understand the everlasting virginity of Mary. For that most chaste person, as a kind of house when (?) it is enclosed, the son and the word of God as a divine ray descending from the sun, Father of Justice, which, having entered through the glass window of her ears, has illuminated its most holy house and again . . . has gone out, without even in the least having despoiled her virginity, but just as before birth, also in birth and after birth has preserved the chastity of the Virgin.)

9. In the *Annunciation* in Utrecht, University Library, ms. 373, and in the *Nativity* in Munich ms. Clm. 5683. Cf. H. Cornell, *Biblia pauperum,* Stockholm, 1925, p. 17.

10. Salzer, *loc. cit.* Salzer's compilation is very valuable. He does not attempt, however, a history or critical account of the simile.

I have assumed the flesh without sin and lust, entering the womb of the Virgin just as the sun passes through a precious stone. For as the sun, penetrating a glass window, does not damage it, the virginity of the Virgin is not spoiled by my assumption of human form.[11]

Around the twelfth century the simile was developed further under the influence, apparently, of a newer form of art. Impressed by the great stained glass windows of the cathedrals, theologians began to say: as light is colored by radiation through stained glass, the Holy Spirit acquires human form by entering the sacred chamber or temple of the Virgin. St. Bernard, after alluding to the ray and the unbroken window in the passage quoted above, adds:

As a pure ray enters a glass window and emerges unspoiled but has acquired the color of the glass . . . the Son of God, who entered the most chaste womb of the Virgin, emerged pure, but took on the color of the Virgin, that is, the nature of a man and a comeliness of human form, and he clothed himself in it.[12]

In the late Middle Ages the simile of the ray and the glass appears frequently in theological treatises, Latin and vernacular poems, in the mystery plays, and in hymns,[13] such as the following, which was sung in the Low Countries in the fifteenth century and perhaps earlier:

11. "Assumsi carnem sine peccato et concupiscentia, ingrediens viscera Virginea, tanquam Sol splendens per lapidem mundissimum. Quia sicut Sol vitrum ingrediendo non laedit, sic nec virginitas Virginis in assumptione humanitatis meae corrupta est." *Revelationes Sanctae Birgittae,* Rome, 1628, i ("Revelations," p. 1).
12. ". . . sicut radius in vitrum purus ingreditur, incorruptus egreditur, colorem tamen vitri induit . . . sic Dei filius purissimum Virginis uterum ingressus purus egressus est, sed colorem Virginis i.e. humanam suscepit naturam humanaeque speciei decorem induit et praecinxit se." (Quoted by Salzer, *loc. cit.*)
13. Salzer, *op. cit.,* pp. 71–74, quotes a number of hymns and a great many German mystics and writers of vernacular prose and poetry. Cf. also Hirn, *op. cit.,* pp. 343–345 (Alexander Neckham, a thirteenth-century hymn, French fifteenth-century mystery play, German poem). The simile appears at the end of the text of the *Defensorium inviolatae virginitatis Mariae* in Munich ms. Cgm. 258 (Cornell, *Iconography* . . ., p. 79).

7. **Annunciation of the Death of the Virgin,** Fra Filippo Lippi. Florence,
Uffizi

Courtesy of Art Reference Bureau

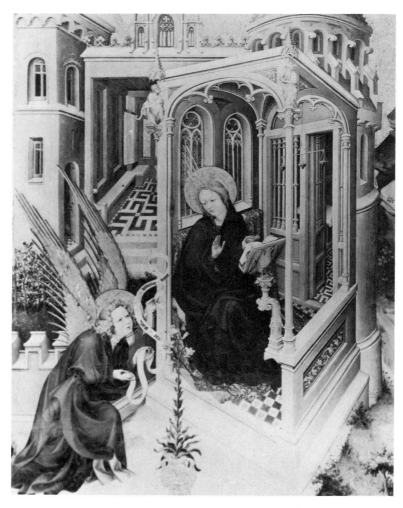

8. **Annunciation,** Melchior Broederlam. Dijon, Museum
Courtesy of Caisse Nationale des Monuments Historiques

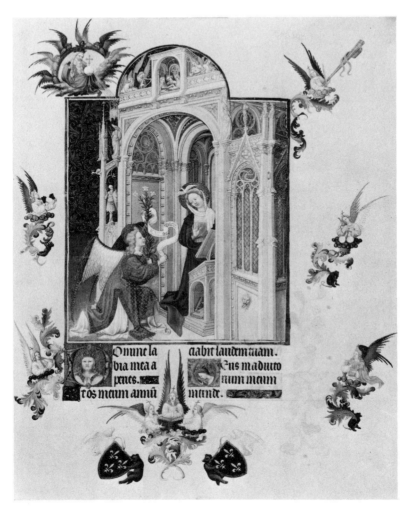

9. **Annunciation,** in the **Très riches heures du Duc de Berry,** the Limbourgs. Chantilly, Musée Condé

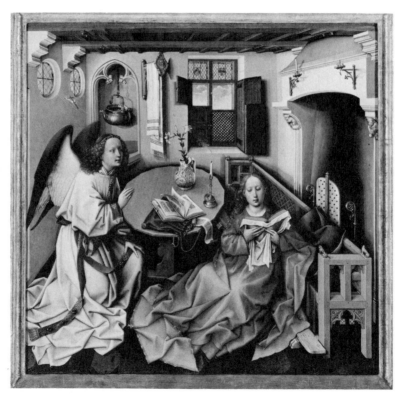

10. **Annunciation,** central panel of the Mérode Altarpiece, Master of
Flémalle. New York, Metropolitan Museum of Art, The Cloisters
Collection

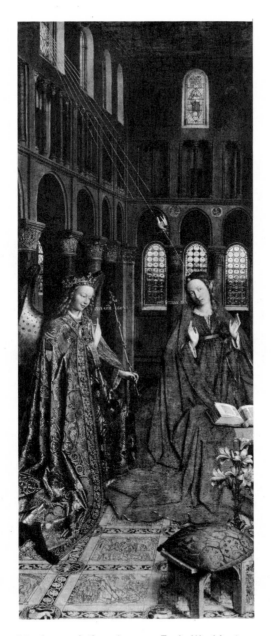

11. **Annunciation,** Jan van Eyck. Washington,
National Gallery of Art, Mellon Collection

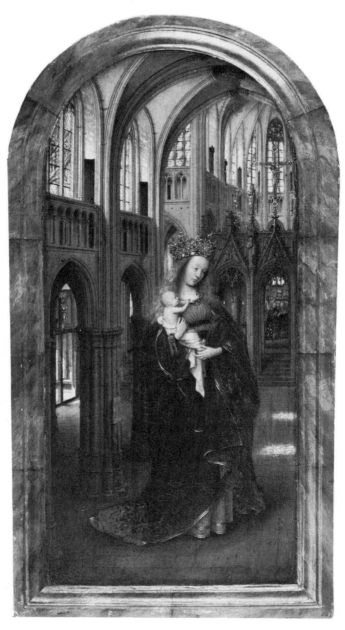

12. **The Virgin in the Church,** Jan van Eyck. Gemäldegalerie
Berlin, Staatliche Museen

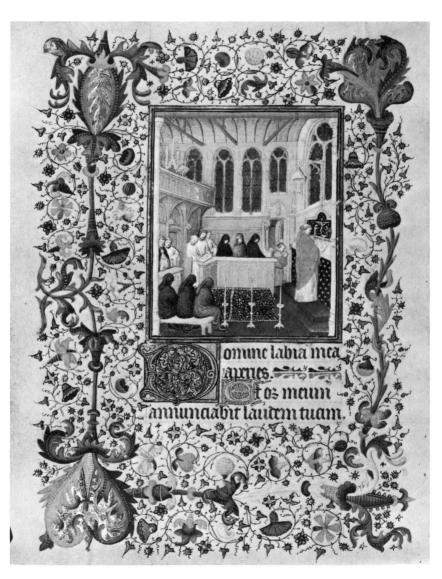

13. Mass for the Dead, Boucicaut Master. London, British Museum
Courtesy of the Trustees of the British Museum

> Een glas al heel dat schijnt daer door,
> Ten breket niet van der sonnen;
> So heeft ene maghet nae ende voor
> Joncfrouwe een kint ghewonnen.[14]

In several representations of the *Annunciation* by painters of the Netherlands in the late fourteenth and fifteenth centuries the rays, which as usual extend from heaven or God the Father to the ear of the Virgin, pass through a glass window. The earliest instance seems to be the *Annunciation* by Broederlam in Dijon, painted between 1394 and 1399 (fig. 8), in which Smits[15] already perceived a symbol of the incarnation. The emergence of the rays from the glass is prominently shown just above the head of the Virgin, and the motif appears in a painting that is rich in symbolic forms, such as the "thalamus Virginis," the "hortus conclusus," and the prophets on the exterior of the building. The rays in the *Annunciation* are in essence symbols of the Holy Spirit, but they are usually conceived as light, and in paintings of the *Annunciation*, from the fourteenth century on, windows or other openings are often provided to permit their passage into the chamber of the Virgin.[16] It seems very probable then that in Broederlam's panel the divine rays which actually effect the incarnation have a natural aspect that symbolizes and explains the miracle.

The rays likewise pass through a glass window in the *An-

14. Hoffmann von Fallersleben, *Niederländische geistliche Lieder des fünfzehnten Jahrhunderts* (*Horae Belgicae,* Part x) (Hannover, 1854), p. 53.

15. *Iconografie van de Nederlandsche primitieven* (Amsterdam, 1933), p. 47. Smits also refers to the passage of the rays through the glass in Jan van Eyck's *Annunciation* in Washington.

16. Cf., for instance, two late fourteenth-century Florentine *Annunciations,* one in the Vatican, the other in S. Spirito, Prato, both reproduced by G. Prampolini, *L'Annunciazione,* Milan, n.d., figs. 18 and 19; Crivelli's *Annunciation* in the National Gallery, London; the *Annunciations* in the Breviary of Belleville, Hours of Jeanne of Navarre, Breviary of Charles V, all reproduced by Robb, "The Iconography of the Annunciation in the Fourteenth and Fifteenth Centuries," *Art Bulletin,* 18 (1936): figs. 16–18. Only a study of the original paintings would reveal whether or not there are small areas of glass in the windows of these or other representations of the *Annunciation* before Broederlam. In any event, the glass is prominent for the first time in Broederlam's work.

nunciation in the *Très riches heures* of the Duke of Berry, painted shortly before 1416 (fig. 9). This painting resembles Broederlam's in other ways also: in the appearance of the prophets, the posture of the Virgin, and the oblique arrangement of both figures and architecture, although the latter now has a contemporary ecclesiastical form.[17] The motif then recurs in two of the major works of the early fifteenth century, the Mérode *Annunciation* by the Master of Flémalle (fig. 10) and the approximately contemporary *Annunciation* in Washington by Jan van Eyck (fig. 11).[18] In the Mérode *Annunciation* the window, set in the wall of a domestic interior, is a small oculus. In Jan's painting the rays pass through the clerestory window of a church, accompanied by natural light which brightens the jambs. This window is filled with clear glass, unlike the one at the rear which contains the figure of Christ.

The subtle and pervasive symbolism characteristic of the work of both these painters shows itself again in the use of precisely seven rays in these representations. In late medieval painting the number of rays in the *Annunciation* varies greatly, from three to twelve or more. Three, symbolizing the Trinity, is perhaps the most common. Seven undoubtedly refers to the seven gifts of the Holy Ghost: wisdom, understanding, counsel, strength, knowledge, piety, and fear.[19] Christ Himself is endowed with these seven spirits, and He is sometimes shown surrounded by them in the form of seven doves, as in windows at St. Denis and Chartres.[20] The seven spirits, enumerated by Isaiah (11:1–3), are mentioned by St. John in his vision of the Lamb (Rev. 5:6) and there are seven major rays proceeding from the dove in Jan's painting of this subject in the Ghent altarpiece.[21]

17. It might be expected that the passage of the rays through the glass would be represented in the paintings of the Boucicaut Master, who created the first complete church interior in scenes of the *Annunciation;* but none of his paintings shows it.
18. Both paintings were probably made around 1425.
19. See Didron, *Christian Iconography* (London, 1886), ɪ, pp. 423 ff.
20. Cf. Mâle, *L'art religieux du treizième siècle* (Paris, 1925), figs. 91, 93.
21. Seven rays appear, of course, in some other paintings of the *Annunciation.* See the two Florentine paintings cited in note 16; also the *Annunciation* by an imitator of Flémalle in the Prado.

The passage of the rays through the glass is represented in several later paintings of the *Annunciation,* such as that by an imitator of Flémalle in the Prado,[22] Roger's Columba altarpiece, and Jan Provost's panel in the hospital at Genoa.[23] In an *Annunciation* by the Virgo Master the rays are supplanted by a beam of light.[24] It is possible, in fact, that the conception is symbolized in certain paintings in which the rays are lacking, as they often are after the middle of the fifteenth century. In two paintings by Albert Bouts, for instance, large windows which admit the daylight are placed near the Virgin.[25] And the three windows behind the Virgin in Jan van Eyck's *Annunciation* (fig. 11) may symbolize not only the Trinity, as Tolnay has suggested,[26] but also—for a second time in this painting—the incarnation. The radiant window alone, without a visible beam of light, may refer to the Virgin and the miraculous conception and birth; she was sometimes called "tu fenestra vitrea sole radiata."[27]

22. M. Friedlaender, *Die altniederländische Malerei* (Berlin), ii, p. 192, pl. 45. The perfunctory nature of this painting is shown by the fact that only a few of the rays actually pass through the window; others strike the stone base.

A. Liebreich, "L'Annonciation d'Aix-en-Provence," *Gazette des Beaux-Arts,* 19 (1938) : 65, says that the passage of the rays through the rose in the Aix *Annunciation* symbolizes the incarnation. Judging from a photograph, I am not sure that there is actually glass in the window.

23. Friedlaender, *op. cit.,* ix, pl. 69.

24. Friedlaender, *op. cit.,* v, pl. 31.

25. Paintings in Cleveland and Berlin; cf. Friedlaender, *op. cit.,* iii, pls. 50, 51.

26. "Flemish Paintings in the National Gallery of Art," *Magazine of Art,* 24 (1941) : 178. Tolnay also refers to the radiant windows as symbols of Christian revelation, which Panofsky had pointed out in a somewhat different context ("The Friedsam Annunciation . . .," *Art Bulletin,* 1935, p. 450).

27. Mone, *Hymni Latini Medii Aevi,* Freiburg i. Br., 1853, ii, no. 600. Reference should also be made to the flask partly filled with water which appears in several early Flemish paintings as a symbol of virginity. The glass is usually irradiated with light, as in the *Annunciation* in the Ghent altarpiece (cf. Smits, *loc. cit.*). In this same painting sunlight falls on the wall alongside the Virgin.

The flask is placed in the foreground of the *Annunciation* by Fra

In all the foregoing paintings the light and the glass windows seem, and are, normal elements of the interiors represented or the scenes enacted in them. Their symbolic meaning is, however, entirely consistent with other aspects of the works and with an attitude of mind shared by the painter and his audience alike.[28] In the Mérode *Annunciation* (fig. 10), for instance, the candle, the towel, the vessel, and the mousetrap all have religious significance, and the forms in Jan van Eyck's *Annunciation* in Washington (fig. 11), the lilies, the church and its murals, the zodiacal signs, and the Old Testament scenes in the pavement, are attributes of metaphors of the Virgin and the incarnation.[29] Further proof of Jan van Eyck's intention to symbolize the incarnation by the passage of light through a glass window is provided, I believe, by another of his panels.

In the *Virgin in the Church* in Berlin (fig. 12),[30] painted a few years earlier than the *Annunciation* and in fact the earliest of all his works, the splendor and subtlety of the painting of light is unsurpassed in Western art. A bright sun strikes through the glass in the clerestory, flickers on the jambs of the windows, spreads over the ribbed vaults, and falls in two brilliant patches on the floor of the nave. The lower part of the church is relatively dark; here the light is concentrated in the Madonna and the two glowing spots on the floor. Deeper in space the shadows are relieved by burning candles on an altar and, at the left, a sunlit portal. The flow of light through the empty church, the stillness, the rapt mood of the Virgin and her abnormal size create a sense of mystery, of a meaning beyond the immediately comprehended.

Is the wonderful radiance of the windows and the intensity of

Filippo Lippi in S. Lorenzo, Florence. Its use seems to be another instance of Flemish influence on the work of the painter who was the first in Italy to adopt the domestic interior as a setting for the Madonna (panel from Corneto Tarquinia, dated 1437).

28. Cf. Huizinga, *Waning of the Middle Ages* (London, 1937), especially chap. 15.

29. See note 2. Also, for the Washington *Annunciation,* Tolnay in *Magazine of Art, op. cit.,* and for the symbolism of the mousetrap, Schapiro, p. 21 ff. and fig. 5.

30. Friedlaender, *op. cit.,* I, p. 78 f.

the light on the floor just behind the Virgin intended to symbolize the miraculous conception and birth of Christ? We should be uncertain were it not for the original inscription on the frame which the painting bore when it first became known to scholars. Shortly before 1855 de Laborde[31] saw the panel in the collection of an architect at Nantes, one M. Nau, who had bought it for some fifty francs. He noted the inscription, and in 1869 Buerger, who came across the painting in the Suermondt Collection in Aachen, read it in essentially the same way.[32] In 1874 the painting was acquired by the Kaiser Friedrich Museum, and shortly afterward it was stolen, only to be returned without the frame. On the lower frame appeared: "FLOS FLORIO-LORUM APPELLARIS."[33] Around the other three sides of the frame was written the following, which obviously has a poetic form, as I have indicated by division into verses:

> MATER HEC EST FILIA
> PATER HIC EST NATUS
> QUIS AUDIVIT TALIA
> DEUS HOMO NATUS ETCET

This may be translated:

> This mother is the daughter,
> This father is born.
> Who has heard of such a thing?
> God born a man.

These lines compose the first half of the second stanza of a medieval Nativity hymn, which begins:

> Dies est laetitiae
> in ortu regali,
> nam processit hodie
> ventre virginali

31. *La Renaissance des arts à la cour de France* (Paris, 1855), I, p. 604.
32. *Gazette des Beaux-Arts,* 2d ser., 1 (1869) : 12.
33. Cf. *Kaiser-Friedrich-Museum, Beschreibendes Verzeichnis der Gemälde* (Berlin, 1906), p. 126.

> puer admirabilis,
> vultu delectabilis
> in humanitate,
> qui inaestimabilis
> est et ineffabilis
> in divinitate.

The fifth stanza of the hymn begins:

> Ut vitrum non laeditur
> sole penetrante
> sic illaesa creditur
> virgo post et ante.[34]

This has been translated by Neale:

> As the sunbeam through the glass
> Passeth but not staineth
> Thus the Virgin, as she was,
> Virgin still remaineth.[35]

Thus the inscription on the frame proves that the painting in Berlin is not simply the usual cult image of the Madonna, but a sort of Christmas picture that contains allusions to the incarnation and birth of Christ and the virginity of His mother. The hymn was undoubtedly a familiar one. The painter explicitly refers to it in its entirety by adding "ETCET" to the part he quoted. Because of this, and also because Jan's work shows a wide knowledge of religious texts and symbols, we are justified in supposing that he had in mind the simile in the fifth stanza and that he symbolized the virginity of Mary "post et ante" by

34. I owe to Meyer Schapiro the identification of the hymn in Mone (*op. cit.*, I, p. 62, no. 49). Mone based his text on a fifteenth-century manuscript in Trier, but drawing from other manuscripts, he substitutes "factus" for "natus" in the fourth line of the second stanza. Daniel, *Thesaurus hymnologicus* (Leipzig, 1862), I, p. 320, omits the stanza which appears in part on the Berlin painting. The section of the fifth stanza dealing with the sun and the glass is quoted by Salzer, *loc. cit.*
35. J. M. Neale, *Medieval Hymns and Sequences* (London, 1857), p. 186.

the radiation of sunlight through the glass, more resplendent here than in any other of his paintings.

This interpretation seems confirmed by other aspects of the work. The windows are filled with clear rather than stained glass, even though they are set in a Gothic church, the characteristic features of which are described with astonishing perception, and even though Jan at other times avoided large areas of clear glass and bright light.[36] Mary, standing in the church with her Child, appears as a virgin "post partum." An allusion to her virginity at, and perhaps before, the conception is made by the representation of the Annunciation just alongside her head in the relief in the first bay of the choir screen. In the relief of the second bay appears the *Coronation*,[37] the final act of glorification, and just below this relief, though back in the choir, two angels sing her praises, probably in the words of the hymn inscribed on the frame. On the pinnacles of the screen is represented the Crucifixion, the major event following the incarnation, which terminates Christ's life on earth and assures man's redemption. The Child, wrapped to the hips in a white cloth, is unusually small and relatively unformed.[38] He seems wholly dependent on His mother, and reminds us more of the Infant in the *Nativity* than the older, more robust and independent Christ Child of Jan's other works.[39] Are these qualities

36. The painter of the copy of 1499 in the Antwerp Museum [Fierens-Gevaert, *Primitifs flamands* (Brussels, 1912), i, fig. 11] inserted figures in the glass of the nave windows, and omitted the patches of light on the floor, showing that he failed to understand the meaning of Jan's composition.

37. The sixteenth-century copy in the Doria Gallery adds a third bay with a relief of the *Nativity* (CF. Weale, *Hubert and Jan van Eyck* (London, 1908), p. 135 and pl.). Weale claimed that the third bay and other peculiarities of the Doria panel must have been included in the original work (he believed the Berlin painting to be a copy). For many reasons this view is untenable.

38. Bode, "La Renaissance au Musée de Berlin," *Gazette des Beaux-Arts,* 2d ser., 35 (1887) : 216, commented unfavorably on the small size and poor formation of the Child.

39. With the exception of the *Madonna of the Fountain*, Antwerp, where the Child is also quite small, though more active and with a more developed structure.

of the Child determined simply by the early date of the picture, as has been suggested, or are they expressive of extreme infancy and recent birth, in accordance with the ideas of the hymn?

The sunlight that streams into the church has still another sense in the rich and subtle context of this painting. Buerger read on the border of the Virgin's tunic: ". . . SIOR SOLE . . . HEC ES . . ."[40] and observed that this was part of the same text that is written on the frame of the Dresden triptych. It appears also, in fact, on the panel of the Virgin in the Ghent altarpiece and on the frame of the Paele altarpiece. It reads:

HEC EST SPECIOSIOR SOLE SUPER OMNEM STELLARUM DISPOSICIONEM LUCI COMPARATA INVENITUR PRIOR CANDOR EST ENIM LUCIS ETERNE SPECULUM SINE MACULA DEI MAIESTATIS

(Wisd. of Sol., 7:29, 26) [41]

[For she is more beautiful than the sun, and above all the order of the stars; being compared with the light, she is found before it. For she is the brightness of eternal light, and the unspotted mirror of God's majesty.]

This is Jan van Eyck's favorite text—no other is repeated in this way. Like his paintings, it is full of images of light. It is first used in the *Madonna* in Berlin, and here it is most closely connected with the painting, for this is the only work in which the Virgin is actually related to the light of the sun.

The Berlin painting is both the representation of a magnificent Gothic cathedral in which appears the visionary Madonna, preternaturally large, and a pattern of symbols in which the image of the Virgin is surrounded by a rather small church expressive of several aspects of her nature. We have already referred to the light, the windows, and the reliefs; and the church itself is one of the most common metaphors of the

40. Buerger, *loc. cit.* I have found no later record of this inscription. In the photograph here reproduced I can make out the letters ..R..SO.., and further to the right, LU.
41. W. Weale, *The van Eycks and Their Art,* ed. Brockwell (London, 1912), p. 123, note 1, says that this text was used in the little chapter at Lauds on the feast of the Assumption, in the breviary according to the use of St. Donatian, Bruges.

Virgin.[42] According to Jan van Eyck—if we may accept as
evidence the inscription on the Ypres altarpiece—she is the
"temple of the builder; the sanctuary of the Holy Spirit."[43]
Theologians had even compared Mary, who bore the Light in
her womb, to a church filled with daylight:

> Lumine plena micans, imitata est aula Mariam
> Illa utero lucem clausit et iste diem.[44]

In Jan's painting, the daylight fills the church as the Divine
Light filled the womb of Mary.

Just behind the Madonna, in the first bay of the choir screen,
a statue of the Virgin and Child stands on an altar between
burning candles—themselves symbols of the incarnation.[45] The
relationship between the sculpture and the Virgin seems
pointed. It is true that the statue is of an earlier style (thir-
teenth century?) than the living Virgin. But in both groups the
Madonna carries the Child on her right arm, in both she wears a
crown, and the posture of the Child is remarkably similar. The
Madonna is enveloped by the nave of the church, the statue by
an arch of similar shape. Furthermore, at each side of the statue
is a burning candle—an artificial light, while the living Virgin is
celebrated at left and right by the natural light of the sun. As
we contemplate these two figures in the shadowy interior we
seem to witness a miracle of animation, a statue come alive. The
painter and his audience would have known of similar occur-
rences. They had probably not heard of those in the ancient
world, but they were certainly familiar with the accounts of the
animation of statues of the Madonna given by many of her most
ardent worshippers, including St. Bernard.[46]

42. Cf. Livius, *op. cit.*, pp. 263–277.
43. "Conditoris templum; sancti spiritus sacrarium." Cf. Weale, ed.
Brockwell, p. 137. If this inscription is not authentic, it probably copies
Jan's original.
44. Venantius Fortunatus (7th century), quoted by Hirn, *loc. cit.*
45. J. Sauer, *Symbolik des Kirchengebäudes* (Freiburg i. B., 1924), p.
187.
46. Cf. P. Sausseret, *Les apparitions et révélations de la très Sainte Vierge*
(Paris, 1854).

For a spectator of Jan's time, the style of the church and the sculpture recalled a great Christian period, more devout and less troubled than the present. But is there latent also in the comparison of the living Virgin and the inert, outmoded statue a subtle reference to the painter's own artistic achievements, to his progress beyond his predecessors (fig. 13) ?[47] This suggestion may seem less fantastic if we recall that the mirror in the Arnolfini portrait and in a lost work[48] seems to express, beyond its other connotations, Jan's awareness of a new relation of his art to actuality. And, after all, the phrases on the Ghent altarpiece referring to his brother Hubert and himself—"major quo nemo repertus" and "arte secundus"—are more than conven-

47. The Boucicaut Master, in a *Mass for the Dead* (British Museum Add. 16997, fol. 145) comes closer than any other pre-Eyckian work to Jan's painting, especially with respect to light and perspective.

Tolnay, in *Münchner Jahrbuch*, 9 (1932) : 324, claimed a dependence of Jan's *Madonna* on the *Virgin in the Church* by the Master of Flémalle, known by several copies (cf. Friedlaender, *op. cit.*, II, pl. 63) , and in his book [*Le Maître de Flémalle et les frères van Eyck* (Brussels, 1939) , p. 24] he attributed the invention of the architectural composition to the same painter, referring to a *Presentation in the Temple* in the Pelletier Collection, Paris, which copies, at least in part, a lost work of Flémalle. Tolnay was the first to recognize the full extent of the influence of Flémalle on Jan, but the fact that the former influenced some of Jan's later paintings is no indication that he holds a priority in all the innovations that appear in the work of the two painters. Until the paintings in question can be more precisely dated there appears to be no certain way of solving the problem. But it is clear that in form and meaning Jan's painting is far richer, and that the small size of the Child, which Tolnay adduced as evidence of Jan's dependence, seems to be motivated specifically in his work and not in the painting by Flémalle.

As for the beautiful church interior in the *Mass for the Dead* in the Milan Hours (Museo Civico, Turin) I agree with the opinion of Dvořák, Tolnay and others, that it, and the other miniatures in this style, are not by the van Eycks, and are not early. To the evidence which has already been accumulated in support of this view I should like to add here one comment: that the spots of reflected light, especially on the metal utensils in the *Birth of the Baptist,* are extraordinarily large and coarse, and seem to be the work of a painter who was imitating and exploiting an original observation, rather than of the originator himself. (In later publications I have not maintained this conclusion.)

48. Cf. the copy by W. van Haecht (Weale, *op. cit.*, pl. opp. p. 176) .

tional statements. So remarkable in fact is the self-consciousness and pride which they manifest that it has increased the doubts of some scholars as to the authenticity of the entire inscription.

The church in the painting in Berlin has been identified as a free copy of St. Denis[49] or the cathedral of Ghent,[50] but, as in the case of other buildings and panoramas, Jan seems to follow no single model. Rather he composes in the style of thirteenth-century Gothic. His painting is, in fact, the earliest document we possess, apart from the buildings themselves, of the actual appearance of the interior of a Gothic cathedral. Not until two hundred years after the construction of the churches themselves was a painter able to capture the qualities of space and light of their interiors. But if artists of his time in the Low Countries enjoyed debating the relative merits of the several arts, as they did in Italy, we can surmise Jan's contribution to the "paragone." He would have argued of course for the supremacy of painting, and his thesis might conceivably have been that painting is not only the one art which can truly mirror the world, but that it incorporates, in a sense, the other arts. As proof he could point to the church, the sculpture, and the beautiful specimen of goldsmith's work in the *Virgin in the Church*.

49. K. Voll, *Die altniederländische Malerei* (Leipzig, 1906) , p. 39.
50. Hulin de Loo, *Catalogue critique des tableaux flamands exposés à Bruges* (Ghent, 1902) , pp. 2–4, 58.

Part II

Reconstructions Through Written Evidence

4

The Painter Niccolò Pizzolo

by ERICE RIGONI

EDITORIAL NOTE: *It is a commonplace that Renaissance art was born in Florence and had its other greatest flowering in Venice. In the transmittal from Florence to Venice, the most striking incident occurred in the 1440's in Padua, twenty-five miles from Venice. At that time the great Florentine sculptor Donatello was settled at work there for ten years and the great Paduan painter Mantegna was growing up, so affected by his stimulus that in 1448 he began the first great set of Venetian Renaissance paintings, the frescoes of the Ovetari chapel. An almost forgotten Paduan painter and sculptor called Niccolò Pizzolo worked on nearly equal terms first with Donatello, and then with Mantegna in this chapel, so that his role in these events was important.*

The following documents permit various interpretations. In particular a recent study has proposed that, since the Ovetari had agreed to pay seven hundred ducats for the frescoes, more money than they received by selling their farms, the accounts printed here showing that by 1455 they had spent all the proceeds of the farms do not imply that all the frescoes had been

69

*painted by then. The St. Christopher frescoes might have been
painted later. (See G. Paccagnini in* Atti del VI Convegno di
Studi sul Rinascimento, *Florence, 1965.*)

THE VIOLENT DEATH by which Niccolò Pizzolo's young life was
cut short,[1] in 1453, made such an impression on the artists of
Padua that it was still present many years later in 1470. On
commission from Giovanni Alvise Pasini, a druggist "at the
Terrace," the painter Pietro Calzetta had painted a chapel
dedicated to St. John, one of those in the church of Santa Maria
dei Servi surrounding the choir, which then was almost in the
middle of the church.[2] The patron solicited estimates of the fee
from the sculptor Giovanni Fondulo of Crema and the painter
Girolamo dei Maggi,[3] but Calzetta was unwilling to submit to
their judgment, on grounds confirmed by other painters who
were brought forward as witnesses in November, 1470, in the
litigation between him and the druggist.

The two experts were in no position to make a proper
valuation, Master Girolamo because he was too young—he had
been enrolled in the artists' guild only the year before, at
eighteen—and also because he was not familiar with fresco
technique. As for Master Giovanni, although he was a good

1. For information on Niccolò Pizzolo, see V. Lazzarini, *Documenti
relativi alla pittura padovana del sec. XV,* with commentary by A.
Moschetti (Venice, 1908), pp. 69–77; G. Fiocco, *L'arte di Andrea
Mantegna* (Bologna, 1927), pp. 137–52; E. Rigoni, *Nuovi documenti sul
Mantegna* (Venice, 1928), pp. 4–7; G. Fiocco, *Mantegna* (Milan, 1937),
pp. 19–20, 22–24.
2. "Master Angelus painter, son of the late Master Sylvester, living in
Crossbearers' Field Street," called by Pasini as a witness in his suit against
Calzetta, testified: "Other chapels on the near side of the choir of the Servi
are more beautiful than the said chapel of Master Giovanni Alvise, and
this he said he knew on the basis of what he the witness saw and judges as
an expert in the art." The Pasini, as the documents show, had their burial
place in the church of the Servi in the chapel of St. John.
3. The two artists have been discussed by A. Moschetti, "Giovanni
Fondulo scultore," in *Bollettino del Museo Civico di Padova,* n.s., 3
(1927): 76, and "Un ignoto dipinto del quattrocentista padovano
Girolamo dei Maggi," in the same journal, n.s., 8 (1932): 34.

master in sculpture, he was not qualified as a painter merely because he himself sometimes colored the figures he modeled in clay, and he was besides a bitter enemy of Calzetta, forever talking against him and abusing his work, alleging further that he was a deceiver, and had assaulted him. What is more, one day Fondulo had given the painter Bartolomeo Scodellaro a message to tell Master Pietro that "if he didn't leave him alone, it would go with him as it had with Master Niccolò the painter" who was murdered, a threat that Master Bartolomeo carefully refrained from passing on to the interested party.

Thus after many years there was still a lively recollection of the tragic fate of Pizzolo, killed by treachery, as Vasari tells it, one evening while returning home, apparently by another artist hostile to him, perhaps envious of the young master's success.

But Pizzolo's death was not instantaneous, since he still was able "at the time of his death" to urge his brother Gerardino to treat his wife Maria generously and assign her the largest dowry his means would permit if she wished to remarry.[4] And the widow did hasten in 1453, the year of the death of her husband (by whom she had had no children), to obtain her brother-in-law's promise of a two-hundred-lira dowry, having in mind to marry the shoemaker Galvano da Montagnana.[5]

Niccolò's restless and pugnacious temperament once made him fall into the hands of justice. During one period of his life, certainly when he was still very young, he was in the habit of wandering at night, sometimes armed, through the suburbs of the city, with other unbridled youths, among them the cousins Ilario and Nicolo of the aristocratic Sanguinazzi family. One evening, apparently armed, he was surprised by the watch with others in front of the Sanguinazzi house, which was by Santa Sofia, and taken to jail. The next morning the magistrate

4. Papers produced by Vittor dei Porcellini, attorney of Donna Maria, formerly the wife of Master Niccolò the painter and now wife of Giovanni of Montagnana the shoemaker, in her suit with Gerardino the rag dealer: "Item, the said Master Niccolò at the time of his death said and ordered the said Master Gerardino to give Donna Maria his wife as large an amount out of his property as he could when she wished to marry."
5. E. Rigoni, *op. cit.,* p. 6.

questioned him and since he seemed reticent in his answers
subjected him twice to the rope torture. But since he was still
unwilling to talk in spite of the torture, the magistrate ordered
him returned to jail, with the intention of resuming the inter-
rogation another time. This unpleasant episode occurred very
probably in 1438, when he was either seventeen or eighteen: he
was then still a lively and imprudent youth, and in fact is not
described as painter or master in the document.[6]

But with the passing years his proud and violent character
became no milder and brought him enemies even among his
fellow artists, toward whom he did not always use proper and
well-bred language, as the following episode shows. The painter
Luca da Puglia had come to Padua[7] and applied to Pizzolo in
November, 1448, to be trained in painting, but since the master
had nothing for him to do at the moment he recommended him
to Master Francesco dei Bazalieri, who kept him in his shop and
paid him subsistence until the next March, when Luca went to

6. The document from which this account is derived has no specification
of the year but only day and month, Saturday, February 22, nor can we
deduce the year from nearby papers, since the sheet in question was used
as the cover of a notebook containing civil actions of the Bear law office in
the year 1490.

In view of the relatively short span of Pizzolo's life, from 1420 or 1421 to
1453, this event could have happened in 1438, 1444, or 1449, years in
which February 22 fell on Saturday. But 1449 can be excluded at once,
since Ilario Sanguinazzi, Niccolò's companion in adventures, was dead. On
June 28, 1447, Master Niccolò, son of Master Pietro of Vicenza, living in
San Luca Street, is heard as a witness in a suit between the heirs of Ilario
Sanguinazzi and the doctor of laws Giacomo of Brescia. Nor would 1444 be
possible, in my view, a date when Pizzolo was a painter of such recognized
authority and experience that we see him on May 27, 1443, selected along
with the miniaturist Gerard of France to value a missal illuminated by
Master Bartolomeo of Urbino (see doc. III). In 1444 he was, further, an
officer of the artists' brotherhood and, along with Master Andrea, son of
the late Natale, another officer, gave judgment on an altar frontal executed
by the painter Giacomo of Cathedral Street (see doc. IV). Hence 1438
remains.
7. This artist was inscribed in the brotherhood of Paduan painters on
October 1, 1449, under the name of Luca of Mola; he was thus from Mola
near Bari in the Puglia region. V. M. Urzi, *I pittori registrati negli statuti
della fraglia padovana* (Venice, 1933), p. 9.

work for Pizzolo. This departure made Master Francesco, who had supported the Pugliese during the winter season, quite hostile. "And it is true," observed the painter Andrea, son of the late Natale, "that masters of painting in the winter have little income beyond their costs, or rather almost nothing, on account of the unfavorable weather." When spring came and Master Francesco would have needed him more, Luca had left him.

Bazalieri therefore brought suit against his ex-employee, and painters were called as witnesses on both sides: Matteo the furniture painter, Riccio son of master Luca, Cecco of Rome, Andrea son of Master Natale, Valerio son of Bartolomeo the carpenter, "Baldesar the German living in the house of Master Bono by the week," and Niccolò of Villa Ganzerla, who is Pizzolo. The last-named, in his testimony of August 27, 1449, expressed the view that Master Luca would have deserved a wage of a ducat a month from Master Francesco besides his costs. The painter from Puglia would not have been qualified to execute the works the witness was doing, but he had enough ability to paint chests, horse trappings, and that kind of thing which was being done in Bazalieri's shop, where Luca couldn't have learned more than he already knew when he entered it, because, Pizzolo concluded, "the said Francesco doesn't know how to paint anything but rough work" (doc. V) —rather offensive words about an artist older than the attacker, who maintained a respected shop and executed, the documents tell us, fairly important paintings.

Perhaps Pizzolo's disdainful attitude toward his colleagues was dictated by awareness of his being superior to them. His prestige and reputation had grown after he worked side by side with Donatello from 1446 to 1448 on the reliefs for the altar at Sant' Antonio, and then he took on the fresco project of the Ovetari chapel in collaboration with the young Mantegna and major artistic questions were submitted to his judgment. On July 30, 1451, chosen arbiter along with Francesco Squarcione, he estimated the fee for an altarpiece and some chests painted by Zanino Storlato (doc. VI); in December, 1452, Master Niccolò, called "Little" (*Piccolo*), estimated by himself the fee

for paintings that Giacomo of Cathedral Street had executed in
the Badoer house; in 1451 a drawing of his was valued at a
ducat (doc. VII) .

His sudden and early death must have occurred near the end
of 1453, since the questions raised by the work he had left
unfinished or had not yet been paid for were settled in the last
months of that year and the first of the next. At the request of
Donatello the Florentine, on November 24, 1453, twelve slabs
of marble or stone were impounded from Gerardino the tailor,
brother of Niccolò Pizzolo, on five of which the artist (surely
Master Niccolò) had begun to sketch figures in relief, while the
other seven had remained in the rough (doc. VIII) . Since the
altar of Sant' Antonio had been finished in 1450, Donatello
must have been carrying out a new work with the help of the
Paduan sculptor, but we cannot say what it was, for whom it was
being made, or whether it was carried out with some other artist
substituted for Pizzolo.

Certainly if Donatello stayed on in Padua after the Gatta-
melata monument was unveiled in October, 1453,[8] it was for
reasons connected with work. He left the city definitely in early
1454 after living there ten years, but not without interruption,
since he went to Ferrara, Mantua, and Modena between 1450
and 1451,[9] while he must have left Padua at least briefly in
1449 as well, since on January 24, 1449, he left a power of
attorney with his nephew Giovanni, allowing him to represent
him in a law case before the Padua magistrate and obtain the
money due him (doc. IX) . From this power of attorney it
appears that in 1449 Donatello was living in Santa Croce Street.
Gloria showed from documents that in 1448 he was living in a
house on the Square of the Santo called "The Fish" and in 1450
had moved into a nearby house belonging to the lawyers'
guild.[10] This would make it seem that he moved to Santa Croce
Street in 1449 and back to the same Square the next year. I
think it likelier that, while living at Santa Croce, he still kept

8. See A. Venturi, *Storia dell'arte italiana*, VI, p. 336.
9. *Ibid.*, p. 335.
10. A. Gloria, *Donatello fiornetino e le sue opera mirabili nel tempio di S
Antonio di Padova* (Padua, 1895) , pp. xxii ff.

the house for which he paid rent to the lawyers' guild as a workshop, since it was conveniently near the church of Sant' Antonio for which he was working.

Because of Niccolò's sudden death, Gerardino also had a dispute with his brother's landlord. As is known,[11] Niccolò lived in his father's house at San Luca for many years and was still there in January, 1449,[12] but moved in that same year to San Daniele Street, as we learn from the agreement of July 30, 1449, between Niccolò and Mantegna naming the doctor of laws Giacomo Alvarotti as arbiter of the disagreements that had come up in their joint work. From a previously known legal document of September 4, 1452,[13] we learn that Niccolò lived "in Torricelle Street on the river." Thus the house where he had gone to live in the last years of his life was in the stretch of road between the Torricelle Bridge and the church of San Daniele, near the church and on the water. This house belonged to the butcher Paolo Grasseto, who lived in Rudena Street on the side toward San Giorgio.[14] In the house that he rented Pizzolo had painted, apparently not long before he died, a figure of Saint Sebastian, and in Grasseto's house other figures "in green"—that is, in terre verte monochrome.

According to Rossetti's guidebook of Padua of 1786, the chapter house of the Lodge of St. James was also painted in fresco in terre verte monochrome with representations of St. James, by an unknown artist.[15] The Lodge, which stood in Piazza Mazzini opposite the Palazzo Maldura, was torn down in the early nineteenth century along with the church of the same name. A document informs us that the painting of the Lodge's chapter house had been undertaken by Nicolo Mireto and Giacomo della Bianca of Cathedral Street (doc. XI). When the latter died in 1447, as the membership books of the Paduan

11. V. Lazzarini, *op. cit.,* pp. 70–73.
12. V. Lazzarini, *op. cit.,* doc. lxxxvi.
13. V. Lazzarini, *op. cit.,* doc. lxxxix.
14. "Paolo Grasseto butcher son of Master Bartolomeo of Rutena Street"; "Master Paolo Grasseto butcher son of Bartolomeo living in Padua on Rutena Street on the San Giorgio side" (docs.).
15. P. 169.

painters' brotherhood confirm, and the interested parties could
not agree on the payment, the responsibility for deciding the
value of the paintings was placed by the president of the
brotherhood of St. James as one party, and Nicolo and the heirs
of Giacomo as the other, on August 4, 1448, in the hands of
Giovanni d'Alemannia and Niccolò of Villa Ganzerla, Pizzolo,
the latter chosen in all probability because he was expert in this
type of painting, which he practiced in the house on Rudena
Street.

The estimate on the paintings by Pizzolo in the two houses
owned by Paolo Grasseto was made by Andrea Mantegna, called
Squarcione, and by Zanino Storlato, who on January 9, 1454,
presented their decision that the paintings were worth six and a
half gold ducats altogether (doc. XII) .[16]

Finally, in February, 1454, an estimate was presented for part
of the decoration of the Ovetari chapel,[17] and perhaps this
brought to a close the problems produced by the painter's
sudden death. Even considering his brief life, his activity as a
painter and sculptor seems very slight, because, according to
Vasari's account, he was more given to arms than to practicing
his art. The little that was left of his work was in the Ovetari
chapel,[18] now unhappily destroyed, and showed that this
Vicentine's contact with the Tuscan masters who came to Padua
was by no means without its effect. Because of this Tuscan
background, Pizzolo was regarded among the Paduan painters
of his time as the propagator of Renaissance forms, as the
vanguard of a new style, and Master Luca da Puglia applied to
him in November, 1448, to teach him to paint *in recenti*, i.e.,
according to the modern way (see Document V) .

A record of expenses in the Ovetari chapel here published
(doc. XIII) , somewhat more detailed than the one published

16. The judge of the Eagle office confirmed the two experts' decision in his
verdict of January 10.
17. E. Rigoni, *op. cit.*, p. 7. Antonio Ovetari's widow and executors felt
that Squarcione's estimate of February 6, 1454, was too favorable to the
other side, and on June 28 of that year they appealed the verdict of the
judge who had confirmed it.
18. Cf. G. Fiocco, *Mantegna*, 1937, pp. 19, 20, 24.

by Lazzarini,[19] provides some other information on the work in the chapel, especially in connection with the frescoes. Unlike the one previously known, this new document does not end at May 13, 1452, but records other payments in 1452, 1454, and 1455. The payments for the last two years are in the handwriting of Giovanni da Verona, man of business for Donna Imperatrice, the widow Ovetari.[20] In these accounts we see that occasionally after the dissolution of the partnership between Mantegna and Master Niccolò in September, 1449, the latter's name recurs, on October 23, 1449, again on December 22, 1451, and finally on June 9, 1452; thereafter, perhaps, the artist stopped working in the chapel.

On July 8, 1448, 68 lire 8 soldi were paid out to Giovanni da Pisa, for the specific purpose of modeling the terra cotta altarpiece, but it was far from finished on September 27, 1449, when the job of completing and gilding it was assigned to Pizzolo,[21] who was perhaps its designer, unless that was Mantegna.

This new expense record allows to date precisely the fresco painted in the chapel by Bono da Ferrara, to whom 102 lire 12 soldi altogether were paid out on July 24 and 30, 1451. The Ferrarese had already been in Padua in 1449 if, as seems likely, he is that Master Bono of whom the painter Baldassare of France was a dependent, as mentioned earlier. In 1451 he returned to paint in the Ovetari chapel, but on August 6 of that year the administrator of the painters' guild warned him to do no more painting nor let his assistant do any, since he was not a member.[22] He never actually became one, as the initiation list shows, but perhaps never applied, since he soon left the city.

It had been asserted that after his brother-in-law Giovanni d'Alemannia died, Antonio Vivarini never again set foot in the

19. V. Lazzarini, *op. cit.,* doc. ciiii.
20. Giovanni da Verona was agent and attorney of Donna Imperatrice. See E. Rigoni, *op. cit.,* docs. vii and viii.
21. E. Rigoni, *op. cit.,* doc. vi.
22. "Friday August 6 [1451]. On the motion of Pietro painter, chairman of the brotherhood of painters, Bartolomeo the sergeant-at-arms stated that he had personally informed Master Bon, painter of Falaroti Street, that he should not work at the art of painting, on pain of ten small lire, nor have an assistant work, on the same penalty."

chapel,[23] but, on the contrary, we see his name recorded again on November 27, 1451. He receives ten ducats for completing the parts of the vault that had been his originally. Payments into Mantegna's hand are recorded three times in 1451: on February 25 and October 25 he receives money alone, and on October 30 he and Master Ansuino receive 171 lire together.

Venturi[24] had drawn attention to striking likenesses between the first two scenes of St. James, then considered to be Pizzolo's work, and the fresco on the opposite wall signed by Ansuino, likenesses that he regarded as the result of Ansuino da Forli's influence on Pizzolo, the master from Vicenza; but they should rather be considered due to Ansuino's direct participation in the left lunette scenes of St. James, Mantegna having taken him on as an associate replacing Pizzolo.

In 1451, too, the Forli master must have executed the fresco that he signed on the right wall, as also, in my opinion, Mantegna must have painted the great scene of the Martyrdom and Death of St. Christopher, for the following reasons: in 1451 the expense book for the chapel shows various payments to the painters, particularly Mantegna, Ansuino da Forli, and Bono da Ferrara. In 1452 only 114 lire were paid out to Donna Imperatrice's man of business, Bonifacio Frigimelica, in May and on June 9 there is a record of the payment to Master Niccolò already mentioned. For 1453 no expenditure is recorded. In those two years Mantegna was busy with other work, as is well known.

On the left wall, devoted to scenes of St. James, following the upper lunette, which is rather different from the scenes below and which I think Mantegna painted in 1451 in collaboration with Ansuino da Forli, Mantegna could not have painted any more until after the death of Pizzolo and after the experts had made estimates of the work he had done, as I showed through documents.[25] The payments of 1454 and 1455 are to be connected with this wall, and with the *Assumption* behind the altar. Hence the money received by the artists in 1451 went

23. V. Lazzarini, *op. cit.*, p. 91.
24. *Storia dell'arte italiana*, VII, part 3, p. 84.
25. E. Rigoni, *op. cit.*, pp. 6–8.

largely for paintings of the right wall, devoted to scenes of St. Christopher, which was finished then or at the latest in early 1452, thus preceding the other by some years.

Although the controversy between Mantegna and Imperatrice Ovetari over the number of apostles to be included in the Assumption[26] only arose at the beginning of 1457, the whole cycle of frescoes including the Assumption was complete in 1455, in view of the fact that the last payment made to Donna Imperatrice's man of business for the work in the chapel is of January 28 in that year. The expenditures on that date amounted to a total of 3,213 lire 2 soldi, a sum scarcely distinguishable from the estimated value of the property left by Antonio Ovetari to pay the expenses of the decoration.[27]

Having finished the chapel, the young Mantegna was able to go back to Venice in this same year, 1455, where he had married the year before.

DOCUMENTS

I. Wednesday, November 14, in the Morning [1470]

Master Bartolomeo Scodellaro, painter, witness brought forward on behalf of Master Pietro Calzetta, painter.

Questioned on the first item, he answered on oath that he knows nothing except that he the witness heard the said Gio-

26. The widow Ovetari may have waited to sue Mantegna until he had returned to Padua. In July, 1456, he seems to have been back [see D. R. Zanocco, *Il palazzo vescovile di Padova nella storia e nell'arte della rinascenza* (Padua, 1928), p. 7], and he certainly was in the following October. On the twenty-seventh Master Andrea, painter son of the late Master Biagio, called Mantegna, of Vicenza, living in Padua on San Matteo Street, petitioned the magistrate's deputy for permission to accept, with benefit of inventory, the estate of his brother Tommaso, who in that month had died of the plague in the hospital of San Francesco and who, in his will of July 11, had named Master Andrea guardian of the estate and of his daughters.
27. An estimate was made on June 7, 1452, of the value of the farm that Antonio Ovetari had left in his will to satisfy the costs of the chapel that he willed. Subtracting the dues paid to the church of Sant'Andrea, the estimate was 3,263 lire 2 soldi. On January 28, 1455, the sum still available had thus dwindled to 50 lire.

vanni da Crema several times and in various places, about a year
ago, talk against the said Master Pietro, saying he was a man of
evil life and condition, that he had sworn falsely a hundred
times on behalf of a certain nobleman of this city, that he did
not know how to work and was not a good painter, and he
despised his works, and it is about a year since the said Giovanni
da Crema said to him the witness that he should tell the said
Master Pietro that "if he didn't leave him alone it would go
with him as it had with Master Nicolo the painter," who was
killed, but he the witness never reported the said words to the
said Master Pietro. . . . Questioned on the second item he
answered that he knows nothing except that the said Giovanni
da Crema is a good sculptor but he the witness never knew that
the same Giovanni da Crema knew painting.

. . . Master Prospero, painter of the street by Councilmen's
Square, a witness brought forward as above, questioned on the
second, answered that he believed the contents of the said item
were true, that the said Giovanni da Crema is a sculptor and not
a painter, etc.

. . . Master Lorenzo, painter son of Master Jacopo, living in
Padua on Councilmen's Square, witness produced on behalf of
Master Pietro Calzetta.

Questioned on the first item he answered that he the witness
knew Giovanni da Crema named in the item, and many, many
times for a year and more he had heard the said Giovanni
complaining of Master Pietro named in the item, saying that
Master Pietro was treacherous and that he and Galeazzo Mus-
sato had struck him down, the said Giovanni da Crema, and
many, many times and very often he had heard the said Gio-
vanni da Crema abuse the works and person of the said Master
Pietro as worthless, saying the said Master Pietro had made an
altarpiece for the altar of Corpus Domini in the church of Saint
Anthony in the chapel of Master Bernardo de Lazara, etc.

Questioned on the second item he answered that Giovanni da
Crema is not a painter, but knows how to model clay figures
well and is a quite good master in that specialty, but in his the
witness' judgment Giovanni would not know how to estimate
colors and other things necessary for a painter to use, since he,

Giovanni da Crema, does not practice the art of painting but only makes figures as stated, and he sometimes puts the colors on some of the figures he himself has made. Likewise he said that the said Master Giovanni would not know how to estimate colors that are applied to a wall by painters who apply colors, and there is a wide difference in applying colors on walls and panels, and in the opinion of this witness the said Giovanni would not know how to estimate the work done in the chapel on which this dispute between the parties turns since, as he said, this is not the area of competence of the said Giovanni, who does not work on walls, etc.

Questioned on the fifth item he answered that Girolamo named in the item is a painter, but young, and in the judgment of this witness would not know how to estimate the works of the said Master Pietro made in the said chapel, since he does not work very well on walls with the competence of a painter, and he the witness worked together with the said Girolamo on a certain wall in a certain house of Master Marco Giustinian's in Padua, and the said Girolamo treated this witness badly, because he did not understand the work. Therefore this witness considers the said Girolamo not adequate to judge similar work, as described above.

Questioned on the sixth, he answered that in the judgment of this witness, according to the experience he has in similar cases where he had done work, there are fifty leaves and more of gold and a pound and a half of azure in those two other chapels newly done in the said church, and he the witness would not do it with the said fifty leaves of gold and one pound of azure, etc. . . . he the witness is a painter on his own account and has a shop of his own.

[Tuesday, November 6, 1470]

Master Matteo di Puccio, painter, living in Padua in the Street of the Shield near Saint Anthony, witness brought forward on behalf of Master Pietro Calzetta in the suit he has with Master Giovanni Alvisio the druggist. . . .

Questioned at the instance of the said Master Pietro as to what and how much the said Master Pietro would deserve for the work in the chapel he has done in the Servite church on

order of the said Giovanni Alvisio, answered and said on oath
that the said Master Pietro would deserve twenty ducats for the
work and materials in the execution of the said chapel, etc.

II. Saturday, February 22

Nicolo son of Pietro of Villa Ganzerla, appearing for ques-
tioning before the said lord magistrate and his court, and asked
if he knows for what reason he is detained, answered no. Asked
if two months before he went by night through the suburbs of
Padua and which ones and for what purpose, he answered that
he sometimes went among them by night with Master Ilario,
joining him in such places say as the Portello Road and the
Ballot Road.

Asked if he went to the house of Nicolo dei Sanguinazzi by
night, he answered that maybe two weeks ago or about then he
was in the said house about the third hour after dark with
Master Ilario, Francisco Barisono, and no others, that Master
Ilario had a pair of iron gauntlets and a skewer in his hands,
and the said Francisco had a cuirass on. Asked whence they were
coming and where they had gone afterward, he answered that
they had come from the house and returned to the house. Asked
if yesterday morning, when Vincenzino the huckster and his
mate saw him on the doorstep of Master Ilario's house, he was
armed, he answered no. Asked who was with him, he answered
it was Master Leonino of Bergamo, who had a small stick in his
hands. Asked if Master Ilario had any arms on his person at that
time, he answered he didn't know, and the lord magistrate or-
dered him to be stripped and bound; and when asked if he was
in All Saints Street, he answered that about two weeks before he
was in two or three alleys near that street, unarmed, starting
from nightfall for two hours, after they entered the Santa Sofia
Gate, and the lord magistrate ordered him to be hoisted up; and
since he said he wanted to tell the truth, he ordered him let
down, and when he was put down he said he didn't know any-
thing else, and again he had him hoisted up, and when he was
hoisted up he said as above that he didn't know anything else,
and the lord magistrate ordered him put down and removed
from torture, and taken back to prison, with the idea of interro-
gating him again.

III. [May 27, 1443]

Master Gerard of France, miniaturist, chosen on behalf of Master Brother Arcangelo, and Master Nicolo Pizolo, chosen on behalf of Master Bartolomeo of Urbino, miniaturist, chosen as arbiters between the said parties to see, arbitrate, decide, and declare the said Master Bartolomeo's compensation for illuminating one missal of the said Master Brother Arcangelo, labeled by me, having seen and diligently inspected and examined and considered the things that should be considered in this work and also having consulted Master Giovanni of Mantua chosen as the third party, in unanimous agreement said, concluded, and in arbitration and decision declared and valued the said labor of illuminating the said book at thirteen ducats in gold which the said Master Bartolomeo should have for the said entire work from the said Brother Arcangelo, and thus they gave their verdict and estimate, praise be to God.

IV. [August 11, 1444]

Master Andrea, son of the late Master Natale, painter of Torricelle Street, and Master Nicolo, son of Pietro of Villa Ganzerla, painter, officers of the brotherhood of painters, chosen by Master Jacopo painter of Councilmen's Street on the one hand and Master Antonio Burleto on the other hand, to estimate an altar frontal, having seen the same estimate on oath that the said Master Jacopo ought to have for his labor for the said altar frontal, and for four coats of arms in the chapel of the said altar, sixteen small lire altogether.

V. Tuesday, August 27 in the Morning [1449]

Master Nicolo of Villa Ganzerla, painter, witness brought forward, sworn, and examined as above.

Questioned on the items on both forms, he answered on oath that in the month of November last the said Luca, whom he had not known before, came to the witness and wished to stay with him so that he could learn painting in the up-to-date way, and since he, the witness, did not have anything for him to do for him, he came to the said Francesco and asked if he wanted him,

and he answered that he would keep him, Luca, for some days and try him out, and so he did, then when after many days he saw the said Francesco he, the witness, asked him if Luca pleased him. And he answered yes, and that he wanted to keep him, and so he stayed with him up to the month of March last, until a certain day which he, the witness, noted well. And what he, the witness, said about wages was not otherwise agreed to, but in his judgment he deserved a ducat a month beside his living expenses for the time that he, Luca, stayed and worked all this past winter painting chests with Master Francesco. And he, the witness, did the arbitration of a certain painting that the said Francesco and Master Antonio had had as an order from Francesco da San Lazaro, and he, Luca, had been involved in the painting of the said work. And when questioned he, the witness, said that the said Luca would not be competent to paint the pictures that he, the witness, painted, taking into account the fee that he receives for the said pictures, but for painting chests and horse trappings and doing the things that are done in the said Francesco's shop the said Luca was adequate, as he, the witness, saw from his own observation at the time when he sent him to stay with the said Francesco. And he said that in the said Francesco's house he could not be taught more than he had been taught before, that he, Francesco, didn't know how to paint anything but rough work, of which, he, Luca, had had experience when he went to stay with him, as he, the witness, knows because he saw what the said Luca knew how to do.

VI. Friday, July 30, in the Morning [1451]

Master Zanino, painter, chose Master Scorzano, painter, and Master Dainese, goldsmith, executor of the estate of the late Master Bonsignore, tailor, chose Master Nicolo painter son of Master Pietro of Villa Ganzerla, painter [sic], and Master Francesco Squarcione, painter, chosen by Master Zanino, painter [sic], to estimate the chests and altar panel made by him, Master Zanino, for the said late Master Bonsignore, to report to the lord judge how much the said Master Zanino

ought to have from the said inheritance for the chests and altar panel made by him for the said late Master Bonsignore, tailor. And then and there the said arbiters, having seen these same chests and altar panel, said and decided that the said Master Zanino for this painting, gold, and workmanship, except for the wood of the said chests and the said chests made of wood, and for the altar panel, should have ten gold ducats, taking into account, too, whether the said chests are now new, and now just recently made. And so they report that he Master Zanino deserves and should have that much for his work and the painting of the said altar panel.

VII. *Friday, April 16, in the Morning [1451]*

For judgment before the honorable doctor of laws lord Michele di Milliaro . . . in the presence of Master Nicolo painter of Villa Ganzerla, there appeared Master Andrea of Mantua, carpenter, making known that the said Master Nicolo had had made for him two frames, one for a glass window and one for a copper grillwork, for which he asks five small lire. And the said Master Nicolo should be condemned in the said amount and costs, etc. And the said Nicolo answering said he had not had anything made but a window or rather a frame for a window, and that he made for him, Master Andrea, a drawing for it of the value of one gold ducat, asking that he be condemned in the said amount and costs for the said suit. And the said Master Andrea admitted that he had got the said drawing and that he is prepared to pay him for the said drawing at the rate estimated by experts in such matters.

VIII. *[November 24, 1453]*

On the petition of Master Donatello of Florence, Marinus reported on inquiry that he had personally stopped and expropriated from Master Gerardino, tailor, five images begun on five slabs and seven slabs not begun, and he asked to have them.

IX. *Friday, January 24 [1449]*

There and then the honorable Master Donatello, whose craft is sculpting stone and bronze figures and who is the most excellent

craftsman in the said things, son of the late Nicolo, son of Betto of Florence, living in Padua in the street Holy Cross Road, with every oath and way and form that he best can makes his legitimate attorney the honorable man Master Giovanni, son of the late Bonaiuto, son of Lorino of Florence, his own nephew, there present and willingly accepting, in all his suits either brought or to be brought against any person whatsoever, to appear before the lord magistrate of Padua, his deputies or judges, etc., and wherever it may be necessary. And especially to seek and demand from any persons obligations owing to him the assignor, etc.

X. *Tuesday, July 30, After Nones* [1449]

There and then the prudent and learned men Master Nicolo, painter, son of Master Pietro of Villa Ganzerla of the street of San Daniele of the first part, and Master Andrea, painter, son of Biagio, carpenter, of Padua of Saint Lucy street of the second part, for all purposes, etc., both submitted to the honorable doctor of laws Master Jacopo degli Alvarotti, for arbitration, decision, mediation, as friendly compromiser and common friend, to see, recognize, state, and decide in law and in fact and equally in fact and in law and both, in all and in each of the disputes of any sort at odds between them and which have been at odds between the two painters for whatever reason and cause up to the present day, the said parties promising to keep steadfast and unaltered.

XI. *On the Said Day* [August, 1448]

Then and there the honorable man Master Elias, draper, guardian officer of the venerable brotherhood of St. James of the Millers' Bridge, of the first part, and in the name of the said brotherhood, and Master Nicolo of Mireto, painter, of the Valley Meadow road, on his own account, and Master Zanone dalla Seta, son of the late Master Perino, attorney, in the name of the estate of the late Master Jacopo, son of Matteo, painter, formerly living in Cathedral Road, of the second part, unanimously and by agreement concurred and chose Master Giovanni

of Germany, brother-in-law of Antonio of Murano, painter, chosen on behalf of the said Elias in the name aforesaid, and Master Nicolo, painter, son of Master Pietro of Villa Ganzerla, chosen for the other party. These chosen had to see and estimate a certain work of painting that has been done in the hall of the said brotherhood and other work done outside the hall by the said late Master Jacopo and the said Master Nicolo of Mireto, and on oath report the estimate to be made of the aforesaid work. And if they should not agree together, then the same parties could chose a third, which third then chosen together with these now chosen would have to report as mentioned, the same parties promising, etc.

XII. *On the Said Day* [*January 8, 1454*]

Master Paolo Grasseto, butcher of the first part, and Gerardino of Villa Ganzerla, rag dealer, as heir of the late Nicolo Little, painter, his brother, of the second part, concurrently chose Master Zanino Storlato, painter, and Master Andrea Squarcione, painter, to see what and how much the said late Nicolo deserved and ought to have for a certain painting of Saint Sebastian made and painted by the said late Nicolo in a certain house of the said Paolo, in which the said late Nicolo lived, and likewise for certain other figures made in the house of the said Paolo, promising to keep steadfast and unaltered, etc., with obligation of all their goods, etc.

On the said day [January 8, 1454]
And shortly after the aforesaid there appeared the aforesaid Master Zanino Storlato and Andrea Squarcione, painters, chosen as above, and said that they had diligently observed the figures of Saint Sebastian, painted at an earlier time by the late Master Nicolo Little, painter, brother of the said Gerardino in a certain house belonging to the said Master Paolo Grasseto, in which the said late Master Nicolo Little lived, and likewise certain paintings drawn in green in his, Paolo's, own house. And that they had diligently examined all the aforesaid, that they report in agreement, and fix the price as they do on the

basis of their knowledge, that the said late Master Nicolo should
have had six and a half gold ducats for the aforesaid work.

XIII.

Master Francesco Capodilista and Master
Antonio Forzate and Master Francesco da
San Lazzaro are credited with a deposit re-
corded by the hand of Andrea da Buvolente,
notary, on July 8, 1448 Lire 3,800, s.—

Note that the said property is to be sur-
veyed, and if there is more, paid more for,
and if there is less, paid less for.

Note that I must be reimbursed from the
said property for paying seven lire and one
pair of chickens to Sant'Andrea.
[on the facing page]

Debit to the same, July 15, 1448, count out
to Master Francesco and Master Antonio
and Master Francesco to give to the painters
100 gold ducats, written by the hand of
Andrea da Buvolente Lire 570, s.—

Debit on October 19, to be received by
Master Nicolo, painter, written on the same
day by the hand of Andrea da Buvolente Lire 71, s. 6

Debit December 16, count out to Master
Francesco Capodilista and Master Francesco
da San Lazzaro to give to the painters, writ-
ten by the hand of Andrea da Buvolente Lire 142, s. 10

Debit April 24, 1449, which is received by
Master Nicolo, painter, ten gold ducats
equal to Lire 57, s.—

Debit June 6, 1449, which is received by
Master Nicolo, painter Lire 13, s.—

Debit July 16, which is received by Master
Andrea, painter, 25 gold ducats equal to Lire 142, s. 10

Debit July 8, 1448, which is received by Master Giovanni of Pisa for part of the altarpiece he is making — Lire 68, s. 8

Debit August 30, 1448, which was counted out to Master Francesco Braga for an iron grillwork fence owing him in the name of the tomb of St. Anthony, written today and countersigned by the hand of Master Andrea da Buvolente when he had received the abovementioned 50 ducats — Lire 216, s. 12

Debit July 23, 1449, which was received by Master Giovanni, painter, 20 gold ducats worth — Lire 114, s.—

Debit October 23, 1449, which was received by Nicolo, painter, 10 ducats worth — Lire 57, s.—

Debit August 25, 1450, which was received by Lady Imperatrice to give to the painters 50 gold ducats — Lire 285, s.—

Debit October 15, 1450, which was counted out to Lady Imperatrice 20 gold ducats worth — Lire 114, s.—

Debit December 24, 1450, which was counted out to Lady Imperatrice 15 gold ducats worth — Lire 85, s. 10

Debit February 22, 1451, counted out to Lady Imperatrice worth — Lire 85, s. 10

Debit February 25 counted out to Lady Imperatrice to give to the painters, that is to Master Andrea — Lire 28, s. 10

Debit July 16, which is received by Master Imperatrice to give to the painters — Lire 142, s. 10

Debit July 24, 1451, counted out to Master Francesco Forzate to give to Master Bon painter — Lire 28, s. 10

Lire 2,221, s. 16

Debit what Lady Imperatrice has to give me for her back taxes	Lire 120, s.—
	Lire 2,341, s. 16
Debit July 30, 1451, counted out to Lady Imperatrice to give to Master Bon, painter, 13 gold ducats	Lire 74, s. 2
	Lire 2,341, s. 16
	Total Lire 2,415, s. 18
Debit October 23, 1451, received by Lady Imperatrice, saying she wished to give it to Master Andrea, painter, and Master Ansuino, painter	Lire 114, s.—
Debit October 30, 1451, received by Lady Imperatrice, saying she wished to give it to Master Andrea, painter, and Master Ansuino, painter	Lire 171, s.—
Debit November 27, 1451, received by Lady Imperatrice, saying she wished to give it to Master Andrea, painter	Lire 57, s.—
Debit December 22, 1451, received by Lady Imperatrice, saying she wished to give it to Master Nicolo, painter	Lire 57, s.—
	Lire 2,814, s. 18
Debit May 13, 1452, received by and counted out to Master Bonifacio Frigimelica	Lire 114
	Lire 2,928, s. 18
Debit June 9, 1452, received by Master Francesco Forzate to give to Master Nicolo, painter, Lire 34, s. 4	Lire 34, s. 4
	Lire 2,963, s. 2
Debit December 5, counted out to Master Paolo Loredan, provost of Sant'Andrea, Lire 21, s.—	Lire 21, s.—
Debit December 4, 1454, counted out to the undersigned Master Giovanni da Verona, Lire 129, s.—	Lire 129, s.—

Debit January 28, 1455, counted out to the undersigned Master Giovanni da Verona, Lire 100, s.—

Lire 100, s.—

Lire 3,213, s. 2

The property was surveyed on June 7, 1452. 35 fields, two and a half quarters, and one rod and nine yards, by Master Galvan, surveyor. There remains to subtract from the said total three fields which are the dues paid to Sant'Andrea, there remains net 32 fields, two and a half quarters, and one rod and nine yards at Lire 100 per field

Lire 3,262, s. 10

Note that the lands that pay the dues are 2½ fields and a quarter field.
Received as appears on the opposite side in several places

Lire 2,963, s. 2.

Balance to be added, the rod and nine yards

Lire 300

Total Lire 3,263, s. 2.

And received, counted out to Master Paolo Loredan, December 5

Lire 21, s.—

And received December 10, 1454, counted out to Master Giovanni da Verona

Lire 129, s.—

And received January 28, 1455, counted out to Master Giovanni da Verona

Lire 100, s.—

2,963 s. 2
21 s. —
129 s. —
100
3,213 s. 2

5

The Hall of the

Great Council of Florence

by JOHANNES WILDE

EDITORIAL NOTE: *In this essay documents and other writings, long known, are used for a new reconstruction of a destroyed monument, or rather one that has been remodeled beyond recognition. The author's skill in bringing to bear other tools of social history, technical terminology, and fragments of measurements and specifications makes the conclusions seem easy and obvious, but they make the hall part of our visual awareness in a way that previously had seemed beyond reach. The ironic result of the care required for this purpose is that we now know the hall's appearance and meaning more intimately than others which still stand, and can apply our knowledge of it to understanding them. Wilde's findings have been debated, especially as to the location of Leonardo's and Michelangelo's murals, but have continued to be approved by most specialists.*

AN ATTEMPT TO reintegrate a monument which preserved its original state for only a few years, and to describe a scheme of decoration which was never executed, calls for an explanation.

The Council Hall, erected by the government which followed on the November revolution of 1494 in Florence, was the direct result of the new constitution and, at the same time, its expression in monumental form. The political ideas of the new

regime determined the shape of the building and also the plan of its decoration in all its details. This is one of the rare cases where a clearly definable historical occurrence expressed itself immediately in a work of art or—to put the statement in reverse form—where the existence and significance of a work of art can be completely explained by reference to a political event.

The Venetian constitution had admittedly served as a model for the reform of the Florentine Government in 1494, which a contemporary, Francesco Guicciardini, called "a people's government in the Venetian manner." Similarly, the Hall was built in deliberate imitation of the Sala del Gran Consiglio at Venice (completed in 1419). We therefore witness a close contact between the two major powers of the Italian civilization of the period and, in contrast to earlier occasions, Venice appears in the role of the leader.

This occurred at one of the most momentous epochs in the history of Florentine art. The Hall is the last great Quattrocento monument on Florentine soil. Had its decoration been executed, it would have been one of the earliest examples of the new style in Italy; and the designs for Leonardo's and Michelangelo's mural paintings prove sufficiently how different the course of the historical development might have been. The significance of these paintings has always been recognized, but it must be admitted that our understanding remains incomplete without a clear conception of the Hall for which they were commissioned and which would have been their setting.

If one considers the above three facts, the historian's interest in a nonexisting monument needs no justification. One is rather inclined to ask why this legitimate interest has not hitherto been more apparent. Apart from a collection of documents, no monograph on the building exists. It has received but casual atention from students of the history of art in dealing with Leonardo's and Michelangelo's cartoons, or in connection with the new structure by Vasari; and most of these students based their accounts only on Vasari's description. The one exception is A. Lensi's book on the Palazzo Vecchio (1929). It contains a short history of the Hall and, in addition to Vasari, the author uses the evidence of records and of Landucci's and Cambi's

chronicles. But even Lensi does not attempt a reconstruction of the Hall.

THE SOURCES

There is enough evidence available to reconstruct, in their essential features, the Hall and its decoration.

In the second edition of the *Lives,* in his biography of Cronaca, Vasari gives a fairly detailed description of the Hall.[1] It should however be remembered that this description is in itself partly a reconstruction. Vasari did not know the Hall in its original shape. Immediately after the fall of the democratic government in 1512, part of the furniture had been demolished, and structural alterations and additions begun; and although fifteen years later, during the last Florentine republic, the Hall regained its place of honor for a short time, and the additions to the fabric were then removed, the short duration and straitened position of the Republic forbade the replacement of what had disappeared. But Vasari knew many people on whom he could draw for information on the former appearance of the Hall and, as he was the architect in charge of the new building from 1560 onwards, there were practical reasons enough for him to investigate the history of the structure. His judgment was, however, biased by his own share of responsibility in giving the building an entirely new shape, and by the new ideals of the late cinquecento by which he was guided. He calls the old Hall "low, dark, melancholy and out of alignment" (p. 451).[2] A loyal adherent of the regime to which the Hall owed its existence judges differently. The pharmacologist Luca Landucci concluded his account of the demolitions of 1512 with the words: "this saddened all Florence—not the change of government, but that beautiful cabinetwork that cost so much. And

1. *Le Vite,* ed. G. Milanesi, IV (1879), pp. 448 ff. References to Vasari are to this edition, and only the page numbers are quoted in the text.
2. At the very end, on p. 452, modifying his unfavorable opinion, Vasari begins his account of Cosimo I's building program with the words: "His excellency, taking note that the body of this Hall is the largest, most splendid and beautiful in all Europe, has decided to finish off the defective parts."

it meant great prestige and honor to the city to have such a fine
official seat. It amazed all who saw it when an embassy came to
visit the Government, when they walked into such a grand
official seat and before the gaze of such a large council of
citizens. Praise and glory to God forever for all things."[3]

The relevant entries in Landucci's and Cambi's contempo-
rary diaries[4] confirm Vasari's description and give additional
information on the structural history of the Hall. It is quite
possible that this material might be increased if other con-
temporary writers were searched for similar accounts, but in
present circumstances such a search was not feasible.

The State Archives of Florence, notably the Deliberazioni
della Signoria and the Deliberazioni and Stanziamenti of the
Operai del Palazzo, contain valuable records which were re-
peatedly consulted in the nineteenth century.[5] In 1909 K. Frey
published a rich collection of these documents in summarized
form without commentary.[6] Although far from being exhaus-
tive, this publication contains so many important data on the
Council Hall that it is hard to understand why it has not been
used more extensively as a source of information.[7] It should,
however, be borne in mind that the majority of the 258 records
which Frey published do not concern the Hall but refer to
works in the Old Palace or other buildings, and that it is not
always easy to determine the right application of a reference
made in any particular record.

The present building ought to be examined and measured.

3. *Diario Fiorentino,* ed. J. del Badia (1883), p. 333. References to this
publication in the text are by page numbers.
4. Giovanni Cambi, *Istorie,* ed. Fra Ildefonso di San Luigi, in *Delizie degli
Eruditi Toscani,* vols. 20 ff. (1785–86). I have not been able to consult this
publication, and have used only the passages quoted by Lensi.
5. Among others by G. Gaye; by G. Milanesi in his annotated edition of
Vasari; by J. del Badia for his edition of Landucci; by C. V. Fabriczy for
his documents relating to Cronaca.
6. *Studien zu Michelangelo und zur Kunst seiner zeit,* III, C: "Die Sala del
Consiglio Grande im Palazzo della Signoria zu Florenz"; *Jahrb. d. Kgl.
Preuss. Kunstslgn.,* 30, 1909, *Beiheft,* pp. 113 ff. From now on quoted in
the text by the numbers of the documents (doc. 1, 2, . . .).
7. Even Lensi does not seem to have consulted Frey's publication; but he
made some use of the same records.

Only when this is done can the evidence gained by all three categories of sources be properly assessed. Up till now this obvious preliminary has not been tackled; and we still lack an architectural history of the Palazzo Vecchio, based on an adequate standard of scholarship. The only part of the original Hall which is still visible is the center part of the northern wall with the bricked-up window, as was recently pointed out by Charles de Tolnay.[8]

THE HISTORY OF THE BUILDING

The events which followed the invasion of Italy by the French are well known. They led to the fall of the Medicean domination and to a new form of government in Florence. It is only necessary to recapitulate the facts here in so far as they bear upon the new building.[9]

A few days after the French had left the town, on December 2, 1494, all the parties agreed to choose twenty leading men who should govern the town during the period of transition and work out the new constitution. The creation of a Great Council, the Venetian answer to the problem, was first proposed by the jurist Paolantonio Soderini, but violently opposed by part of the nobility (optimates). The idea gained ground only after Savonarola had thrown his whole influence into the balance. On December 12 the Frate told the Florentines from the pulpit: "I believe the Venetians' form of government is very good, and it should seem no shame to learn from others, since that form of theirs was given them by God; and since they adopted it, they have never had a civil conflict."[10] At last the people believed

8. *The Youth of Michelangelo* (1943), figs. 228–29. The author corrects the wrong statement, sometimes found in earlier books, that all the windows to be seen today in the two short walls are the original ones (pp. 106, 216).

9. Among contemporary accounts see especially Francesco Guicciardini's early work *Storie Fiorentine,* ed. R. Palmarocchi (1931), and Jacopo Nardi, *Le Istorie della Città di Firenze,* ed. A. Gelli (1858); among modern accounts P. Villari, *La storia di G. Savonarola e de' suoi tempi,* new ed. (1887). An excellent short survey is given in the introductory chapters of C. Roth's book, *The Last Florentine Republic* (1925).

10. P. Villari—E. Casanova, *Scelta di prediche e scritti di Fra Girolamo Savonarola* (1898), pp. 86 ff.

they had understood the issue; they marched through the streets in procession and loudly demanded the Great Council. The essential laws constituting the Great Council were passed by the "parlamento" on December 22 and 23; and all the citizens of Florence over twenty-nine years of age whose forefathers had been members of the governing bodies and who were themselves not in arrear with payment to the municipality ("netti di Specchio") were to be its members. On the strength of this roll it was estimated that the Council would be composed of 1,500 or more members, and all responsible citizens would thus be enlisted in the affairs of the government. At the same time the "parlamento," i.e., the mass vote of the whole population on the Piazza, was abolished; in the hands of the Medici it had been abused as an instrument of their veiled autocracy.

The decision that a new Hall should be erected was taken simultaneously with the acceptance of Savonarola's proposals of government reform, at the close of the year which had seen the revolution; for the statutes already contained provisional regulations for the period during which the newly created Great Council would still have to meet in the old Sala del Consiglio— today called Sala de' Dugento. In the spring of the following year the new Hall became an urgent necessity; and on May 11, 1495, the Signoria ruled that the "palace officials and overseers" should be appointed within a week, "since space must be provided in view of the large size of the council and the scale of the present hall, which is inadequate for so many citizens without discomfort" (doc. 3). On May 23 the commission of works nominated Antonio da Sangallo as the architect;[11] and on July 15, when the plans for the building had already been agreed upon, Monciatto and Cronaca were appointed foremen builders and Niccolò de' Popoleschi superintendent of works (doc. 4). Vasari alleges that long deliberations were held before the work on the building started, and this statement may contain a germ of truth (p. 448; see also IV, p. 41).[12] The names of Leonardo, Michelangelo, and Giuliano da Sangallo, which occur in

11. For the exact date see docs. 51, 74, 81.
12. An usher of the University of Pisa was, for instance, awarded the sum of two gold florins, July 15, 1495, "pro suo modello sale nove quem fieri fecit suis sumptibus" (doc. 5).

Vasari's list of the artists engaged, should, however, be ignored, because they were away from Florence at this time. The two other artists on his list were actually employed on the building; Cronaca as temporary builder, together with Baccio d' Agnolo, though at a later date; the latter also executed important parts of the woodwork. In order to correct Vasari's misleading account, it should, however, be noted that the documents explicitly refer to Antonio da Sangallo as the designing architect, and not to Cronaca or Baccio d' Agnolo.[13] On May 9, 1497, the Operai del Palazzo confirm that for two years Antonio da Sangallo had been working as their architect to their great satisfaction, and the "Sala Nova" heads the list of his works (doc. 42). He was also in receipt of payments for the models of the roof, the ceiling, and the entire Hall, "models conceived and made by the labor and industry of the said Antonio" (doc. 25, May 19, 1496). Other documents tell the same story (docs. 17, 59). On May 24, 1498, Sangallo was replaced by Baccio d' Agnolo in his office of "capo maestro del palazzo" (doc. 74) — that is, at a date when the building itself was finished and only the furnishing remained to be executed. The two builders who had been appointed in July, 1495, had already left some time earlier, probably immediately after the termination of the actual building operations.

Monciatto and Cronaca were urged by the "operai" to get on with the work at the greatest possible speed. At the same time they were authorized to erect the supporting pillars as they thought fit, "so long as the said pillars are of stone that will last forever" (doc. 4); and Landucci reports that the laying of the foundations had begun as early as July 18, 1495 (p. 112 f). By August 12 part of the vaulted substructure was built and the whole job was finished by October 12 (pp. 114, 117).

Reporting that construction had started, Landucci remarks:

13. In his first edition, p. 859, Vasari mentions the Hall as Baccio d'Agnolo's work. In his second edition, in Baccio d'Agnolo's *Life* (V, p. 351), he says only that Baccio was responsible for the staircase jointly with Cronaca and others; otherwise the whole building is treated as Cronaca's work. Cronaca was a well-known adherent of Savonarola's (cf. Vasari IV, p. 453).

"the Frate kept encouraging them to get on. The Hall was being made on his advice"; and there is a passage in Savonarola's sermon of July 28, 1495, which reads: "Have this Hall pressed forward, and let it move quickly, not like the ox that goes slow. Now speed it up, and everyone who can, lend money to press it forward. . . . Hurrying this Hall is something for the Government to do."[14] The provision of funds to meet building expenses seems to have been one of the major concerns of the authorities, and the Signoria conferred special powers to that effect on the Operai (docs. 6, 9, 10). At the same time efforts were made to find suitable building materials (docs. 11, 26, 30).

In October and November the walls of the Hall were erected; and on December 3, Monciatto was ordered to start work on the roof (doc. 13), the model of which, as we saw, had also been executed by Antonio da Sangallo. Landucci reports on December 15: "The rafters of the Customs Hall were raised up" (part of the Hall was erected above the Customs House) "so as to set the roof on them" (p. 121). This work was finished by the beginning of February, 1496 (see doc. 17). Vasari describes the construction of the roof in detail and praises it highly. Fig. 14 shows an attempt to illustrate his description.

On February 22, 1496, Cronaca is authorized "to break the wall so as to get into the Great Hall newly constructed" (doc. 18). We shall see that this refers to the passage leading from the main story of the old Palace to one of the two entrances to the Hall, or more exactly, to the door in the north end of the west wall. Three days later, on February 25, "The Council went into the new hall, which was finished being covered, but not yet bricked, nor with benches. The door from the Palace into the hall was made; it was blocked out, and nothing was finished yet" (Landucci, p. 126). This official inspection concludes the actual period of construction, which is surprisingly short. Savonarola and his adherents declared that God's angels had had a hand in it.[15]

14. Villari—Casanova, *op. cit.,* p. 172.
15. Benedetto Varchi, *Storia Fiorentina,* ed. G. Milanesi (1888), I, p. 141.

Floor and ceiling remained to be done. Landucci records the completion of the bricked pavement on May 11, 1496: "the bricklaying of the Great Hall of the Council was completed" (p. 131). The ceiling, of timber and coffered, is first mentioned on February 12, when one of the two builders was ordered to supervise the ten carpenters amongst whom he was to distribute the execution of the panels, "according to and just like the model brought before the said overseers by Antonio da San Gallo". (doc. 17).[16] Not more than three months were allowed for the job; but, owing to lack of funds, this term was not kept to, with the result that as late as January 13, 1498, Antonio da Sangallo, at that time the only *capomaestro,* had to be commissioned "to have work undertaken on executing and completing the whole ceiling of the new hall" (doc. 59). The center piece of the ceiling, made by Clemente del Tasso after a model which one of the *operai* had submitted, was not paid for until November 29, 1498 (doc. 71). The cornice around the four walls of the Hall—actually part of the ceiling and, like the ceiling, made of timber—was put in hand in the spring of 1496 (doc. 23) and completed in the summer of 1497 (docs. 52–55).

The second working period, which lasted into the summer of 1502, saw the termination of the furnishing of the Hall; the galleries for the Magistrates, complete with seats, parapets, and steps; the rows of benches for the Council members and the passages leading from the entrance doors to the center of the Hall; the tribune of the Signoria; and the Chapel with pulpit, barriers, and stalls. They will be described later. It seems that some temporary fittings were first put in and gradually replaced by permanent ones. For as early as April 26, 1496—that is, nine months after the beginning of the work—the Great Council was able to meet in the new Hall for the first time. "The Council assembled in the great hall for government functions; the monks of San Marco said the mass there; and Fra Dominico said it and then preached a little . . . the Council stayed until the

16. The document does not make it clear to which of the two artists the order was given, because the two names are confused: "Simon Thomasi alias Monciatto"; Simone di Tommaso was Cronaca's patronymic, whereas Monciatto was called Francesco di Domenico.

twenty-second hour [6 P.M.]" (Landucci, p. 129 f.) .[17] Fra Domenico da Pescia who celebrated mass on that day was Savonarola's most faithful follower, and, as appears from the minutes of the Friar's trial, also his spokesman in audiences with the Signoria in matters connected with the construction of the Hall.[18] From then on the Hall was permanently in use. Savonarola preached his first sermon in it on August 20, 1496;[19] and on the night of May 22, 1498, it was here that he took leave of the two companions who accompanied him to his doom, Fra Domenico whom we have just mentioned, and Fra Silvestro.[20]

A monumental entrance hall was still needed to complete the Hall, and to connect it with the old Council Room. This anteroom was finished in April, 1497, with the exception of the pavement, which was only laid down in 1505 (Landucci, p. 146; doc. 224) . A monumental staircase led from the arcaded court-yard of the Old Palace to the second entrance door of the Hall, also included in the original plans, at the south end of the west wall. This staircase was not built until 1510.[21]

The history of the building should also comprise the story of its demolition. This started as early as seventeen years after work on it was begun. On August 31, 1512, the "Doge of Florence," Gonfaloniere *a vita* Piero Soderini, was forced by the adherents of the Medici to resign. Two weeks later Giuliano de' Medici took possession of the palace without encountering resistance and, with the help of the "parlamento," he abolished the democratic constitution. Consequently the Great Hall lost its function and, as the symbol of the Republic and the visible

17. This opening was preceded by a solemn consecration; see C. Roth, *op. cit.*, p. 57, n. 72: "There is an interesting account of the original consecration in the Ricordanze di Sta. Maria del Carmine, Vol. XIX, in the R. Archivio di Stato di Firenze, its Friars having officiated." Unfortunately the author does not mention the date.
18. Cf. Villari, *op. cit.*, II, appendix, p. 217.
19. Villari—Casanova, *op. cit.*, pp. 253 ff. At that time Savonarola pleaded for a free debate in Council instead of merely voting on prepared lists and proposals.
20. Villari, *op. cit.*, II, pp. 237 ff.
21. Cambi, quoted by Lensi, *op. cit.*, pp. 105 ff.

sign of the people's will to be free,[22] it had to disappear. Not even the name was allowed to survive. On November 22, 1512, the Signoria gave instructions to the *Opera dell' Duomo* for various timbers to be placed at the disposal of the *capomaestro* "to refinish the hall of the said palace that *was* called the hall of the great council." The *capomaestro* of that time was the same Baccio d'Agnolo who had such an eminent share in the erection of the Hall; and the timber was required "for constructing apartments for the Watch of the new hall."[23] The epitaph of the Hall is found in Landucci's diary; his entry of December 12, the last sentence of which was quoted above, reads; "At this time it pleased this new government to break up the hall of the great Council, that is, the woodwork and the many things that had been made at such great expense, and many fine stalls; and they built some little rooms for soldiers and made an entrance from the Salt Office." The Hall of the Great Council was turned into a soldiers' barracks and an office for the levy on salt. In January of the following year the finished parts of Leonardo's mural painting had to be boarded up "to protect them from being damaged"; when this work was paid for the Hall was already called "large guardhall."[24] In October, 1513, Landucci records that the building was seriously damaged: "a truss was broken in the great hall above the Customs House, because they had built over it" (p. 343).

During the short revival of the Republic in 1527–30 the Hall regained its place of honor. The youth of Florence and members of the noble families worked for a day and a night to clean and refurnish it; and on May 21, 1527, it was the scene of the reconstitution of the Great Council.[25] It still witnessed a number of memorable meetings.

After the final destruction of Florentine liberties, Cosimo I chose the palace as his residence and designated the Great Hall as his presence chamber. This decision marks the beginning of a

22. In this sense Macchiavelli said soon after, in his Advice to Leo X: "The Florentine citizenry as a whole will never be satisfied, *if the hall is not reopened.*" (cf. Villari, *op. cit.,* I, p. 319).
23. J. del Badia in his edition of Landucci, p. 333, n. 1.
24. G. Poggi, *Vita di Leonardo da Vinci,* 1919, p. 54, n. 2; also doc. 244.
25. Roth, *op. cit.,* pp. 49 ff.

series of additions and alterations, first by Bandinelli, later by Vasari and Ammannati, and executed not in wood but in more durable materials. New decorations followed and completed the transformation of the Hall into a sumptuous setting for princely display, in which no memory of the original room survives.

THE BUILDING (Figs. 14, 15)

From the fourteenth century, the whole site which the present block of the Palazzo Vecchio occupies was owned by the municipality. But it is not known exactly how far the area behind the trecento building of the Palazzo, down to the Via dei Leoni, was built up during the fifteenth century, nor what types of buildings existed there. Immediately behind the east elevation of the Palazzo rose another municipal building, the low structure of the Dogana,[26] and documents tell us that the new Hall was built partly over the Dogana, partly over the "Corte del Capitano" (doc. 4; Landucci, p. 114). The site of the new building was at a distance of 25 ells from what was then the back elevation of the Palazzo, parallel with it and extending over its whole width. Moreover, the Hall was on the same level as the main storey of the Palace. By these means the new structure was brought into line with the original fabric, and formed a possible new cross axis for a later extension. The oblique lines of the south and north elevations, one facing the street opposite the Romanesque Church of S. Piero a Scheraggio, the other toward the Mercatanzia, had to be continued for practical reasons, with the result that the short sides of the Hall diverged from each other toward the East, that is, away from the Palace, and, if the existing plans are reliable, at unequal angles. Consequently the ground plan of the Hall had roughly the shape of a trapezoid. Apart from this irregularity, the position of the Great Hall is reminiscent of the Saloni on the Piano Nobile of Venetian palaces which extend from one street front to the other.

There was, however, yet another irregularity. The long sides of the Hall are not quite parallel. They converge slightly

26. See the map of Florence of 1472 in Cod. Vat. Urb. 227, in A. Warburg, *Ges. Schriften,* I, fig. 42.

toward the north, probably because the elevation of the Dogana over which the west wall of the Hall was erected did not run quite parallel to the back elevation of the Palace. The east wall of the Hall was built parallel to the front of the Palace so as to redress the balance and give the whole enlarged block, Palace and Hall, a regular shape.[27]

Vasari's measurements of the ground plan are as follows: depth of the Hall, 38 ells; length of the west wall, 90 ells; the short sides deviate from the rectangular by 8 ells, from which follows, length of the east wall, 106 ells. As exact measurements of the present Hall do not exist, Vasari's figures must be checked with the help of documents. Payments made on August 3, 1497 (docs. 52–55), indicate that altogether 265 ells of cornice were required. If we take the total of Vasari's figures for the four walls and assume that the cornice projected by half an ell, the required length would be 271 ells. This small difference can be partly explained by the two deviations from the geometrically regular form which we have just discussed. As the long sides converge, the north wall appears to have been 2 ells shorter than the south wall; and as the angle of the northeast corner is more obtuse than that of the southeast corner, the east wall has about 1 ell less than the length that Vasari allows for it. If these calculations are correct they account for half the difference between the two figures; and the rest is negligible. The diagrammatic drawings published here follow Vasari and are, in the light of these modifications, certainly not quite exact. But the small inaccuracy hardly counts against the enormous dimensions of the Hall.

The height of the Hall is implicit in Vasari's statement that he added 12 ells to the height and that his new room was 32 ells high, leaving 20 ells for the original room. These figures are correct.[28] The 12 ells of added height recur in the contract with

27. I.e., to make the front and back elevations parallel. In this the architects succeeded.
28. Though in other writings Vasari makes different statements concerning the increased height of the Hall. The figure of 12 ells was proposed by Michelangelo in 1560; cf. *Lettere di M.A.*, ed. G. Milanesi (1875), p. 553.

the architect of April 23, 1563;[29] and Vasari himself, writing at a time when the measurements of the building must have been still fresh in his memory, says in a letter that the new room was 33 ells high including the depth of the coffers.[30]

Taking the Florentine ell at 58.4 cm., the measurements in meters are these: depth of the Hall, 22.19 m.; length of the west wall, 52.56 m.; length of the east wall, 61.9 m.; height of the Hall, 11.68 m.[31]

Vasari does not mention the wooden cornice which surrounded the Hall below the ceiling. It was the work of four wood carvers: Antonio da Sangallo, Bernardo della Cecca, Baccio d'Agnolo, and Lorenzo Ciccheri—with the exception of the last named all distinguished masters of their craft—each of whom executed the same length, 66¼ ells (docs. 52–55). To judge by the low fee—42 soldi per ell (docs. 23, 28)—the cornice must have been simple in form; and in spite of its being called "cornicione" in the documents it can certainly not have been a triple cornice like that of the old Sala del Consiglio. We have assumed that it was 1 ell high and projected ½ ell—these are the minimum measurements. When Vasari represented the old Sala del Consiglio in one of his history paintings on the ceiling of the rebuilt Hall,[32] he put in a number of features from the Great Hall, among others the wooden cornice.

Leaving aside the construction of the roof (see p. 99), we turn to the ceiling. This is how Vasari describes it: "When the rafters thus made had been hoisted up and placed six feet apart, and the roof likewise installed in a very short time, Cronaca had

29. G. Gaye, *Carteggio inedito,* III (1840), p. 104.

30. Letter to Cosimo I of November 23, 1564; Gaye, *op. cit.,* p. 156.

31. Baedeker's *Oberitalien,* 1928, p. 520, gives the following measurements of the rebuilt Hall: breadth, 22.4 m.; height, 18.7 m. (exactly 32 ells); length 53.7 m. (breadth and height erroneously reversed). Assuming that these measurements are correct they confirm Vasari's figures. The difference in length can be accounted for by Bandinelli's alteration which caused the north wall to deviate slightly from the rectangular, with the result that even today the east wall is a little longer than the west wall. Baedeker probably uses the higher figure; if the available ground plans are accurate the difference corresponds approximately to the actual one.

32. Reproduced by Lensi, *op. cit.,* p. 240.

the ceiling nailed in, which at that time was made of simple timbers and divided into squares, each eight feet long on every side, with a molding all around in the form of a frame and few details, and a plane surface as thick as the beams was set all the way around the squares and the whole, with bosses on the crossings and corners of the whole ceiling." (p. 449 f.) Vasari also mentions that it was intended to gild the ceiling, but this was postponed until it was too late. Since we know that the beams were laid at intervals of six ells,[33] the arrangement of the ceiling can be worked out from this figure with the aid of Vasari's description. It must have contained one hundred coffers, ten of which could not be squares. This is confirmed by documents. The deed of commission of February 12, 1496, twice mentions this number of a hundred coffers (doc. 17) ; and one of the later payments refers to "a square . . . without the rosettes" (doc. 56) —i.e., an incomplete coffer, since the complete ones had rosettes in the center. (The reason why Vasari does not mention the rosettes is that he takes them for granted. My drawing shows neither the rosettes of the coffers nor the bosses, or borchioni, at the points where the beams intersect.) By comparison with his own new ceiling Vasari calls the old one "ordinary and simple and not fully worthy of that hall" (p. 452) ; but judging from the comparatively high rate of 23 lire or more paid for each of the coffers measuring 16 square ells, they cannot have been quite plain. Some of the work was executed by well-known artists such as Baccio d' Agnolo, Bernardo della Cecca, and Clemente del Tasso (docs. 56, 62, 64, 66) . The moldings round the coffers which Vasari calls "ricignimento attorno di cornice," were denticled (doc. 34) . We have allowed half an ell for the width of the moldings, and one ell for that of the beams and cross beams.[34]

Vasari makes no mention of the center piece, for which Clemente del Tasso was paid 180 lire. According to the documents (66, 69, 71) it must have covered a space equal to that of four coffers, and showed the coat of arms of the people in the

33. Confirmed by the contract for the new ceiling of 1563; Gaye, *op. cit.,* p. 105.
34. See again Vasari's ceiling picture.

circular center and the eight coats of arms of Florence in the
crossarms.[35] A general idea of the effect of this ceiling can be
gathered from the contemporary hall in the Scuola del Santo at
Padua in which, however, the center piece is missing.

In speaking of the fenestration Vasari relates that each of the
short walls had three big windows and goes on to say: "But
when it was all finished, they found that this hall had turned
out ill lit, because of its immense size, and relative to its great
length and width of body, dwarfish, and with little release
upward, and in fact out of proportion in almost every way, and
they tried to improve it, but it didn't help much, by putting
two windows on the east side at the middle of the room, and
four on the west side" (p. 450). It is not surprising to hear that
the Venetian method of lighting a long room by windows in the
short walls only could not be applied to a hall of these dimen-
sions. Vasari observed that the lights in the two long walls were
later additions, and the documentary evidence proves him to be
right. Work on the west windows was still going on as late as
May 20, 1496 (doc. 27). It is also proved that windows existed
in the south, north, and west walls, and we know how many
there were in each (docs. 159, 167, 176); there is therefore no
reason to doubt that Vasari's account of the east wall is also
accurate. This was the only side with an unimpeded view; and
the fact that it had only two windows, and that these two were
placed near the center, seems to indicate that from the start the
rest of the wall space was reserved for great mural paintings. We
shall not be far wrong in assuming that all the windows were
like the walled-up window—the only one still visible from
outside in the middle of the north wall[36]—in shape, size, and
distance from the floor.[37] The circular lights above the win-
dows were fairly large to allow the ceiling zone to be lit;
stylistically they derive from Brunelleschi. It has here been
assumed that the windows were partitioned like those of the
Old Palace, and in accordance with contemporary practice;

35. For a list of the coats of arms of Florence see Lensi, *op. cit.,* p. 35.
36. See above p. 96 and n. 8.
37. Doc. 27 indicates that the west windows at any rate had an arched
top.

compare, for instance, Cronaca's windows in the Palazzo Strozzi. The horizontal distribution of the windows was determined by the decorative scheme (see below).

The Hall was entered by two doors, not mentioned by Vasari, one at each end of the west wall. The entrance at the north end led to the Hall from the main floor of the Old Palace, and a lobby shaped like a broad passage connected the old council room with the new one. Door and ricetto still exist, the door lintel raised and the ricetto newly decorated in the second half of the sixteenth century. Landucci says on April 21, 1497, of the original ricetto: "they finished setting up those marble columns on the doorway from the Palace to the great Hall, on the Chamber of Commerce side" (p. 146). J. del Badia remarks at this point that the Signoria had asked for the columns to be brought from the Palazzo Medici as early as December 9, 1495. Stones of different kinds, all highly polished, were used for the incrustation of the lobby (docs. 46, 47); and a pavement of hexagonal bricks was laid down later (doc. 224). The door at the south end of the west wall gave access to the Hall from the street; a staircase led up to it which opened from the arcaded court of the Palace;[38] and at the same time the Palace was given a new side entrance facing the town, replacing the original door which had been walled up since 1380 (Landucci ad August 22, 1508, and November 12, 1509, pp. 287 f., 299). The staircase, which was later sacrificed in the course of alterations, was described by Vasari as follows: "After that Cronaca made . . . a grand staircase, twelve feet wide, in two flights with a turn, by which to go up to this Hall. It was richly ornamented in stone, with pillars and Corinthian capitals and double cornices and arches of the same stone, semi-circular vaults, and windows with columns of veined marble and capitals of carved marble"; but he calls it "awkward and too steep, considering that it could have been made a gentler incline" and praises his own new staircase (p. 451). According to Cambi the stairs were not built until 1510, and so Cronaca, who died on September 27, 1508, cannot have been responsible for them; one is inclined to think instead of Baccio d'Agnolo, who at that time was the sole

38. See above p. 69.

"capomaestro del Palazzo." As a matter of fact Vasari mentions the staircase in the first edition of his book as Baccio d'Agnolo's work.[39]

THE FURNISHING

Vasari's description can here be amplified by primary sources. (The operative words are in italics.)

"After that, to give it its final finish [i.e., the Hall], they rapidly made on the brick floor . . . a wooden *gallery* all the way around the wall of it, six feet high and broad, with seats as in a theater and banisters in front, on which gallery all the magistrates of the city had their places . . . and in the middle of the gallery and at the corners were certain passageways with six steps, which gave convenient access to the little tables for collecting the ballots."[40] Vasari's expression implying that the gallery continued round the whole room should not be taken quite literally. In addition to the unavoidable break caused by the two entrance doors at the corners of the west wall, the gallery was interrupted at the centers of the two long walls. It had not been finished by the autumn of 1496 (doc. 34) when reference is made to the platform and the parapet; the last fee for the banisters is not paid until the spring of the following year (doc. 45). The stone gallery outside the west and north elevations of the Old Palace (dating from 1323)[41] gives an idea of the appearance of the timber gallery inside the Hall, except

39. "He made the staircase that leads to the said hall, with a very beautiful stone decoration" (p. 859). Compare also p. 98, n. 13 above. The papers of the Operai del Palazzo for the years 1506–12 are missing; see Frey's note to doc. 244.

40. The last sentence comes at the end of the description, after Vasari's discussion of the benches in the center.

41. This *ringhiera* in front of the Palazzo, which was not destroyed until the nineteenth century, is represented on the following paintings among others: D. Ghirlandajo, "Confirmation of the Franciscan Order," SS. Trinità (detail in Lensi, *op. cit.*, p. 31); Piero di Cosimo, "Portrait of a Warrior," Nat. Gall., London (detail in Sir K. Clark, *More Details*, 1941, pl. 87); G. Stradanus, "I fuochi di S. Giovanni," Palazzo Vecchio (detail in Lensi, *op. cit.*, p. 277). Doc. 33 refers to this *ringhiera*.

that the latter had a balustrade in front, not a stone parapet, and, being less deep, it had space for only two rows of seats instead of three. The steps alone were of stone; and the combined evidence of payments for them shows that some were 4 ells wide (docs. 40, 65). Probably the steps led up to the level of the second row of seats. Their number implies that the height of the whole gallery, including the seats, was 3 ells, that is to say the platform itself was only about half as high. It must be assumed that along the walls destined to have mural paintings the second row of seats had backs, or that there was at least an adequate height of empty wall space left behind them. (The balustrade and steps are not shown in our schematic drawings.)

"In the middle of the east wall was a higher *loggia,* where the eight Councilmen sat with the Chairman; and on the sides were two doors, one giving access to the Segreto and the other to the Specchio." Vasari may have known this loggia only by hearsay; but it is the topic of a number of documents, and probably also the main object of Landucci's lament on the destruction of beautiful woodwork. It was only finished in the summer of 1500. Not much is known of its appearance; in my drawing I have given it as simple a shape as possible, gained from documents concerning similar loggie.[42] It is possible that the loggia, like the gallery, was placed on a raised platform;[43] and its back wall may have been decorated with inlay, for Domenico delle Tarsie was paid several times for work of this kind in the Hall (docs. 44, 76, 80a, 86). Its two side barriers ("aliette"), as well as its entablature with architrave, frieze, and cornice, received special attention. They were by Baccio d' Agnolo, who received a particularly high remuneration for them (docs. 77, 84, 95, 99, 124). The entablature was also gilded (doc. 96). The very fact of its existence is proof of the considerable height of the structure. Its breadth is indicated by the document in which the fee for the entablature was fixed; it was 12 ells (=7 m.; docs. 95, 99). This seems quite a normal width for a loggia which had to accommodate a middle seat for the Gonfaloniere and four seats

42. See for instance Gaye, *op. cit.,* I, p. 576, and Vasari's ceiling picture.
43. It seems to be a point in favor of this view that it is occasionally called "Udienza" (doc. 124), or "il Tribunale" (J. Nardi, *op. cit.,* I, p. 430).

to each side of it for the eight Signori. Its formal significance is that it relates to the center piece of the ceiling. The two doors right and left of the loggia led to rooms connected with the business transactions of the Council: in the "Segreto" votes were counted;[44] in the "Specchio" registers were kept of persons who were debtors to the municipality and therefore constitutionally excluded from membership of the Council.[45] On January 13, 1498, Antonio da Sangallo was commissioned to execute "two small concealed doors—well and with all due diligence and beauty" (doc. 59). The diminutive is deceptive: it does not necessarily mean that the doors were small. Another "little door" belonging to a relatively small hall in the Old Palace, mentioned in a document (21), required 15½ ells of stone framing. Only 12 ells would be needed for the door in our drawing.

"In the wall opposite this, to the west, was an *altar* where mass was said . . . and beside the altar the pulpit for preaching." The documents mostly call this middle section of the west wall "chapel"; it was dedicated to the Holy Virgin (doc. 127). A temporary altar was erected as soon as the Hall was opened (cf. Landucci, pp. 129 f.). Later, in January, 1498, Antonio da Sangallo received an order "to place and set up the altar so that it may stand forever" (doc. 59). At the end of another period of four months, on May 18, he and Baccio d'Agnolo were given a contract for the whole "decoration and labor in wood for the chapel and on the chapel or altar of the new hall of the great council, according to the model signed by the hand of Antonio dei Paganelli, one of the said overseers of the palace" (doc. 68). The measurements—4.44 meters by 3.04 meters—of Fra Bartolommeo's unfinished altarpiece provide the scale for the size of

44. I.e. "gold" or "silver" balls which were thrown into big narrow-necked urns in the Hall, "come si fa a Venezia"; see Landucci on June 25, 1496, and J. del Badia's note, p. 134.
45. These rooms were built on to the Hall. Ch. de Tolnay (*op. cit.*, p. 107) assumes that the right-hand door still exists. This is not likely. The door in question, about 4 ells more to the center than the one on our drawing, is exactly in line with Vasari's new entrance door in the west wall, and the position of this entrance door was presumably determined by other considerations.

the chapel.[46] Though this picture was not commissioned until 1510, the gilt frame which it was to fill had already been executed, and it appears to have been a masterpiece. It was designed by Filippino Lippi, its execution took Baccio d' Agnolo four whole years, and a price committee decided in June, 1502, that he should be awarded the very high fee of 280 gold florins (=1,960 lire) for it (docs. 127, 129). In Vasari's time it was still in a private collection at Florence (III, p. 475). Otherwise the published documents do not tell us much about the chapel; we only have a casual reference to wooden candelabra, also made by Baccio d' Agnolo (doc. 72). The pulpit (bigoncia), of which a certain likeness is preserved in Vasari's ceiling picture, was used not only by preachers during the service but also by political orators. The chapel seems to have been enclosed by barriers at the sides, and by a balustrade in front (docs. 70, 72, 104);[47] and benches, richly ornamented, "with banisters and inlay in walnut wood, where the judges and the ten of the *balia* sit"—also the highly paid work of Baccio d' Agnolo—were standing in front of it (docs. 127, 130, 132). After the Signoria, the Ten of the Balía formed the most important authority of the Republic. The conduct of the war against Pisa and other rebel towns was part of their office. The benches in this second loggia had altogether a length of 42 ells; it is therefore likely that they were arranged in three rows. This number would be in accordance with the documentary account of their position "ante altare Virginis et residentie Dominorum," and the whole feature corresponded, like the Gonfaloniere's loggia, to the center piece of the ceiling.

"Then in the middle of the room were *benches* in ranks and files for the citizens."[48] Benches are mentioned several times in

46. The measurements of the altar on our drawings are those of the former High Altar of S. Lorenzo in Florence; compare Michelangelo's ground plan (with indication of the measurements) of the choir chapel of S. Lorenzo, in Casa Buonarroti (Frey 68).

47. The "aliette" mentioned in the last document cannot be those of the Signoria's loggia, as these had already been paid for six months earlier; I take them therefore to refer to the Chapel.

48. At this point occurs Vasari's sentence on the passages through the benches, quoted above in connection with the *ringhiera*.

payment notes (docs. 43, 50, 59, 63, 137). They were arranged in aisles, separated by wooden barriers to which more seats were fixed (docs. 39, 88, 136, 137, 214); Landucci emphasizes the beauty of these barriers (p. 333). We have accounts of two such passages between the benches: one is described as leading to the chapel from the main entrance on the Palace side; the second as leading from the chapel to the seat of the Signoria—that is to say, it was a central passage which divided the Hall into two halves (docs. 59, 159). (The benches of the members and the passages are not shown in fig. 15.)

One more detail should be mentioned. Landucci relates: "In this hall two marble plaques were set up, one with verses in Italian, one in Latin. The Italian one said in substance: Who would have a mass meeting would take the rule from the people. The other, which was in Latin, said that such a Council was of God, and ill will befall whoever seeks to harm it" (p. 126).[49] A. Lensi concluded from documents that these inscriptions were placed above the entrances on red marble slabs.[50] The date of the resolution is noteworthy; it was taken on the day of Savonarola's condemnation, May 22, 1498. This seems to be more than a coincidence. Probably the act was meant to be understood as evidence of the government's intention to honor the Frate's political bequest in the face of his condemnation by the Church. For the inscriptions express the two fundamental tenets of Savonarola's Christian democracy. They are a monumental extract from his treatise "On the Rule and Government of the City of Florence," written a few months before his death—in spite of the Church ban—at the request of the Signoria.

THE RELATION OF THE HALL TO ITS VENETIAN MODEL

Like the reform of the constitution, the erection of the Great Council Hall was inspired by the Venetian model. This is surprising because conditions in Florence were so different from

49. Compare also B. Varchi, *op. cit.,* I, p. 267.
50. *Op. cit.,* p. 81 and note.

conditions in Venice. The Sala del Maggior Consiglio was conceived as a self-contained monumental building with splendid fronts on three sides, and it was erected in slow stages. When finished, it became the cause, model and nucleus for the rebuilding of the Venetian seat of Government—a process which seems expressive of the idea that the Great Council was the cradle, and the Council Hall the symbol, of all the power in the state. All this was inspiring but could not be exactly imitated. In view of the speed with which the Florentines wished to proceed, it was not possible to aim at more than the erection of a simple, serviceable building; and this building had to be coordinated with the existing monumental structure of the Government Palace. The way, however, in which it was done permitted the hope that by continuing the side fronts of the Palace the two independent blocks might be combined into an organism which would be as suggestive as the seat of the Venetian government. And the admiration for this model was so profound that the Venetian building—one and a half centuries earlier in date—was copied not only in its layout and proportions but even in all its measurements. (The oblique side walls of the Florentine Hall, the only essential difference from the Venetian model, were designed in view of the projected union between the Hall and the Palace.) The Sala del Maggior Consiglio is 24 meters wide, 54 meters long, and was originally 11.2 meters high; compare these figures with the measurements of the Florentine Hall (p. 105).

The different position of the Florentine Hall within its architectural surroundings gave it, however, a completely different artistic character. The Sala del Maggior Consiglio at Venice is a longitudinal building.[51] It is entered by doors at the two ends of one of its short walls and from there the view opens on the whole length of the hall. Originally a lobby gave access

51. The original appearance of the Sala del Maggior Consiglio can be quite well deduced from the well-known engravings by P. Forlani and G. B. Brustolon. Thanks to the conservative character of the Venetians the renovations of the sixteenth century did not change the essential features of the hall.

to it. From all parts of the room the eye was directed toward the entrance wall. Here was the center of gravity of the hall: the Bancale di San Marco, the Doge's seat, and the place of the Signoria. This tribunal, on a high platform and with strongly projecting side wings, occupied the space between the two entrance doors; above it the whole width was filled with Guariento's fresco. This wall had therefore no windows, but it received ample light from three sides. The remaining three walls were treated uniformly. The lower part was filled with two rows of seats, resembling stalls, for the magistrates; above them, between large windows, history paintings covered the walls up to the cornice. In the middle of the hall the seats of the council members were arranged in nine double benches through the length of the room.

The Sala del Consiglio Grande in Florence was a broad room, accessible only through doors at the ends of one of its long walls. The oblique slant of the two short walls away from the entrance of the room increased the effect of its breadth. The visitor faced a wide wall, well lit in comparison with the rest and unbroken down to the central bay. By whichever door he entered, one of these two great wall expanses would be opposite him; the effect must have been that of standing in front of a façade, terminated by the strong accent of the central bay which was emphasized by the organization of wall, ceiling and floor. The benches for the members were also orientated toward the center. This center attracted the eye and must have drawn the visitor to move toward it, down the length of one of the "façades" (from the right or the left); then, after the middle section, followed another similar "façade." This long sequence, with a minimum of architectural detail, made the Hall look bigger than its Venetian model. Vasari's contention that the Florentine building was actually larger in size (p. 451) is not borne out either by its superficial or by its cubic dimensions.

Built for practical purposes and in its initial period left austerely bare, the character of the Hall was in keeping with Savonarola's ideals. Later, its monastic severity was softened by the furniture, without being abandoned in principle. The

dominating character of the east wall was to be emphasized by
the choice and arrangement of its decoration.

<h2 align="center">THE PROJECTED DECORATION</h2>

Vasari relates that the citizens planned to have their Council
Hall gradually decorated with paintings (p. 451). This idea is
not new, especially in Florence; it was also in the tradition of
Italian council halls in general and therefore probably adopted
at the same time as the decision to build the Hall. The known
particulars of the works planned show that they were deter-
mined by the same political and religious ideals as those of
which the enterprise as a whole bore the stamp. Even during
the first period when apparently the spending of large sums on
works of art was not yet envisaged, these principles held good.

On October 9, 1495—at a date when only the substructure of
the Hall was finished—the Signoria resolved to demand seven
statues from the trustees of the Medici estates for use in the
Palazzo della Signoria, "or in the new hall which is being built
at present next to the said Palace of the Signoria."[52] It is
interesting to note which statues were chosen: "two statues of
bronze, one representing David, which is in the courtyard of the
house of Piero de' Medici, and the other representing Judith,
which is in the garden of the said mansion . . . and two statues
of skinned men of marble stones or another mixture, which are
in the said garden near the door; and three other statues of
Hercules, fixed on the wall of the main hall of the said mansion
on certain panels." Judith and David were generally understood
to be religious and moral symbols which now received an added
political significance. That the Florentines accepted the figure
of Hercules in the same sense is proved by the fact that since
1507 they planned a Hercules as counterpart to the "Gigante."
But the requisitioned statues did not find a place in the Great
Hall. Donatello's bronze David[53] was erected in the center of

52. K. Frey, *op. cit.,* Section A, doc. 7.
53. The Signoria already possessed the other famous bronze David from
the Medici collections, by Verrocchio. The figure was bought for 150 gold
florins in 1476 and erected in front of the entrance to the office rooms, the
so-called "catena"; Gaye, *op. cit.,* I, p. 572.

the arcaded Palace court, his Judith on the stone *ringhiera* to the left of the main entrance; later the figure had to make room for Michelangelo's David and was removed to the Loggia dei Lanzi (Landucci, pp. 119, 121, 276). The Hercules figures were brought to the Old Council Hall in the spring of 1497 (doc. 48). Nothing is known of the fate of the two remaining sculptures representing Marsyas.

Five days later, the resolution of October 9, 1495, was followed by another: "All heads of marble or bronze existing in the house of Lorenzo di Piero de' Medici are to be delivered to the overseer of the Florentine palace for the new hall of the said palace" (doc. 8). Twenty-six busts and a bronze horse's head are listed among the objects transferred on the same day. It is not known if any of them ever arrived in the new Hall;[54] Landucci does not mention having noticed them there.

Finally on July 14, 1496, a strict order was issued to all Florentines to the effect that all works of art, architectural ornaments, and whatever objects they might have bought or looted from the Medici Palaces should be declared to the *operai* within a week; from then on the objects were to pass into the possession of the Opera del Palagio "to adorn and ornament the new great hall in honor of this most flourishing people" (doc. 30). We do not know what results this order had; probably the requisitioning of a famous ancient marble bust from one Antonio Masi (doc. 32) is connected with it.

It may be mentioned that on the occasion of the famous inquiry concerning the erection of Michelangelo's David, on January 25, 1504, the goldsmith Michelangelo di Viviano, Bandinelli's father, expressed the following opinion: "to me the location in the Loggia (dei Lanzi) seems good; but if that

54. But it is very likely that the "nine ancient images and/or faces in the keeping of the overseers, i.e., seven of marble and two of wax," which were sent to the sculptors Leonardo and Zenobio del Tasso on November 8th, 1498, for restoration (doc. 82), were taken from this lot. The seven busts were intended as a present for the Maréchal de Gié; see the Signoria's letter of November 10th, 1498, published by Gaye, *op. cit.*, II, p. 52 f. It is well known that soon after, the same French statesman asked for a replica of Donatello's bronze David; as a result of his request Michelangelo was ordered to make such a figure.

didn't suit, then in the middle of the hall of the Council."[55]
But, as is well known, this suggestion was not accepted.

The Altarpiece

The first step toward decorating the Hall in accordance with
the agreed plans was taken when Savonarola was still alive; it
was the ordering of the altarpiece. The document dated May
18, 1498 (doc. 68), in which Antonio da Sangallo and Baccio d'
Agnolo were entrusted with the decoration of the chapel, con-
tains also this passage: "they in fact commissioned a painting
and the ornamentation of a painting . . . from Filippo son of
Fra Filippo, painter, of Florence, for the price and fee to be
announced by the overseers in office at the time." When in the
end the order was given to Fra Bartolommeo it referred to an
earlier contract which does not seem to have been preserved; its
terms were presumably similar to those of Andrea Sansovino's
contract, which will be discussed presently. The order was given
to Filippino Lippi on the strength of his "modello," probably
the drawing of which Vasari says: "He made (in the Palazzo
della Signoria the altarpiece of the Hall where the Committee
of Eight met [and] the drawing for another large altarpiece
and its ornamentation for the Hall of the Council; this drawing
at his death he had not begun to turn into a painting" (III, p.
474 ff.) The word "ornamentation" used both by Vasari and in
the document means that Filippino also designed the altar
frame, which was carved by Baccio d'Agnolo, as Vasari says
explicitly in his Life of Baccio d'Agnolo.[56] Two years later, on
June 17, 1500, Filippino received the first installment of 205
lire "applied to the painting of the altar" (doc. 98). After that
we hear no more of his work and on April 14, 1504, he died. It
was no wonder that the choice had fallen on him. Twelve years
earlier he had painted the altarpiece of the old Sala del Con-
siglio to the great satisfaction of all.[57] This is the picture now

55. *Lettere di Michelangelo,* p. 622.
56. First edition, p. 859; second ed., publ. Milanesi, V, p. 351.
57. Compare the documents published by G. Poggi, *Riv. d'Arte,* 6 (1909):
305.

in the Uffizi, which is the first of the two mentioned by Vasari. It measures 3.55 meters by 2.25 meters. The new order aimed at something similar only on a bigger scale.[58]

More than six years after Filippino's death Fra Bartolommeo received the order for the picture "which on account of his death then following could not be painted by him." This is a step in the long-delayed process of restoring the position of the monastery of St. Mark which had suffered humiliating restrictions since Savonarola's death. Doubtless this painter was the best man in Florence for the task; but only the first stages of his painting (fig. 16) were completed[59] when the fall of the government cut his work short. In his thorough appreciation of the picture (IV, pp. 198 f.) Vasari makes an interesting remark on its program. He says: "in which appear all the patron saints of the city of Florence, and those saints on whose days the city has had its victories." This program also describes Filippino's altarpiece for the old Council Hall; besides the three patrons of Florence, S. Giovanni Battista, S. Bernardo, and S. Zenobio, it represents San Vittorio, on whose day (July 29) the Battle of Cascina was fought in 1364.[60]

C. Roth discovered that a short time before the siege of Florence began in 1529, the Signoria ordered that Fra Bartolommeo's altarpiece, in its unfinished state, should be set up in the Hall.[61] This act is an epitome of the whole history of the Council building.

58. Albertini's "Memoriale" of 1510 says: "In the new large hall of the great council . . . is an altarpiece by Fra Filippo" (ed. Jordan, p. 441). It is tempting to assume that Albertini confused the names and really meant the altarpiece by Filippino. But in the preceding passage he calls the altarpiece in the old Sala del Consiglio correctly "la tavola di Philip." Another explanation would be that a panel by Fra Filippo had temporarily taken the place of the mising altarpiece in the Great Hall. In any case no other mention of this picture is known.

59. For all information on Fra Bartolommeo's panel (today in the Museum of S. Marc's) see H. v. d. Gabelentz, *Fra Bartolommeo,* I, 1922, pp. 64 ff., 159 ff.

60. As Fra Bartolommeo's panel is unfinished the Saints cannot all be identified.

61. C. Roth prints the text of the resolution, dated March 29, 1529, *op. cit.,* pp. 106 ff., and 113, n. 127.

14. Reconstruction of the Hall of the Great Council of Florence before 1512.

15. Hall of the Great Council of Florence, ground plan and section.

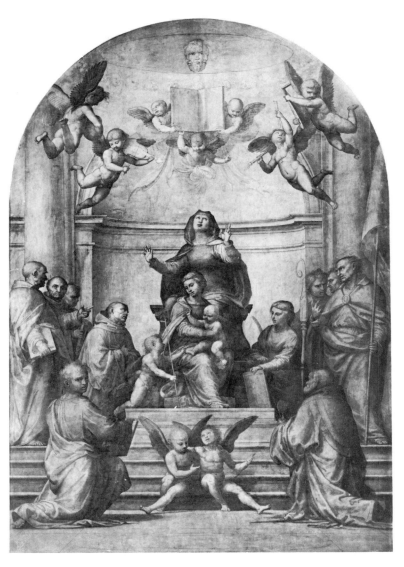

16. Altarpiece, Fra Bartolommeo. Florence, Museo di San Marco
Courtesy of Art Reference Bureau

The Statue of the Savior

Following the order for the altarpiece, but not before the whole equipment of the Hall had been completed, a life-size marble statue of the Savior was commissioned; its place was to be on the entablature of the loggia of the Signoria, above the head of the Gonfaloniere. It appears that the religious works of art were to have precedence over the others. The contract, dated June 10, 1502 (doc. 128), records the temper of the period so faithfully that its relevant passages are well worth reprinting:[62]

Honorable and worthy overseers of Works of the palace of the Florentine people . . . having heard the reputation and the excellence of the skill of master Andrea son of Nicolo of Monte San Savino a district of the Florentine territory, sculptor and noble master of sculpture, and having seen a certain model made by his own hand of San Salvador, and knowing that an image of the said San Salvador of white marble, large but in the likeness of this San Salvador, would fit very well in the great hall of the council of the Florentine people over the cornice of the throne of their lordships the high councillors and in the middle of the said cornice above the seat of the lord high Chairman, in eternal memory of the day of San Salvador when his feast is celebrated, and by the power of the authority of the same . . . decided and commissioned and placed with the said Andrea the image of the said San Salvador of white marble, large but in the likeness of this likeness of the said San Salvador with his own hand and not through others and according as it is shown in the model made by him, in which he is to be restricted to the said San Salvador and not to other images and other ornamentation of the said model, to which model of the said San Salvador and image of San Salvador they relate and refer, and to work and finish the said image well and with the greatest diligence, vigilance and perfection with his own hands. . . .

62. G. Poggi published the documents relating to this order [*Riv. d'Arte*, 6 (1909) : 144 ff.] at the same time as Frey. In our quotation of the text of the contract we follow in some places Poggi's reading.

The regulations which follow stipulate that a committee should fix the fee for the completed statue; that all expenses for marble, etc., should be borne by the artist; and that he should have to refund all advances made to him if he left the work unfinished.

This order was inspired by two ideas. Its explanatory clauses underline the fact that in 1494 Florence was liberated from the yoke of the Medici on San Salvador's day (November 9). One of the earliest resolutions of the new Signoria—published on December 2, 1494—proclaims this day as a perpetual holiday: "Let it be consecrated in perpetuity and kept like Sunday, and a solemn mass in the Cathedral is to be caused to be celebrated every year on that day, at which the Councillors and associates then in office are to be present" (doc. 1). The statue was to be the means of keeping its significance alive in the memory of the Council members. Coupled with the idea of this festival is the conception that none but Christ is the new sovereign of Florence. A few months after the revolution Savonarola said in a sermon: "This new head is Jesus Christ; he wants to be young king!"[63] During the short revival of the Republic (1527–30) this cult had gained so much ground that Christ was formally elected King of Florence by the Great Council at the suggestion of the Gonfaloniere, and this election was commemorated in an inscription over the Palace entrance.[64]

The statue might therefore have become the ideal center of the whole room. The choice of the artist may have been a sign that public taste was beginning to change; perhaps the appointment was already due to the personal influence of Piero Soderini, whose election for life as the head of the government took place about that time. The new style of the High Renaissance was represented in Florence by artists who had made their reputations outside their native city. Andrea Sansovino had returned from Portugal only a short time before. He was passed

63. Villari, *op. cit.,* I, p. 349.

64. Roth, *op. cit.,* pp. 76 f., 141. A similar marble slab was set up over the entrance door to the Chapel in the presence chamber of the Signoria; see the payment of January 31, 1530 (doc. 254).

over when the marble statue of David was commissioned in the
summer of 1501. But not many months before he received the
order from the Signoria, the *Opera del Duomo* had approved
his design for a group of Christ's Baptism, which was to be
erected over the South door of the Baptistery.[65] The contract
concerning the statue of the Savior shows that again Sansovino
had not a single figure in mind, but a group in an architectural
frame, probably a tabernacle. The *operai* rejected this project,
of which unfortunately nothing more is known. On the date of
the contract the artist received an installment of 10 gold florins
(doc. 133) ; a week later he presented his guarantor in accor-
dance with the terms of his contract (doc. 134) ; and the statue
is mentioned only once again: on December 31, 1503, an
expense is recorded of three florins "for transporting a marble
block from the port of Signa to Florence to the house of
Sansovino the sculptor" (doc. 154). It is not known if the artist
ever started to execute the statue in marble. He was called to
Rome by Pope Julius II in 1505, at the same time as Michel-
angelo, and from then on he was lost to Florence as an artist.

The Mural Paintings

The efforts of the Signoria to enlist the best talents of Flor-
ence for their new Hall culminated in the invitation to Leo-
nardo and Michelangelo to decorate it with monumental fres-
coes. In Vasari's accounts of these orders the first sentences—
identical in his two editions—are characteristic, and probably
not without real foundation:

> Therefore, through the excellence of the works of this most god-
> like craftsman [Leonardo] his reputation had increased so much,
> that all people who enjoyed the art, in fact the whole city, wished
> that he should leave it some memorial, and everyone discussed
> having him make some great and notable work, whence the public
> might be adorned and honored by all the talent, grace and judg-
> ment that was recognized as existing in Leonardo's works. And it

65. See the interesting document of April 28, 1502, a companion piece to
our contract, published by G. Milanesi, *Sulla Storia dell'Arte Toscana,*
1873, pp. 250 ff.; also G. H. Huntley, *A. Sansovino,* 1935, p. 44 ff.

was worked out among the Lord Chairmen and the great citizens,
that since the great hall of the Council was newly made . . . it
was ordered by public decree that some fine work should be
ordered from Leonardo to paint; and so the said hall was given
him as a commission by Piero Soderini, then the Lord Chairman
. . . [IV, p. 41].

And again:

It happened that as Leonardo da Vinci, rarest of painters, was
painting in the great hall of the Council . . . Piero Soderini,
then Lord Chairman, had part of that hall given as a commission
to Michelangelo because of the great gifts he saw in him, which
was how he came to do the other wall in competition [VII, p. 159].

In the passage from Leonardo's *Vita,* Vasari shows himself
well acquainted with Florentine chronology; his distinction
between *gonfalonieri* and *gonfaloniere* means that the plans for
the frescoes were discussed even before the "Doge" Piero Soder-
ini came into office on November 1, 1502—that is, at a time
when the gonfalonieri changed every two months. This is quite
plausible—for reasons which were explained in our discussion of
the architectural development. Leonardo had returned to Flor-
ence in April, 1500, after an absence of eighteen years. The
story of his picture for the High Altar of SS. Annunziata shows
what kind of reception he found in his native city.[66] He en-
tered the services of Cesare Borgia in the summer of 1502,
but returned permanently to Florence in the spring of 1503
(not later than March 4). It may have been decided to entrust
him with the order for the fresco before he left. But the
beginning of his work was again delayed. In order to force the
inhabitants of Pisa to surrender, he invented and elaborated an
ingenious plan to divert the Arno—a project for which he
gained the Gonfaloniere's consent against the opinion of all the
experts. He therefore did not move into the rooms allotted to
him near S. Maria Novella until the end of October, 1503, and

66. Vasari, IV, p. 38.

it was here that he began, in February or March of the following year, to work on the full-scale cartoon.[67]

Michelangelo's employment may also have been under consideration at an early date. In 1501, probably in May, he had returned to Florence from Rome, where he had spent five years and where he had gained the first great success of his life with the *Pietà*. But from July, 1501, till the end of March, 1504, he was engaged on the "Gigante" for the Domopera. The Signoria had an eye on it from the start and in the end they acquired it for their own Palace. (Hence the suggestion to house it, among other places, in the new Council Hall.) In the summer of 1503 the Signoria was responsible for an interruption of the work on the "Gigante" by asking Michelangelo to make the cast of a small figure of David for them, for the purpose of political bribery. The Domopera were farsighted enough to try and secure Michelangelo's talents permanently for themselves, beyond the work on the "Gigante," by the timely proposition of a contract which would have given the artist a congenial task—twelve marble figures of more than life size—and ultimately also a house of his own. When the "Gigante" was completed, private patrons too announced their claims; they had become impatient of long waiting for the fulfillment of their orders. In this battle of competitive interests Soderini's eagerness and the illustrious character of the enterprise prevailed, and in December, 1504, nine months after Leonardo, Michelangelo started on the execution of the cartoon for his rival work. The Florentines realized that two powers of extraordinary vigor were here matched against one another.

The program of the frescoes was the representation of two hard-won victories over secular enemies, the Pisans and the Milanese. Both were won by Florentine citizens, the Commissioners of the Balía, who forced the decision against professional soldiers.[68] From the outset the war upon the rebel town of Pisa

67. It is unnecessary to give the evidence for these facts and for Michelangelo's project, since the respective sources have often been published.
68. Compare the detailed descriptions of the two battles by Filippo Villani (*Cronisti del Trecento,* ed. R. Palmarocchi, 1935, pp. 549 ff.), and by Macchiavelli (*Storie Fiorentine,* transl. Thomson, II, 1906, pp. 65 ff.).

had been one of the major concerns—if not the greatest con-
cern—of the new Republic. Guicciardini calls Pisa and the three
other fortresses which Piero de' Medici had arbitrarily ceded to
the French "places whence our strength, safety, authority and
adornment were derived, as the results later showed even
more," and adds: "the loss of Pisa most of all was so great and so
incalculable a blow to the city, that many have questioned
which was greater on San Salvador's day, the gain of recovered
liberty, or the loss of Pisa."[69] The changing fortunes of this
war, which ended in 1509, tell the story of the difficulties with
which the new regime had to contend. The French, who had
guaranteed the ultimate return of the fortresses, were found
time and again to be playing false, and all the enemies of
Florence helped Pisa; during the first years of the war this was
especially true of the Milanese, who wanted the port for them-
selves. Too much bad luck attended the leaders in the field, and
at times the Signoria was hard pressed to obtain the citizens'
consent for the barest necessities with which to continue the
war. The Dieci di Balía lost their credit; for a time all their
activities were suspended. The frescoes were therefore not
merely meant to glorify the state; at this moment they had
become an urgently required instrument of propaganda. The
victory of Cascina over the Pisans was regarded by the Guelphs
as the triumph of the party, and the day of the battle was
celebrated as an annual festival. The battle of Anghiari against
an army of Milanese mercenaries was also a memory which had
associations with the fight against Pisa, for Nero Capponi, the
commissioner who distinguished himself at Anghiari, was the
son of the first conqueror of Pisa; his grandson, Piero Capponi,
was the first commissioner in the new war against Pisa and lost
his life on the battlefield in 1496, mourned by the whole
population of Florence. In representing these wars, the frescoes
would have been a glorification of civilian preparedness, and
this idea was a step on the way towards Macchiavelli's law con-
stituting the militia, a law which was perhaps the most notable
political event in the short life of the democratic republic.

69. *Op. cit.,* p. 100.

On which wall, or walls, were these paintings to be executed? Apart from the already quoted passages of Vasari there is only one more source which refers to this point, namely Michelangelo's draft for a letter of the end of 1523. There he speaks about the time immediately preceding his first summons to the Papal Court in these terms: "quando [il papa] mandò per me . . . io avevo tolto a fare la metà della sala del consiglio di Firenze, cioè a dipignere." Given a new Hall as it was in 1504, the two phrases, Vasari's "the other wall" and Michelangelo's "half of the hall" can, evidently, only have the same meaning if both are used metaphorically. Now, each of them makes good sense if applied to one of the oblong spaces on the eastern wall, to the right and left of the loggia. No other interpretation of the terms seems possible. It is only in these spaces, rendered conspicuous by the whole disposition of the Hall and suitable in every respect for the reception of monumental histories, that the proposed companion pictures could have been placed.

The spaces are very large indeed, and were probably intended to be used for paintings "from the top down to over the bench"—after the manner laid down in a contract of 1494 with regard to the histories in the Sala del Maggior Consiglio of Venice.[70] Even if we assume that small strips of the wall immediately below the cornice and somewhat broader ones at the two corners would have been excluded because of the lack of light, there remain two rectangular spaces, each of about 12 braccia in height and 30 braccia in width (= 7 meters by 17.5 meters). Spaces of such a size as this to be covered by a single picture, had not been available to Italian artists since Guariento painted his Paradise; and later, it was only in the Sala di Costantino of the Vatican that another such opportunity was offered. All our sources agree in stating that the two battle pieces of the Florentine Hall were to be of extraordinary dimensions.[71]

70. Gaye, *op. cit.,* II, p. 70.
71. This is also the solution arrived at by W. Koehler who was the first to raise the question of the position of the paintings in the Hall (*Kunstgeschichtl. Jahrb. d. Zentral-Komm.,* I, 1907, p. 170 ff.). He worked out different measurements for the wall spaces but it should be remembered

The mural paintings shared the fate of the statue of the Savior. By 1505 or 1506 both artists had already given up working on them forever. The question as to how far they had by then advanced in their preparation has been a matter of great controversy. It is not the object of this brief survey to contribute to this discussion. Still less is this the place to inquire into all the sources, both written and pictorial, which might yield evidence as to the style and composition of the lost "modelli." I confine myself to two observations of a general character, which appear to follow automatically from the identification of the places reserved for the two paintings in the Signoria's plan. First—when the peculiarities of lighting in the Hall are taken into account, it will be found that Michelangelo must have been given the space on the left and Leonardo that on the right of the spectator, as in all studies by Michelangelo for his battle piece, and in all copies after his lost cartoon, the figures are lighted from the left; while in the case of Leonardo the light comes from the right. Secondly—the actual measurements of the two spaces indicate that Leonardo's *Battle for the Flag* (fig. 17) and Michelangelo's *Bathers* (fig. 18) —i.e., the two groups which were certainly executed in cartoon—were designed to fill parts of those spaces only. For we have to imagine these groups as consisting of figures somewhat over life size, in accordance with the usage of the time and as we know from our sources. This being the case, it will be found that the *Bathers* would occupy about half the height and two-fifths of the width, and the *Battle for the Flag* over half the height and two-sevenths of the width of the respective spaces available to the artists. In

that he did not have Frey's publication at his disposal. Ch. de Tolnay (*op. cit.*, pp. 107, 216 f.) agrees with Koehler's solution in principle but assumes that another battle piece was to be painted in the space above the loggia—also by Leonardo. This theory is disproved by the sources. According to his contract Leonardo had promised only one painting ("having . . . taken on the painting of *one* picture of the hall of the great council"; doc. 175) ; and the place above the loggia was to be occupied by Sansovino's statue of the Savior. In their reconstructions both authors take only the proportions of the areas into account, not the absolute measurements; and therefore their results are inconclusive.

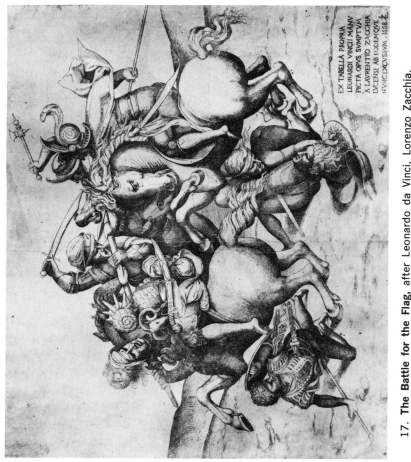

EX TABELLA PROPRIA
LEONARDI VINCI MANV
PICTA OPVS SVMPTVM
A LAVRENTIO ZACCHIA
LVCENSI AB EODEMQVE
IN VINCI EXCVSSVM. 1558. ⅃

17. **The Battle for the Flag,** after Leonardo da Vinci, Lorenzo Zacchia,
Graphische Sammlung Albertina
Courtesy of Graphische Sammlung Albertina

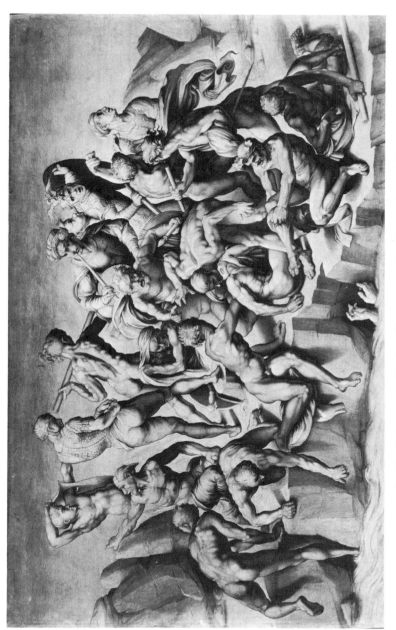

18. **The Bathers**, grisaille after Michelangelo. Norfolk, Holkham Hall
 Courtesy of the Earl of Leicester

other words, these two groups, far from being self-contained wholes, must be regarded as mere fragments of the extensive battle compositions with which the Council Hall of democratic Florence was to be decorated.

Part III

The Theory and Practice of Italian Architecture

6

The Architectural Theory of

Francesco di Giorgio

by HENRY MILLON

EDITORIAL NOTE: *It is commonplace to contrast the human Renaissance with the God-centered Middle Ages, and equally commonplace to speak of the balanced proportions of Renaissance architecture. These two roughly justifiable but vague ideas meet each other when human proportions are the basis for the proportions of buildings. It is not merely a matter of using ratios that are comfortable for human beings to be in, because they fit around us with reassuring scale and rationality, evoking what today we call "the human scale." Building measurements are actually borrowed from body measurements, and*

This article is the result of an investigation begun under Professor Rudolf Wittkower at Harvard University in the summer of 1954 in a seminar on Renaissance Architectural Theory. It was delivered as a paper at the Frick Symposium in the spring of 1956. I am deeply indebted to Professor Wittkower for the basic idea as here expressed and to Professor John Coolidge for his valuable criticisms and sustained interest.

thus, contrary to our instincts today, architecture imitates nature as much as painting does. These ideas were asserted by all Renaissance observers and have been fundamental in recent analyses of Renaissance architecture. The outstanding study is Rudolf Wittkower's Architectural Principles in the Age of Humanism *(available in paperback). But it remained for Millon, a former pupil of Wittkower's, to show how this idea worked in a particular visible case.*

". . . This portion will be a module for the whole building."

FRANCESCO DI GIORGIO (1439–1501) is unique among fifteenth-century architectural theorists for having recorded the mathematical procedures he used in designing a building. His writings contain detailed descriptions of methods for determining plans, elevations, and volumes.[1] Francesco's advocacy of a modular system which orders the entire building is symptomatic of the age, but the century never produced another statement of its modular principles as overt and unambiguous. Neither Alberti nor Filarete gave any detailed concrete information about good proportions or the use of modules, although they clearly imply that both the module and good proportions are necessary to architecture.[2]

All fifteenth-century architectural theorists spoke of proportions in terms of mathematics or in terms of the human body, which may mean there were understood methods that architects

1. Francesco's *Trattato di architettura civile e militare* (printed from MS 11.1.141 in the Biblioteca Nazionale in Florance) was published as part of the military history of Italy by Carlos Promis in Turin in 1841 simultaneously with an extract that contained the *Vita di Francesco di Giorgio Martini,* the *Trattato,* and the *Atlas,* but not the military history. Page numbers used here are from the shorter version.
2. Alberti makes his recommendations for proportions and ratios in a very matter-of-fact way. He suggests that the height-to-width ratio of a door be 2:1 or the square root of 2:1 [L. B. Alberti, *Ten Books on Architecture,* Bartoli translation, Leoni edition (London, 1755), bk. 1, chap. xii], or that in a room "if the length be five times the breadth, make the height the same as where it is four times, only with the addition of one sixth part of that height" (ix, iii). The implication of a modular system is explicit in the demand for "regularity . . . size and situation equality . . ." (IX, viii). Further evidence of a similar nature can be found in VI, ii; IX, ix.

employed when designing, but no attempt to find such schemes precisely applicable to fifteenth-century buildings has been successful. An examination of Francesco di Giorgio's theoretical writings may help to explain the reason since it is possible to define the relationship between his theory and his architectural practice.

<div align="center">I</div>

Francesco describes several methods of obtaining modules and proportions,[3] but the most interesting is the anthropomorphically derived modular grid in which the proportions of the human body are used to determine a temple plan (figs. 19, 20).[4] The head or the face is the fundamental unit, and the divided body indicates the location of the major features in the plan of the building. Proportions of a façade are also derived from the human body (fig. 21).[5] Intersecting circles are super-

3. For Francesco, modules seem to be units of measure large enough to be used for the basic ordering of a building. Modules are obtained in three different ways. By the first, or arithmetical method (*Trattato,* bk. ii, chap. 2, p. 39), a story is divided vertically into a number of equal divisions in which cornices, string courses, windows, and doors are allotted a predetermined number of parts. The method involves only an arithmetical proportional division. The second, or geometrical method, found in both the second and fourth books, uses a construction to find a unit for a modular grid (*Trattato,* ii, 9, pp. 59, 60; iv, 3, pp. 106–108). The constructions are of two different types. One type, used to determine the proportions of a room, utilizes two perfect figures (a circle inscribed in a square), and determines a module that is a portion of the radius which is roughly commensurable with the side of the square. This type of construction is also used in the often reproduced drawing of a façade section for a domed building. The other type of construction utilizes the diagonal of the square (square root of 2) and the diagonal of the double square (square root of 5) to establish an approximate relation between the diagonals and the side of the square. The drawings are attempts to find by a simple medieval geometrical construction a nonempiric Renaissance module which may be used arithmetically to approximate ratios and proportions which are incommensurable. The result is a measuring unit of considerable practical value, for it avoids the problem of the relation of the length of a diagonal to the side of a square or the length of the radius of an inscribed circle to the side of the square.
4. *Trattato,* iv, 4, pp. 109–111.
5. *Trattato,* iv, 1, p. 101.

imposed on a grid generated by using the height of the head as the module.

Francesco devotes an entire chapter to the derivation of the proportions of temples from those of a man, which he illustrates with two examples. The seriousness of his intentions can be seen in the modest statement which prefaces this section. "Finding many varied opinions exist about this body I have determined something which I will demonstrate briefly."[6] The two drawings (figs. 19, 20) represent two different ways of dividing the human body. One system is the seven-head height, the other, the nine-and-a-third-face height. The seven-module division (fig. 19) produces a longitudinal church plan with a dome diameter equal to the width of the church. A double module gives the diameter of the apse. In a more detailed explanation of the nine-and-a-third-module division (fig. 20), Francesco notes that a circle touching the nose and bottom of the torso "will give the width of the temple," and the distance from the nose "to the crown of the head . . . will give the diameter of the hemicycles" which surround the domed area.[7] In a like manner the location of the elements of the plan is outlined according to the anthropomorphic concept.

The two methods represent different and, therefore, flexible canons of proportion, since a comparative examination shows relative parts of the body to be unequal. For example, if we assume the body to be 5 feet 10 inches tall, the head in the seven-part division would be ten inches. This same body in the nine-and-a-third-part breakdown would have a head longer by $1\frac{1}{4}$ inches, roughly the distance from the lips to the nose—a significant change of proportion in any head! It is the system and not the body that determines the proportions. Francesco, like Procrustes, stretches or amputates (note the feet of the nine-and-a-third division) the human figure to conform to his abstractly conceived bed of modules.[8] Is not this method merely a sophisti-

6. *Trattato,* IV, 4, pp. 109–111.
7. *Trattato,* p. 110.
8. The anthropomorphic view is employed not only in plan but in the design of entablatures (Biblioteca Nazionale, ms. 11.1.141, fol. 38v), column capitals (*ibid.,* fol. 34v), and columns (*ibid.,* 11.1.141, fols. 32v, 33r).

cated combination of medieval geometry with Renaissance arithmetic, adapting the prevailing geometrical method so ably illustrated in Villard de Honnecourt's sketchbook?

The anthropomorphic approach is also used to determine the proportions and articulation of a façade (fig. 21) .[9] Francesco's drawing of the façade is accompanied by specific recommendations for determining proportions, by what Francesco calls "una colonna imaginata" or human figure applied to the wall.[10] Illustrating a "proportional and geometrical demonstration," Francesco argues that the relative measurements of a façade for a temple that is either longitudinal or central can be determined by dividing the human body into seven equal parts with the head serving as the measuring unit. The base is given a width of four units. The height of the door is determined by the crossing of the two diagonals, and where the diagonals intersect the next to last grid line "will be the . . . width of the door." Apparently the inscribed circles are useful only in determining the height of the base, which is established by the intersection of the diagonals and the lower circle.[11] Half-unit divisions indicate the location of architrave, frieze, and cornice. One half-unit is arbitrarily added to the summit "because the head is something superior."[12] This deviation is useful for it gives the rise

9. *Trattato,* IV, i, contains the textual matter relating to this drawing but Promis does not reproduce the drawing, which appears in Biblioteca Nazionale, *op. cit.,* fol. 39v. A reproduction may be found in Stegmann and Geymüller, *Architektur der Renaissance in Toscana,* XI, 3, p. 19. A drawing of a similar nature though less geometrical, and probably earlier, can be found in the Codex Saluzziano, Turin, Library of the Duke of Genoa, ms. 148, fol. 21v.
10. *Trattato,* p. 101.
11. Francesco states *(loc. cit.)* that the base height is determined by the intersection of the diagonals and the circles. However, the drawing in the Biblioteca Nazionale, *op. cit.,* here reproduced, shows the base height determined by the intersection of the circle and the interior vertical grid lines. This is probably an error of the copyist and speaks strongly against Francesco as the author of the drawing. It is unusual that the major intersections of the two circles or the intersections of the circles and the diagonals in the middle region do not establish any significant point. The upper circle serves no function at all.
12. *Loc. cit.*

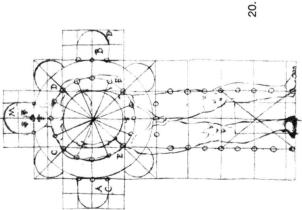

19. Proportions of a Temple Plan Derived from the Human Body, Francesco di Giorgio. Florence, Biblioteca Nazionale

20. Proportions of a Temple Plan Derived from the Human Body, second type, Francesco di Giorgio. Florence, Biblioteca Nazionale

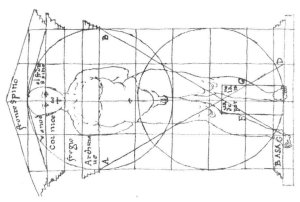

21. Proportions of a Temple Façade Derived from the Human Body, Francesco di Giorgio. Florence, Biblioteca Nazionale

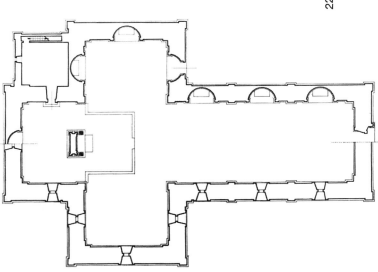

22. S. Maria del Calcinaio, Cortona, plan, Francesco di Giorgio. From Papini, **Francesco di Giorgio Architetto**, III, pl. 56

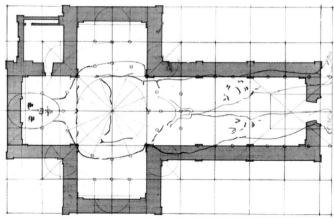

23. Fig. 20 superimposed on fig. 22, author's drawing.

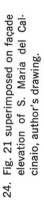

24. Fig. 21 superimposed on façade elevation of S. Maria del Calcinaio, author's drawing.

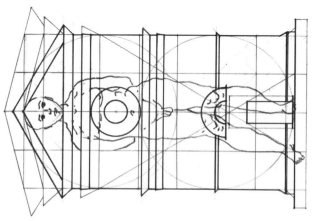

of the pediment. Even though it is only diagrammatic, this drawing describes the major features of a façade rather completely.

II

The chief problems resident in the application of a theoretical diagram to an actual building are concerned with those matters that are usually left unstated in diagram. For example, there is usually no indication of either wall thickness or wall placement in a theoretical sketch. Should the wall be placed on the outside or on the inside of the grid line? Is a combination of these two indicated for different situations? How thick should the wall be? To what extent is this determined by what the architects thought was structural necessity, i.e., the supposed compressive strength of masonry, the forces at work on the masonry, the size of the building, and to what extent by geometrical calculation?

Fortunately, there are in Francesco's manuscripts a few examples of plans that contain grid lines and also show wall thicknesses.[13] In several cases the wall is placed with its inside face on the grid line with pilasters projecting from the wall on the opposite side of the grid line.[14] Columns are usually placed on the grid line or centered on the intersection of two lines, as they are on the nine-and-a-third-module height plan.[15] Unfortunately, there is no such drawing extant to aid in the determination of wall thickness or structural nature of a façade which would enable us to relate it to an actual project.

Since the buildings designed in Francesco's *Trattato* are of a different size from those he actually constructed,[16] some diffi-

13. For example, in the Codex Saluzziano, Biblioteca Reale, Turin, fol. 11v, all three plans; fol. 12r, all five plans; fol. 12v, the plan in the lower center of the folio.
14. For example, in the Codex Saluzziano, fol. 11r, plan second from the left; fol. 11v, plan on the lower right; fol. 12r, the two full plans; fol. 12v, the plan in the lower center.
15. Also in the Codex Saluzziano, fol. 11v; fol. 13r, the two plans in the upper right.
16. Most of the buildings illustrated in the manuscripts are considerably larger, as evidenced by the great number of supporting columns, the

culty may be expected in the direct transferral of his theoretical proportions to his extant work. Also, information concerning the attributions of buildings to Francesco di Giorgio and what part he played in them is still inexact.[17] The one building that is attributable to Francesco with some degree of certainty is the church of Santa Maria delle Grazie in Calcinaio, near Cortona.[18]

length of the naves in relation to the transepts, the spacing of the columns, the size of the entrances, and the complex structural nature of the apse and transepts. While it would not be impossible to design structures that make scale determinations difficult (as was so often done in the next century), it is probable that the intercolumniation distances are intended to be governed by structural considerations and thus to determine within certain limits the absolute size of any example.

17. Just what Francesco actually constructed remains somewhat mysterious. There is immense difference of opinion in distinguishing his own work from that done after his designs. A. Venturi (*Storia dell'arte Italiana,* VIII, 1, pp. 737–833) would ascribe some thirty buildings or parts of buildings to Francesco, while A. Weller [*Francesco di Giorgio, 1439–1501* (Chicago, 1943), pp. 199–210] lists only six. For a fairly complete bibliography on Francesco's architecture see Sections A, B, and E of bibliography in Weller, *op. cit.,* pp. 405ff., or the bibliography in the handsome monograph by Roberto Papini, *Francesco di Giorgio architetto* (Florence, 1946), II, pp. 267–275. Publications which appeared after Papini's book that should be noted include Giovanni Canestrini, *Arte militare meccanica medioevale* (Milan, 1945) (?); Mario Salmi, *Piero della Francesca e il Palazzo Ducale di Urbino* (Florence, 1945); and Mario Salmi, *Disegni di Francesco di Giorgio nella Collezione Chigi Saracini* (Siena, 1947).

18. The documents that pertain to the church have been assembled in Appendix II of Weller, *op. cit.,* pp. 352–354. The decision to build the votive church in Calcinaio came soon after Easter in 1484 when there were evidences of some miraculous happenings. On July 1, 1484, Francesco, who was in Gubbio working for the Duke of Urbino, was paid a certain sum for a drawing and model of the church. In April of the following year Francesco was in Cortona and on the eighth of the month received payment as the designer of the church. Another document mentions Francesco as still in Cortona on April 30, 1485. The church was dedicated in June, 1485, and the long account which is preserved in the Cortona archives mentions Francesco by name. What may be a drawing of a church of a similar nature can be found in the Codex Saluzziano, fol. 14r, and in the Codex Laurenziano-Ashburnham 361 in the Laurentian Library in Florence on fol. 12v. Francesco died in 1501 and left the building unfinished. The work was carried on after him by Pietro di Domenico, who completed the dome in 1515.

The plan of the building is a standard Latin cross with the nave divided into three equal bays and a choir and transept containing one bay each (fig. 22). The plan is perfectly symmetrical about the longitudinal axis with the exception of the small sacristy to the south of the apse. The initial impression is one of order and consistency. By placing over fig. 22 a tracing of the theoretical plan divided anthropomorphically into nine-and-a-third parts (fig. 20), a correspondence is obtained that is too precise to be accidental (fig. 23).

1. The entire building rests within a rectangle of 9-by-6 squares.
2. The transept arms in both of the plans are of the same width.
3. The naves in both plans are of the same width.
4. The circle of the crossing in the Francesco drawing corresponds in size to the octagonal dome of the church.
5. The distance from the center line of the nave to the exterior face of the nave wall equals the radius of the dome carried on the ring of columns.
6. The pilaster-wall-grid line relationships are identical to the manuscript plans noted earlier.[19]

The differences are:

1. The side aisles are absent.
2. At the extremities of the arms of the transepts, the walls are inside module lines, rather than outside, but they are consistent in this respect.
3. The dome does not rest on a ring of columns.
4. The sacristy is asymmetrically placed.
5. The hemicycle width at the apse indicated by the head is wider than the existing niche.

The correspondences are clear in every part except for the one-third-module at the west front.[20] Could this mean there was

19. See note 14 for manuscript and folio citation.
20. It is this same extra $\frac{1}{3}$ module which caused Francesco to alter awkwardly the column spacing in the last bay of the $9\frac{1}{3}$-face height plan. He never knew what to do with the extra $\frac{1}{3}$ module, and perhaps it was ignored in this plan.

a series of steps leading down, which were intended or have since been covered or lost? Or is this another example of Francesco's procrustean adaptation?

The west elevation of the building presents a façade that is divided in three vertically. Uniform string course and entablature heights are used throughout the building. The west front is surmounted by a pediment, while the two arms and the apse are covered by a hipped roof. The whole is surmounted by a pointed octagonal dome set on an octagonal drum.

When the anthropomorphic design for a façade examined earlier (fig. 21) is placed over this façade, the height-to-width ratio is identical (fig. 24). The manuscript drawing is for a somewhat smaller church and the door size is, correspondingly, much larger. Accordingly, the architrave, frieze, and cornice in the theoretical drawing occupy far too large a portion of the façade of Santa Maria delle Grazie. However, the regulating lines determine the following:

1. The height of the base, which is found at the height of the intersection of the lower circle and the two diagonals as Francesco instructs in the text.
2. The height of the top of the prominent lower string course.
3. The height of the top of the main cornice. Also, the main cornice and frieze together equal one-half module (that allocated to the frieze in the manuscript drawing).
4. The rise of the pediment is exactly one unit.

Perhaps the grid determines some of the following also:

1. The door is a standard 1:2 ratio, but the height and consequently the width may be taken from the diagonal lines.
2. The cornice of the pediment is one-quarter module high instead of one-half module, but since the entablature of the building is about one-half the size of the one in the manuscript drawing this may be a justifiably noted correspondence.
3. The placement of the circular window may have been intended to coincide with the module line at its lower extremity.

If one labored over the point, many more correspondences could be alleged. The admittedly variable nature of Francesco's method of design might make such a comparison deceptive and the attempt foolhardy. For instance, the upper circle in the manuscript drawing is apparently there only to form a logical whole, and on the façade it determines nothing. Likewise, at the points where one would expect something to occur—such as at the intersections of the two circles or at the intersections of the circles and the diagonals in the middle region—nothing happens. Although the placing of the circular window, the secondary cornice, and the height of the arch over the doors may not have been determined from such a drawing as this, the correspondence of the theoretical drawing and the actual project indicate a very close relationship. The degree of correspondence is about all that should be expected of Francesco.

III

The definable correspondence between the architectural theory and practice of Francesco di Giorgio gives a clue as to the standard practices of the fifteenth century. Francesco di Giorgio was certainly not an architect generously endowed with talent, and any indication about his methods should shed light on everyday practice. It cannot be denied that the family of building forms and proportions of the last half of the fifteenth century indicate some geometrical or mathematical method was used in their creation. A great many studies have been made which attempt to show by constructions with right and isosceles triangles, root triangles, golden sections, etc., how the main proportional lines of the building were derived.[21] The con-

21. The following is a partial listing, in chronological order, of attempts at proportional derivations: A. Thiersch, *Handbuch der Architektur,* IV, 1 (Stuttgart, 1883); G. Dehio, *Ein Proportiongesetz der antiken Baukunst und sein Nachleben im Mittelaltar und in der Renaissance* (Strasbourg, 1895); L. Denina and A. Proto, "La real chiesa di San Lorenzo in Torino" *Architettura italiana* (Turin, 1920); Jay Hambidge, *Dynamic Symmetry* (New Haven, 1920); F. M. Lund, *Ad Quadratum* (London, 1921); Jay Hambidge, *The Parthenon and other Greek Temples; Their Dynamic Symmetry* (New Haven, 1924); Le Corbusier, *Vers une Architecture*

structions usually entail a number of decisions about the place-
ment of the regulating lines, and more often than not there is a
conscious fudging of certain parts to make the building fit the
rule. Were there distinguishable ratios, proportions, and geo-
metrical figures used in the buildings?

Francesco di Giorgio presents, with his own drawings, what
may be one solution to the problem. He used a mathematically
coherent system in a highly flexible way. While Francesco's
procrustean method of adapting the figure to the method indi-
cates little regard for what should be the "perfectly propor-
tioned" human figure, he exhibits an equal disregard for the
precise application of his abstract method to an actual building.
The geometrical construction is not superior to the building
and serves merely as an aid to determine proportionality. Pro-
portionality becomes something which is dependent at its in-
ception on geometry and arithmetic, but final adjustments are
made by the eye of the architect and do not depend on the
abstract rules of the compass.

All other architectural theorists of the century also spoke
about mathematical derivations of proportions. There is a gen-
eral agreement in the fifteenth century that proportions are not
created by individual taste but are the result of an envisioned
congruency of mathematics, music, and the laws of nature

(Paris, 1924), pp. 58–62; M. Borissavlievitch, *Essai critique sur les
principaux doctrines relatives à l'esthétique de l'Architecture* (Paris,
1925); Robert W. Gardner, *The Parthenon, Its Science of Forms* (New
York, 1925); Jay Hambidge, *Elements of Dynamic Symmetry* (New York,
ca. 1926); Arthur Butler, *The Substance of Architecture* (New York,
1927); Julien Gaudet, *Eléments et théorie de l'Architecture* (Paris, n.d.);
G. Giovannoni, *Saggi sulla architettura del Rinascimento* (Milan, 1931),
p. 12ff.; Theodor Fischer, *Zwei Vorträge über Proportionen* (Munich,
1934); Marcel Texier, *Géometrie de l'Architecture* . . . (Paris, 1934);
Louis Hautecoeur, *De l'Architecture* (Paris, 1939?); Robert Gardner, *A
Primer of Proportion* (New York, 1945); Matila Ghyka, *The Geometry of
Art and Life* (New York, 1946); Bruno Zevi, *Architettura e storiografia*
(Milan, 1959), p. 51; George Jouven, *Rythme et Architecture* (Paris,
1951); Charles Funck-Hellet, *De la proportion* . . . (Paris, 1951); Cesare
Bairati, *La simmetria dinamica* (Milan, 1952); M. Borissavlievitch, *Le
nombre d'or* (Paris, 1952); and *idem, Traité de l'Architecture,* 2 vols.
(Paris, 1954).

itself.[22] Architectural harmony derived from mathematics or from the human body would reflect the all-inclusive harmony of the universe. Did these architects also pay lip service to an intellectual doctrine while in practice relying on visual judgment to make final decisions?

The flexible way in which Francesco utilizes these immutable relationships may suggest how fifteenth-century architectural writings should be interpreted and may help explain the difficulty in finding consistent, logical systems that were employed by architects. Francesco did not follow his theoretical teachings in a doctrinaire manner but felt that "although [the façade] owes its height to [the measure of the body] it can be decreased somewhat or increased at the choice of the artisan."[23]

22. This is the major thesis of the book by R. Wittkower, *Architectural Principles in the Age of Humanism* (London, 1952). See also, e.g., Alberti, *op. cit.,* ix, v, vi.
23. Promis, *Trattato,* p. 101.

7

Architectural Practice in the

Italian Renaissance

by JAMES S. ACKERMAN

EDITORIAL NOTE: *Prior to this study, exploration into the working conditions of Renaissance artists had tended to draw inferences backward from the resulting works of art, but the phenomena revealed here are rather different from the picture that had thus been evolved. We have been much more familiar with the general situation of the artist before the Renaissance, the medieval craftsman, and after the Renaissance, the romantic in a garret. The Renaissance artist by contrast with his predecessor, socially secure but of low status, and his successor, socially marginal even when idolized as a genius, seems to have had the best of both worlds. He is socially accepted and admired not for hand labor but for his individual imaginative capacities. In our modern society the closest analogy for this is with the professional man, such as the trial lawyer, whose personality is prized as the basis of his work but whose work is used to exalt the interests of his client and not his own internal concerns. Still more striking in this essay, though less emphasized, are the deductions it permits in extending effects of social circumstances into the style of the work produced, such as the unusual emphasis on interior space at the expense of the façade.*

IN THIS PAPER I have chosen to concentrate on the High, or as I prefer to call it, the Roman Renaissance of the first half of the

sixteenth century only because I am more familiar with the sources of this period than of those that precede and follow. But I think that a proper study of Italian Renaissance practice ought to divide the field into at least three parts: first, the generation of Brunelleschi and Alberti, which is documented by archival material, theoretical writing on architecture, and biography. Here one might trace the emergence of practice from the medieval guild system into the sphere of humanism. Second, the period I shall discuss, which is not strong in theory, but which compensates by providing richer biographies, more letters and archival records, and above all, large collections of drawings—sources which are almost nonexistent for the first period. This is an age of rugged individualism in architectural practice. Finally, something should be said about the later sixteenth century, when, along with the foundations of the first academies, architects begin to write about practice, while they tend to stabilize theory into law. Here architecture begins to take shape as a distinct profession, perhaps for the first time since antiquity.

Leaving this more ambitious scheme to future students, my present intention is to draw from the sources at hand certain generalizations concerning the apprenticeship and training of the architect, the practice of the profession, and the process of design during the period bounded by Bramante's arrival in Rome in about 1500 and Antonio da Sangallo's death in 1546. Antonio will get more attention than his distinguished contemporaries because we know more about him and also because he deserves distinction for being one of the few architects of his time who never wanted to be anything else.

Italian architects in the fifteenth and sixteenth centuries ordinarily turned to building at an advanced age. They apprenticed in the studio of a painter or sculptor and practiced one or both of these arts until the requirements of some patron turned them to architecture. There was no guild to harbor architects and no means of serving an apprenticeship in the profession. The title of Master Architect, rather than being a prerequisite of employment, was normally granted to a master craftsman in another field in consequence of his receiving his

first building commission. Because in this system architecture perforce involves more taste than technique, the social position of the architect was high, and if a man was not a gentleman before practicing architecture, he became one after. Antonio da Sangallo rose to eminence by another path, which appears to have been a risky and unpromising one. He apprenticed in carpentry.[1] By virtue of excellent family connections and good fortune of working under Bramante at the Vatican, he was able to overcome this stigma and to gain the title Architect, but only at the age of thirty-two, when he was appointed to assist Raphael at St. Peter's.[2] He was the only important Roman Renaissance architect who rose from the building trades, though a generation later Palladio did the same with the help of equally distinguished patronage.

The practical knowledge that the young Antonio gained working in the *fabbriche* of St. Peter's, the Vatican Palace, and the Castle of Ostia, combined with design training as a draftsman for the aging Bramante, appears today to be an excellent background for the practice of architecture. But the sixteenth-century attitude is typified by Benvenuto Cellini, who wrote after Antonio's death that his inferiority to Michelangelo must be ascribed to the fact that he was neither a sculptor nor a painter.[3] The reason for this attitude is best explained by

1. Antonio appears first in Rome in 1504 as a *falegname* at Castel Sant' Angelo (G. Clausse, *Les San Gallo* [Paris, 1901], II, 45) and in documents of 1510–11 as an assistant to Bramante with the title *faber lignarius* or *carpentarius* [Ackerman, "Bramante and the Torre Borgia," *Rendiconti della Pontificia Accademia di archeologia,* 25–26 (1949–51) : 251 ff.]. He held the same position in 1513–14.
2. The papal Breve, in which Antonio is appointed at half the salary of Raphael, is reproduced by V. Golzio, *Raffaello* (Vatican City, 1936), pp. 50 f.
3. Benvenuto Cellini, "Discorso dell'architettura," *Opere* (Milan, 1811), III, 249. He says of Antonio: "But because he had been neither a sculptor nor a painter, but rather a master of carpentry only; for this reason one never sees a sign in his work of that certain noble Character (*virtù*) such as is seen in our true Third (the first and second being Bramante and Sangallo), whom we may place first of all, Michelangelo Buonarroti." This was probably written before Michelangelo's death, but remained unpublished until the late eighteenth century.

Michelangelo, who once wrote, "there is no question but that architectural members reflect the members of Man, and whoever has not been or is not a good master of the [human] figure and likewise of anatomy cannot understand [anything of them]. . . ."[4]

Those sixteenth-century sculptors and painters who undertook the designing of buildings cannot have brought to their first attempts much more than a trained eye and an admiration for antiquity. Even Michelangelo complained that he was forced to build though he was not an architect.[5] Generally the solution of structural problems had to be left to masons and carpenters, who had been accustomed for centuries to inventing means to achieve a given end. Bramante, in spite of some thirty years in the practice of architecture, never did gain much competence in technical matters, and after his death Antonio was kept busy patching up his errors. The Vatican loggias had to be reinforced from below, the Belvedere corridors crashed to the ground, nearly killing a pope, and the St. Peter's crossing piers had to be fattened, much to the detriment of their handsome profile.[6] This lack of technical discipline may explain in part why the High Renaissance is one of the few great eras in

4. Letter of 1560 or thereabouts, supposedly to the Cardinal Rodolfo Pio of Carpi. Milanesi [*Le lettere di Michelangelo Buonarroti* (Florence, 1875), p. 554] transcribes it from an original in the Archivio Buonarroti, while Schiavo [*Michelangelo Architetto* (Rome, 1949), fig. 96] reproduces the same text photographically as a leaf from a Vatican codex *3211* (which collection?), fol. 97.

5. For example, in the draft of a letter on a drawing of about 1546 in the British Museum, he says: "I lack the spirit for it because I am not an architect." Wilde, in his recent publication [*Italian Drawings in the British Museum: Michelangelo and His Studio* (London, 1953), no. 70, pp. 108 ff.] associates this complaint with the commission for the Farnese Palace; but the St. Peter's commission is a more likely cause, since Vasari (*Vite*, VII, 218) reports a similar statement in that connection. Wilde notes that Michelangelo objected for the same reason to his first architectural assignment (Milanesi, *Le lettere*, p. 431).

6. Vasari (*Vite*, IV, 157 f.) blames the state of Bramante's structures on the fact that Julius II demanded inordinate haste in construction—"he wanted buildings not to be built but to be born"—but nevertheless adds: "a carelessness which was the reason why his [Bramante's] works are all cracking and stand in danger of ruin."

architectural history in which a new style emerges without the assistance of any remarkable structural innovation.

Aside from training in one or another of the plastic arts, which provided a foundation in mathematics and perspective, the essential prerequisite for the practice of architecture was a knowledge of Roman remains. This was gained at first hand wherever possible, not only in Rome itself, but throughout Italy and Provence. Most of the major architects, and many whom we know only through their sketches after the antique, filled volumes of notebooks with measured drawings of plans and details, or with impressions in perspective.[7] They became familiar with monuments beyond their reach through the sketchbooks of their contemporaries, which had a wide currency and constituted the textbooks for architectural training.[8] In present-day collections of Renaissance architectural drawings these sketches far outnumber the studies for contemporary buildings. Fanciful reconstructions of Roman remains, which were a passion with late fifteenth-century architects such as Cronaca and Bramantino, were out of fashion after the turn of the century, when the accent turned from a romantic to a practical and archaeological approach.[9]

A knowledge of Vitruvius was equally important and for the same reasons. Vitruvius was significant not because he was a theorist but because his subject was Roman architecture. If

7. A huge collection of these drawings is preserved in the Uffizi Gallery and many are published in the six-volume work of A. Bartoli, *I Monumenti antichi di Roma nei disegni degli Uffizi di Firenze* (Rome, 1914–22). See also H. Egger, *Kritisches Verzeichnis der Sammlung architektonischer Handzeichnungen der K. K. Hofbibliothek in Wien* (Vienna, 1903), vol. I.

8. For example, Huelsen's study of the sketchbook of Giuliano da Sangallo, *Il libro di Giuliano da Sangallo; Codice Vaticano Barberiniano Latino 4424* (Leipzig, 1910), pp. xxxvi ff., shows that copies were made from that source by Antonio da Sangallo the younger, Giambattista Sangallo, the anonymous author of the Soane Museum "Coner" Sketchbook, the Anonymous Destailleur, Vasari the younger, Cassiano del Pozzo, and many others.

9. Some of Cronaca's drawings are reproduced by Bartoli, *op. cit.*, vol. I, pl. XVI, fig. 33, to pl. XX, fig. 42. Bramantino's notebook is published in facsimile, *Le rovine di Roma* (ed. Mongeri, Milan, 1875).

theory in itself had been valued, High Renaissance architects would have studied the writings of Alberti, Francesco di Giorgio, and perhaps Filarete, which they manifestly did not do. Nor did they trouble to theorize themselves; they left writing to their disciples, of whom Serlio is the best known, and his volumes are significantly visual compendiums rather than philosophical treatises—best to be described as printed sketchbooks.

The schooling of the architect dispensed not only with the theories of the fifteenth century but with the monuments as well. It is curious that while Bramante's Roman work was measured and drawn by innumerable architects through the sixteenth century, his Milanese buildings were never examined. His predecessors virtually were relegated to the Middle Ages. I know only three Renaissance drawings after Alberti, and all are copies of one plan for S. Sebastiano in Mantua.[10] The late Brunelleschi interested one or two architects, who sketched the lantern (not the dome!) of Florence Cathedral, and the plan of Santa Maria degli Angeli, presumably because they were adequately Roman.[11] On the other hand, certain buildings constructed or projected after 1500 took their place beside ancient remains, and the younger architects devoted a portion of their sketches to Bramante, or occasionally to Peruzzi, Antonio da Sangallo, and Michelangelo.

10. One by Antonio Labacco is in the Uffizi [Manetti, *Vita di Leon Battista Alberti*, 2d ed. (Florence, 1911), p. 396]. A second is in the sketchbook of about 1535–40 attributed to Aristotile and Giovanni Battista Sangallo in the Palais des Beaux-Arts in Lille (*Fonds Wicar*, fol. 840), and a third, copied from the second, is in a sketchbook of about 1580 by Oreste Vannocci in the Biblioteca Comunale di Siena (*S. IV. I.*, fol. 140). The measurements given on these plans are the roughest approximations of the actual dimensions of the building and helped to hide from the sixteenth century the intricate system of proportions employed by Alberti.
11. Brunelleschi's lantern appears in the Lille ms. mentioned above (fol. 726) and in the Siena ms. (fol. 139), where it is compared to Michelangelo's lantern of the Medici chapel in Florence. The plan of Santa Maria degli Angeli appears of fol. 15 *v* of Giuliano Sangallo's sketchbook (Huelsen, *op. cit.*, p. 27), on a drawing attributed to Jacopo Sansovino (Uffizi, *Arch.* 1949), and in many other sixteenth-century drawings.

To this preparation for the practice of architecture—at best a
haphazard one—was added a kind of schooling that the grandi-
ose projects of the period made available to most of the poten-
tial architects in the urban centers. Projects such as the con-
struction of St. Peter's and the Vatican Palace brought
innumerable artists and artisans into close contact with an
architectural workshop, and I can readily believe that the prac-
tical precepts of the profession were learned by Raphael,
Peruzzi, and even by Michelangelo, from observing what went
on in Bramante's Vatican studio, whether or not these men
originally were given any architectural assignments there.

So much for training. Once launched as an architect, the
early sixteenth-century aspirant established himself by doing
well on an initial commission, and his practice grew much in
the same fashion as that of the modern architect. Sangallo's
earliest commissions are typical. Santa Maria di Loreto he
probably inherited from one of the architects of Julius II.[12]
The church of the Hospital of San Giacomo, as we shall see
shortly, was designed for a competition, one in which Antonio
had the advantage of being a tenant and neighbor of the
institution.[13] The monks of Santa Maria della Quercia in
Viterbo employed him because they said they wanted a ceiling
as elegant as the one he had built for the pope in the Vatican

12. This church generally is said to have been built by Sangallo in 1507.
This is clearly an error, as he was not an architect at that time (see note
1). His activity there dates from the 1520's, and no earlier construction is
visible in the present church [see my book, *The Cortile del Belvedere*
(Vatican City, 1954), p. 48, note 2]. But Julius II must have founded the
church, since it is mentioned among the Pope's contributions to Rome by
Francesco Albertini, *Opusculum de mirabilibus novae et veteris Urbis
Romae* (Rome, 1510).
13. The hospital owned property all along the Via di Ripetta in an area
that has always been the artists' quarter of Rome. Antonio rented "prop-
erty . . . in the new Via del Popolo" from the Trustees as early as 1512
and remained a lessee until his death (*Archivio di Stato*, Rome, Archive of
the Ospedale di San Giacomo degli Incurabili, *Libri di Entrata e Uscita*,
no. 1142, fol. 15 *v*, to no. 1198). At a later date, Peruzzi became a tenant as
well, and painted for the trustees.

consistory.[14] The Farnese Palace is only the first of innumerable commissions for Cardinal Alessandro Farnese (later Pope Paul III) and his sons, euphemistically called nephews. The alliance of an architect with a distinguished family was a common occurrence: Bramante supplanted Giuliano da Sangallo as the architect of Julius II, Raphael was the favorite of the Medici popes, Peruzzi worked for his Sienese compatriots, the Chigi, and so forth. But the arrangement entailed no obligation on either part; clients changed architects and vice versa. Clients, in fact, often resorted to competitions in selecting architects for important commissions. One of the best-known examples of this is the competition for the design of S. Giovanni dei Fiorentini, to which Leo X called Sangallo, Jacopo Sansovino, Raphael, and Peruzzi.[15] Sansovino got the job, but was replaced by Sangallo (it is hard to tell whether an injury or incompetence precipitated this), and after the church was nearly finished, Michelangelo was called in to design a new one. Other competitions were held for completing earlier churches such as San Lorenzo in Florence, San Petronio in Bologna, and Milan Cathedral. Sangallo and Peruzzi competed on other occasions; for the S. Giacomo degli Incurabili commission and I believe

14. According to a document in the archives of Viterbo dated December 8, 1518, Antonio was hired: "ad faciendum palcum subtus tectum Ecclesiae Sanctae Marie in Quercie . . . che detto palco habia essere de quella richeza che è quello de camera de Papa Leone in Palazo di Papa in Roma, dove se fa concistorio; et uno palmo piu' sfondato . . ." (from C. Pinzi, "Memorie e documenti inediti sulla Basilica di Santa Maria della Quercia in Viterbo," *Archivio Storico dell'Arte*, III (1890), 322.

15. This competition is reported by Vasari (*Vite*, VII, 498) and by Temanza [*Vite dei più celebri architetti e scultori veneziani* . . . (Venice, 1778), p. 212] in their Lives of Jacopo Sansovino, and it is mentioned in a letter from Pietro Aretino to Sansovino [reproduced by Giovannoni in *Saggi sull'architettura del Rinascimento* (Milan, 1935), p. 123]. Modern studies on the early history of the church include two by A. Nava, in the *Archivio della r. deput. romana di storia patria*, 59 (1936): 337, and *Critica d'Arte*, 1 (1935): 102; and an unpublished Master's thesis by Ruth Olitsky, *San Giovanni dei Fiorentini*, in the Institute of Fine Arts of New York University, 1951.

also for Santo Spirito in Sassia.[16] Several of their designs for the former are preserved, and a comparison of two of them (figs. 25, 26) shows that both men were working for the same general type of solution: placing the wards along the longer sides of the plot and courts on the interior, and providing churches with access to the street. The absorption with centrally planned churches is symptomatic of the period.

The greatest setback of Sangallo's career was the competition for the cornice of the Farnese Palace. In the last year of his life, as he was completing the chief masterpiece of his long service for Paul III, Antonio was forced to submit to a reconsideration of his cornice design, and four other architects and painters were invited to submit drawings.[17] As everyone knows, Michelangelo triumphed, and Antonio was to have carried out his project, but he shortly died, as the Romantic historian would put it, from shame. I imagine that this affair may be attributed to court intrigues.

16. There is no literature on the competition for San Giacomo; but competing designs for the complex were discovered in the Uffizi by Wolfgang Lotz and published in a short notice in the *Mitteilungen des Kunsthistorischen Insts. in Florenz*, V (1940), 441 ff., figs. 1–3. The only remaining evidence of Sangallo's winning plan is the small church of Santa Maria in Porta Paradisi on the Via Ripetta (fig. 7, upper left-hand corner), built in 1519–26. The Santo Spirito competition is an hypothesis of mine, I have discovered a plan by Peruzzi (Uffizi, *Arch.* 558) for an unidentified church with an adjoining cloister or court to be built on a plot identical in proportion to the oddly-shaped plot of the present church and court.

17. The competition, which involved Sangallo, Michelangelo, and the painters Perino del Vaga, Sebastiano del Piombo, and Vasari, is recorded by the latter in his Life of Sangallo (V, 470 ff.; the account in VII, 223 conflicts with this), and also in letters published by Gotti, *Vita di Michelangelo Buonarroti* (Florence 1875), I, 292 ff. The sources are discussed by Meller, "Zur Entstehungsgeschichte des Kranzgesims am Palazzo Farnese," *Jbh. d. pr. Kunsts.*, 30 (1909): 1. In discussing the competition, Tolnay ["Beiträge zu den späten architektonischen Projekten Michelangelos," *Jbh. d. pr. Kunsts.*, 51 (1930): 33] published an unknown design from the Munich Graphische Sammlung which he attributes to Sangallo. It shows a fourth story or high attic. I believe the attribution is groundless because both the draftsmanship and the architecture are far too feeble to be assigned to the mature Sangallo and because the solution bears no relation to his preserved studies, of which there are several in the Uffizi.

As in the preceding century, the duties of the architect reached far beyond the building of palaces and churches. Sangallo, who was fortunate in reaching the peak of his career at the same time as his patron, spent most of his later years fortifying Rome and the papal states, building entire towns, such as Castro, in the new duchies carved out for the *nipoti,* restoring the Vatican, and designing settings for sundry celebrations. He even built a monumental well for the town of Orvieto.[18]

Financial relations between clients and architects are a mystery. Where private building accounts are preserved, the name of the architect rarely appears, and almost never as the recipient of a fee. Perhaps he was paid by grants of property or by casual sums from the pocket of the head of a family or the trustee of an institution or confraternity. Papal commissions, however, were rewarded in a more orderly manner. A monthly stipend attended each supervisory job. In 1536 Sangallo was receiving 25 scudi monthly as *capomaestro* of St. Peter's, the same for fortifying Ancona, and 10 scudi for the *Santa Casa* in Loreto; two years later another 25 was added for the fortification of Rome.[19] It was understood that any other jobs for the Holy See would be done without further remuneration. But there were exceptions to this arrangement; Michelangelo wrote in 1555 that he had been forced to work on St. Peter's for eight years without pay.[20]

In the largest building programs an architect could devote most of his time to design and supervision because other duties were carried out by a large staff. At St. Peter's, for instance, there was a hierarchy that became more complex as the build-

18. Antonio's career is outlined by G. Clausse, *Les San Gallo* (Paris, 1901), vol. II. The book is obsolete but no other general study exists.
19. Papal Breve of May 28, 1536, reproduced by Pastor, *Storia dei Papi* (1st Italian ed.; Rome, 1924), V, 792, doc. 20; Breve of January 14, 1538, *ibid.*, pp. 796 ff., and several other authors.
20. Letter of May 11, 1555 to Vasari (*Lettere,* ed. Milanesi, p. 537, from the Archivio Buonarroti): "Io fu messo a forza ne la fabrica di Santo Pietro, e ò servito circa otto anni non solamente in dono, ma con grandissimo mie danno e dispiacere."

ing grew.[21] In the 1520's and 1530's it apparently was organ-
ized with an architect (Sangallo) at the head along with a
coarchitect (Peruzzi). The execution was in charge of a *cura-
tore* (Giuliano Leno) and a *computista* (Francesco Megalotti;
later Jacopo Meleghino) immediately below him, if not on a
par, who served as paymaster, and for this reason was a member
of a board of three who measured and priced competed work;
the *mensuratori* (Giovanni Francesco da Sangallo and Rainieri
da Pisa). The funds allotted by the Camera were distributed by
two *depositari,* or treasurers (Simone Ricasoli, Leonardo Bini).
This staff had its *segretario,* whose hand is found in the records
alongside that of the *computista.* On the job there was a group
of five to ten *soprastanti;* who might also be *mensuratori,*
indicating that this position was higher than what we would call
"foreman." It was probably comparable to a junior partner in
an architectural or engineering firm. Next there were the *sotto-
soprastanti,* who were foremen and occasionally specialists, as:
sotto soprastante sopra i legnami (carpenters). At the bottom of
the official hierarchy came the *capomaestri* directing crews in
their special crafts: carpentry, masonry, carving, ironwork, etc.

In this scheme the Renaissance architect played a role similar
to his modern counterpart. But an organized *fabbrica* was
exceptional. As a rule the architect assumed many of the duties
described above. He was the chief estimator, determining the
sum to be paid for a given construction job; he was often the
paymaster, and he might be called on to supply mortar or
materials for large sums that only later would be reimbursed by
the client's treasurer. In doing this he assumed some of the
duties that nowadays are assigned to the contractor. However
there were contractors, and they served almost the same func-
tion as they have served in later times. For example, when the
rebuilding of the Farnese Palace in Rome was started in 1541,
the agents of Pierluigi Farnese signed a contract with the

21. The following data were culled from the nearly 1,000 documents on
the construction of St. Peter's during this period published by Karl Frey
["Zur Baugeschichte des St. Peter: Mittheillungen aus der R.da Fabbrica
di San Pietro," *Jbh. d. pr. Kunsts., Beiheft* to 31 (1911), 1 ff.; *Beiheft* to
32 (1913), 1 ff.].

impresario Bartolomeo Baronio for its construction. It itemizes in detail the responsibilities of both parties.[22] The duke is to supply the mortar ready mixed, while the stone and brick is to come from the contractor, its quality subject to review by Sangallo and his associate Meleghino. The price of construction on walls and vaults is set by the *canna,* the measurement being assigned to two technicians: one appointed by the duke and one by Baronio. Certain prices, related to roofing and moldings, are left to the architects' judgment. The document closes: "and in the event that the said masters should make some omission that causes damages to the said structure by not working honestly as they ought to do, it shall be in the power and judgment of the said master Antonio Sangallo and Giacomo Meleghino to deprive them of the work and to give the structure to other masters."

Antonio's association with Meleghino on this job was not at all to his taste, and it illuminates a curious custom that permitted clients to create partnerships among architects who were unsympathetic to one another. Meleghino was the pope's toady and not much of an architect, which is sufficient explanation for the animosity.[23] Since Antonio's many commissions kept him away from Rome for long periods, he did his best to keep in touch with Meleghino's activities as well as with the progress of the construction. An amusing letter is preserved in which a faithful workman writing from Rome to Antonio in Rieti discusses the design of two windows, which are sketched on the same page, and proceeds to report:

> You ought to know, Sir, that Master Jacopo Menichino [*sic*] has been here at the palace and has given me a message from the Pope that I should make the architraves that go over the pilasters of the entrance toward Santo Gerolamo (i.e., south) and that I

22. The exact source of this document is unknown. It was published by Umberto Gnoli, "Le Palais Farnese (Notes et Documents)," *Mélanges de l'Ecole Française de Rome,* 54 (1937) : 209, from the transcripts that his father, Domenico, had made in the Archivio di Stato, Rome.
23. On Meleghino's career, see K. Frey, "Studien zu Michelangelo Buonarroti u. der Kunst seiner Zeit," Part III, *Jbh. d. pr. Kunsts., Beiheft* to 30 (1909) : 138.

should make the cornice there separately [?] [*istachata*] because there is no stone for it. Now, Sir, advise me if I should do it, and Vincenzo and I reverently send our best wishes. Written on the 9th day of January 1546. Obediently yours. Nardo di rafaello de rossi, carver.[24]

As a rule, the leading architects were assisted by subordinates who could be relied on not to meddle in the design. Antonio had Aristotile and Giovanni Battista Sangallo, for instance, who consistently helped him to keep an eye on far-flung projects, and his notes and theirs are often found together on preparatory sketches. Along with other adherents, these men formed what Vasari disdainfully called the *Setta Sangallesca,* or "Sangallo Clique," but it is hard to see in the group what we should call an architectural firm.[25] Even in the rare cases when a lesser architect executed drawings or made surveys for a more distinguished one, the relationship seems to have been informal. In fact, closer parallels to the modern office are found among painters than among architects in the Renaissance. Painters had to have a shop that was stylistically cohesive, while architects did not, as evidenced by the building of St. Peter's, which brought together some unlikely partners: Bramante and Giuliano da Sangallo, Raphael and Fra Giocondo, Antonio and Peruzzi, and Vignola and Ligorio.

The High Renaissance architect managed without a firm and usually without even an office, because he did so little detailed

24. This letter and the two accompanying drawings are in the Uffizi drawing collection, *Arch.* 302. The text is reproduced by Milanesi in his edition of Vasari's *Vite,* V, 487.

25. The term is used in the *Vite,* VII, 218. The Sangallo group must have included Antonio's brother, Giovanni Battista (il Gobbo), his cousins Aristotile and Francesco, Nanni di Baccio Bigio, and Antonio Labacco, among others. The cohesiveness probably was due to the fact that most of them owed their jobs to Antonio and that after his death they were not imaginative enough to continue ahead with Michelangelo. Vasari repeats a story that shortly after Antonio's death the "clique" confronted Michelangelo with the sententious statement that Antonio's model for St. Peter's was "a field that will never cease to be a pasture." "You are quite right," Michelangelo reportedly answered, "if you are talking of sheep and cows, who do not understand art."

designing. It is in the process of design that his methods are most at variance with those of later periods, a fact that is amply documented by the many surviving early sixteenth-century drawings. In examining a collection of these drawings one's first impression is that very few of them were intended to be used in constructing a building or to be seen by anyone other than the architect. They are nearly all rapidly sketched studies of tentative ideas, sometimes for specific buildings, and sometimes for ideal structures. The few that are finished may be classed in two categories: first, the large, carefully drawn, and attractively rendered projects that were made for the client. These are called presentation drawings; they are rare and they cannot have been much use for construction because they almost never include measurements or a scale. Moreover, they typically show the building that was to have been built rather than the one that was built. A good example is fig. 27, Antonio's final plan for the Farnese Palace. It is a large sheet, without the usual scribblings and measurements, and without indication of scale, though it is identified, "Palace of the Duke of Castro." The wing facing the square appears as executed (though changes were made in partition walls), while the garden front drawn here does not at all resemble what ultimately was built. Figure 25 is, of course, the same sort, though it contains a few measurements, and another well-known example is Bramante's parchment half-plan of St. Peter's in the Uffizi. The second type of finished drawing was intended for use in construction, but it is limited to details—a window, an entablature—and was intended only to guide masons and carvers. Here again one of the Farnese series is a handy example (fig. 28), in which Antonio has drawn meticulously the profiles of window moldings for the use of the stone carvers. They are identified as belonging to windows in the arcade as: "Molding for the capital of the pilaster (*stipite*) of said Farnese Windows." The tradition of verbal communication between architect and craftsman typi-cally comes to the fore as the architect fills the left side of the sheet with instructions in longhand that might readily have been graphically presented. They deal mostly with linear measurements.

All other drawings fall into the category of preliminary sketches, and anyone who has tried to straighten out the history of a sixteenth-century building from drawings will know what a melee of undigested ideas they create. A sheet by the elder Antonio Sangallo presents a familiar confusion (fig. 29). Here the arches and the campanile of San Biagio in Montepulciano appear together with unidentified door brackets, balusters, and the plan of a domestic (?) structure, one piled on top of another. His nephew does the same thing (fig. 31), though he sticks to one project and is spendthrift enough to fill up the whole page with it.

I can conclude from this evidence only that drawings were not the chief means of communication between architects and builders. The enormous expense and effort devoted to the construction of models for the larger projects suggests that much of the designing went on in plastic form at this stage.[26] Builders, rather than work with detailed specifications, got the gist of the design from the model, and when they encountered problems, they simply got the answer from the architect or supervisor by word of mouth. But the importance of models should not be overestimated: like the presentation drawings they rarely represent the structure that ultimately was built, and in any case they were made only for the most grandiose structures. I think that the average palace and church was built from rough plans and a batch of details.

What is curious about High Renaissance drawings is not that they are so frequently plans and details but that they are so seldom anything else. Sections appear where there is a vaulting problem, but what I find most surprising is the rarity of elevation drawings, and particularly of façades. A fear of façades is an

26. Antonio's model for St. Peter's, which still exists, was built for him by Antonio Labacco. It took from 1539 to 1546 to complete, and Frey estimated the cost at between 5500 and 6000 ducats. To judge from the salary paid to the chief architect of the Holy See (see p. 157)a ducat ought to be over $10 in today's exchange. Michelangelo's model for the dome of the Basilica cost about 600 ducats. Cf. K. Frey, "Studien zu Michelangelo Buonarroti," *Jbh. d. pr. Kunsts., Beiheft* to 30 (1909): 167, 171; *idem,* "Zur Baugeschichte des St. Peter," *Jbh. d. pr. Kunsts., Beiheft* to 33 (1913): 21; *Beiheft* to 37 (1916): 81.

Italian phobia of long standing that blighted most of the great Gothic structures: Milan Cathedral, San Petronio in Bologna; in Florence, the cathedral, Santa Croce, Santa Maria Novella, Santa Trinita; Santa Maria sopra Minerva in Rome; and others. The loss of many Renaissance drawings does not quite explain away this phenomenon, because it is clear from the surviving ones that the plan dominated architecture as never before or since. In the development of a design we frequently find plan studies in which the exterior of a building is not even indicated, as is effectively illustrated in Antonio's study for San Giovanni dei Fiorentini (fig. 30). In churches the great trend toward the central plan was accompanied by a method of design that can be described only as centrifugal. The architect starts drawing in the center and works outward, and it is not until he has reached a final solution that he begins to consider what the outer face shall be. I have chosen two examples of this procedure (figs. 31, 32) because it seems to me so revealing of the aesthetic of the period. In the first, which contains further studies by Antonio for San Giovanni in Rome, the only sure thing is the void—a given volume of space—in the middle. Around this, architectural elements appear to explode outward in all directions: a central plan, a longitudinal plan (related to fig. 30), both with variants. The sense of centrifugal force is heightened by the virtual absence of exterior walls. Peruzzi's study for the crossing of St. Peter's (fig. 32) is more definite because the piers were already there when he started. But the outward movement is just as strong, and it is emphasized by the fact that elements lose definition in direct ratio to their distance from the center. The cross section, furthermore, is not drawn as the central portion of a great church, nor even as an isolated chapel, as it seems on first sight, but as a scene such as one would view when standing in the center of the space: a painter's concept of architecture. My impression is that the centrifugal character all comes from the tendency of these architects to visualize themselves in the center of a given space, looking outward. This is why they were so attached to the central plan and, to go a step farther, to *scenografia:* two ways of making it possible to view the whole environment from a single point.

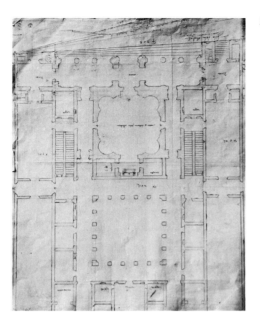

25. Plan Project for the Church and Hospital of S. Giacomo degli Incurabili, Rome, Antonio da Sangallo the younger. Florence, Uffizi
Courtesy of Soprintendenza alle gallerie, Florence

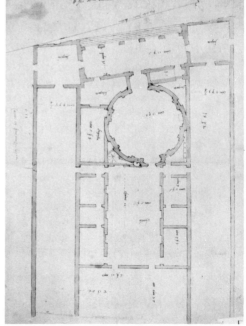

26. Plan Project for the Church and Hospital of S. Giacomo degli Incurabili, Rome, Baldassare Peruzzi. Florence, Uffizi
Courtesy of Soprintendenza alle gallerie, Florence

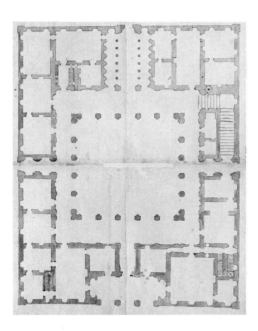

27. Presentation Plan of the
Farnese Palace, Rome, An-
tonio da Sangallo the
younger. Florence, Uffizi
Courtesy of Soprintendenza
alle gallerie, Florence

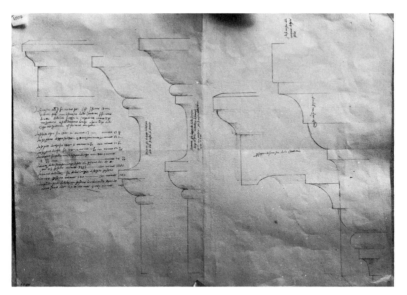

28. Profiles for the Farnese Palace, Rome, Antonio da Sangallo the
younger. Florence, Uffizi
Courtesy of Soprintendenza alle gallerie, Florence

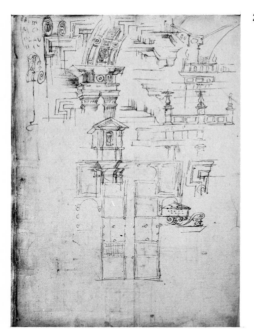

29. Studies for S. Biagio, Montepulciano, and Other Structures, Antonio da Sangallo the elder. Florence, Uffizi
Courtesy of Soprintendenza alle gallerie, Florence

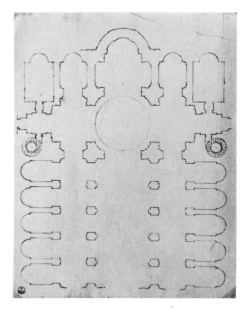

30. Plan Project for S. Giovanni dei Fiorentini, Rome, Antonio da Sangallo the younger. Florence, Uffizi
Courtesy of Soprintendenza alle gallerie, Florence

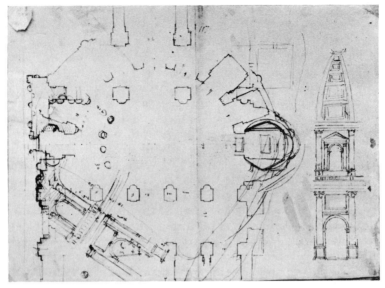

31. Plan Project and Elevation for S. Giovanni dei Fiorentini, Rome, Antonio da Sangallo the younger. Florence, Uffizi
Courtesy of Soprintendenza alle gallerie, Florence

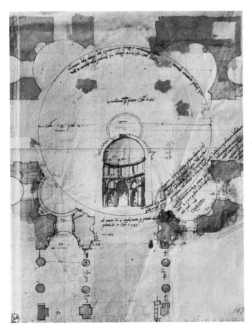

32. Plan Project for the Crossing of St. Peter's, Baldassare Peruzzi. Florence, Uffizi
Courtesy of Soprintendenza alle gallerie, Florence

Even when the architect finally applies himself to the problem of designing the façades, he seldom undertakes to make a scale drawing of an exterior elevation. He proceeds from the perfected plan to entrance portals, windows, and entablatures (fig. 33) . The significance of this procedure is that the architect thinks of the elevation as a neutral field into which plastic incidents are set at intervals: often, rather than draw up an elevation, he will explain it verbally in his plan.[27] As a consequence it often happened that the High Renaissance façade could be expanded or contracted at will, and Raphael's work provides a good example of this. The Vidoni-Caffarelli Palace in Rome was almost doubled in length, the façade of the Vatican Palace was tripled in size and twisted into a court (the Cortile di San Damaso) , and a large part of the design for the Pandolfini Palace in Florence was left out. I believe that none of the designs suffers much from this treatment. It is important by way of contrast to recall Alberti's demand that the façade be developed as an intricate system of interrelating proportions, giving the wall a vitality in plane; the failure of this principle in the early cinquecento is another example of the strange eclipse of the fifteenth century.[28] Perhaps proportions of this sort were

27. Interesting examples of this are Peruzzi's early study for the Palazzo Massimi in Rome and a church plan by Antonio da Sangallo. The first [Uffizi, *Arch.* 368, reproduced by A. Venturi, *Storia dell'arte italiana* (Milan, 1938) , XI, 1, p. 417, fig. 387] is a plan of the palace accompanied by a text explaining the façade: "In front of the portico metopes XX and triglyphs XXI height of the columns with base and capital palmi XX and thickness palmi two and one half that is II½." In Sangallo's sketch (Uffizi, *Arch.* 168, reproduced by Gab. Fot. della Sopraintendenza alle Gallerie, Florence, No. 14389) , the plan of a centralized church (study for S.M. in Monserrato?) is accompanied by the text: "This may be vaulted in two ways. The first, or cheaper, is this: the curve (*sexto*) of the cupola is begun at the same level as the impost of the great arches and the dome is built as a cloister vault (*vela*) . The second way is to make a cornice at the top of the arches constructed to a perfect circle and above this to go on straight so that you may cut in apertures of any kind you want or windows or even roundels. And over the said apertures make another round cornice from which you may begin to spring the cupola; but first keep it straight (i.e., "continue vertically") for a distance of 2½ times the projection of the cornice (an optical correction to make visible a full hemisphere) ."
28. On Alberti's principles of design, see R. Wittkower, *Architectural Principles in the Age of Humanism* (London, 1949) , pp. 40 f., 94 ff.

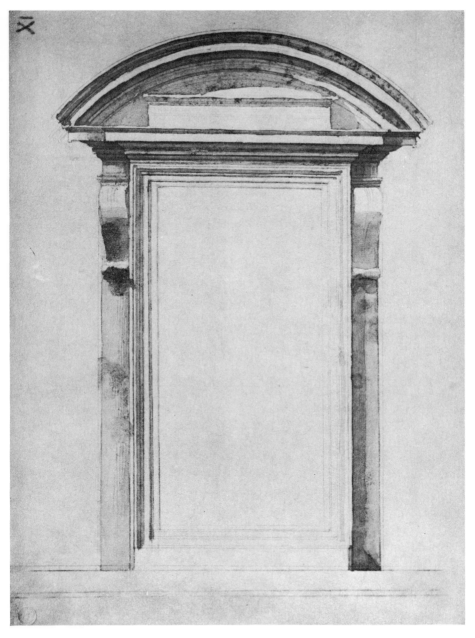

33. Study for a Window, Michelangelo. Florence, Casa Buonarroti
Courtesy of Art Reference Bureau

too abstract for the antitheoretical High Renaissance and had to wait for another humanist, Palladio, to rediscover their place in architecture. With Palladio, elevations and façades take on a role that they never again lost. I wonder if the absorption of the High Renaissance in Roman ruins does not explain this in part. Architects' drawings after antiquity were almost all plans and details—of necessity, since so few ancient elevations remained elevated. In addition, the study of Vitruvius encouraged the dominance of the plan, since the Hellenistic module is an arithmetic one found in the plan of the column, in contradistinction to Alberti's geometric harmony that integrates plan and elevation in one musical system.

Perhaps the character of Renaissance architecture owes much to the fact that its monuments started not from a complete idea, fixed in the symbolism of the blueprint, but from flexible impressions constantly susceptible to change. The ultimate statement, like that of the sculptor, evolved in the process of creating the mass itself. This way of conceiving architecture explains also the peculiarly biological character of Italian Renaissance building. The large monuments that took more than a decade to complete seldom followed an original conception, but evolved like a living organism in their growth. The successive architects at St. Peter's, while they held Bramante in reverence, never made the least attempt to carry out what he would have wanted. They took what was there as an inspiration for new ideas, and this habit of working with and in the building itself brought the efforts of many generations to a cohesive conclusion. How different this is from Renaissance France, where at Fontainebleau, Blois, the Louvre, each successive portion of the structure is methodically isolated from its predecessor! It is not chance that Renaissance Italy had no du Cerceau to preserve its projects the moment they had taken form.[29]

When I began to write this paper I expected to finish with a picture of an architect more like today's. But now he appears to be of quite a different species. What I have called his rugged

29. But it may be coincidence that we know Michelangelo's designs mostly through the engravings of Frenchmen: Beatrizet, Dupérac, Le Mercier.

individualism is illustrated first in his unwillingness to be bound by those abstractions we call plans and elevations; second in his refusal to establish a permanent office staff or even a studio for his own work; and third in his suspicion of theoretical principles and his avoidance of the written word, whether it be his or another's. We are accustomed to caricatures of the bohemian painter and sculptor in the proverbial garret, and the businesslike architect with offices in the commercial district, but in this segment of the Renaissance these roles, in a sense, were reversed. The Roman Renaissance architect was less trained in the technique and less organized in the practice of his calling than any of his contemporaries in the arts. But paradoxically this was a step toward establishing architecture as a respected profession, because it represented, far more than the procedures of painters or sculptors, a liberation from the bonds of the medieval shop system. At this stage the development of the architect's freedom and social stature was more important than the establishment of standards of workmanship.

8

The Importance of Sammicheli in the

Formation of Palladio

by GIULIO CARLO ARGAN

EDITORIAL NOTE: *This essay will seem less difficult when its connection with some familiar ideas is noticed; until then its complex abstract terminology, as with modern poetry, may make us too hastily suppose that it deals with remote questions. It assumes as its background the situation mentioned by Millon, the early-Renaissance idea that shapes in architecture imitate nature. That approach (which is genuinely remote from us, but not difficult) is reversed by Palladio, as the author points out. He introduces abstract proportions, the kind we consider normal (which genuinely are odd, but not strange, and hence easy for us). This conclusion may be related to Ackerman's passing remark that Palladio induced a change of emphasis from plans (the unusual main interest of the High Renaissance) to façades (ordinary in later centuries), since of the two the façade is more readily treated as abstract design. This study seems to contradict the most familiar modern discussion of Palladio's proportions, Wittkower's* Architectural Principles in the Age of Humanism, *which traces them from the rules of musical harmony. But the two interpretations are perhaps reconciled in Argan's observation that Palladio is several stages away from his sources because he has distilled them into an artificial manufacture.*

MANY YEARS AGO, in the course of studying Palladio, I pointed out the great difference between his architecture and classical

Roman systems, and at the same time the analogy in structure between his way of seeing forms and Paolo Veronese's. This difference had been observed by Milizia in the eighteenth century; he, to be sure, did not dare dispute Palladio's reputation as the greatest figure in the assertion and popularization of classicism in architecture, but he could not fail to point out that the artist, even though perfectly orthodox or at any rate a strict student of classical rules in his individual units of form, was nevertheless a good deal less so when constructing proportions and composing his buildings. Since then Fiocco's studies have shown the ties between Palladio and the humanistic culture centered at the University of Padua, a culture whose orientation toward antiquity was focused more on philology and grammar than on history.

Palladio was in fact not only the initiator of a new viewpoint in architectural theory but also the creator of that nonhistorical or, one might say, ideological classicism that later was to form the foundation of neoclassicism. Neither his architecture nor his treatise ever reveals the liking for ruins, so frequent in all Renaissance architecture from Alberti to Bramante, that testifies to a lively awareness that classical art occurred in history. For Palladio, instead, ancient classical form was eternal form, and the process that allows us to reconstruct it was a logical and grammatical process rather than a direct investigation of a monument. It did not matter that this form had been justified initially, and again particularly in Bramante's version of it, by being connected with an established concept of space, and therefore had been the nucleus of a perspective construction. It now had a value in and of itself, the result of a series of steps in logic, and made its own beauty real not through relationship with anything, but absolutely. More precisely, the relationship among the forms no longer existed a priori as a system of proportions but was settled a posteriori as a logical grouping of these absolute forms into a whole, which coordinated and arranged them without diminishing their independence, in fact underlining it. It is appropriate to emphasize the logical quality of this relationship, because it was to become the basis of the abstract rationalism of neoclassical theorists like Padre Lodoli,

whose position, fundamentally typical of the Enlightenment, is important precisely because it supposes and defines constructive logic to be a process or technique taking place exclusively in the human mind. It was no longer assumed to be an inference from nature's logic—that is, from nature understood as space. Hence it can be said that Palladio's architecture is the first in the Renaissance that does not set out to "represent" space or to "construct" it, to show the truth of the supreme laws of the universe in its system of form and construction, but instead is made up as a mere manufacture, an object produced by man for man, a dwelling (fig. 35).

In this way we may explain the relationship established between building and environment, new because it is in addition completely nonperspective. Even though the building does not sum up or represent the space, still it exists within it, and the space, which is no longer thought of as structure, still counts as pure phenomenal reality, as a sensed and shifting assemblage of effects of light and atmosphere. And this empiricism, limited for that matter to neutral acceptance of external conditions, in no way conflicts with the fixing of the form as beauty-in-the-object, independent of all laws of space. For the form retains its aesthetic character however much the environmental conditions may change, precisely on account of this internal perfection of the architectural "term," this absolute value of the image apart from all meaning (a quality that explains the enthusiasm over Palladio's architecture in Elizabethan England). In addition, the concept of the form as produced by the human mind, even by a logic belonging to it alone, explains how Palladio's architecture points the way to a classicism that will no longer be a *Weltanschauung* but only a culture, the culture of an elite, of a privileged and enlightened class. Hence, admittedly through the intermediacy of Scamozzi's city architecture, Inigo Jones will have no trouble transferring Palladio's "beauty" into an ideal of social decorum and combining it with the practical needs and comforts of the English aristocracy.

But returning to the problem of space, there are two contentions that must be thoroughly rejected: first, that simply because Palladio's architecture is fundamentally nonperspective, it

must also be considered nonspatial (as if it were not architectural forms themselves that vied with each other, in instance after instance, to fix the concept of space), and second, that in giving up a point of departure in perspective, this architecture implied that the architect was somehow being stimulated by the so-called spectacle of nature to a free-thinking, spontaneous, palpitating emotionality. Our contention is that Palladio not only is turning away consciously from the perspective interpretation of architectural form but is also deliberately disconnecting and disintegrating it, to produce, out of the destruction of all a priori relationships, the quality of unrelatedness or absoluteness in the individual forms. And this indeed is confirmed by his frequent placing of pure solids and voids in the same plane with no transition. Since the notion of an objective space constant in its structure cannot be accepted, it is clear that Palladio in his architecture realizes a new concept of space, opposed to the traditional perspective concept but no less legitimate, a space no longer the *precondition* of the relations among objects, but instead the *product* of the logical relationship that the human mind sets up among objects. Hence light and atmosphere are no longer cosmic or spatial elements—continually shifting, but still with values that we can fix by the structure of proportion and perspective—but are so many objects, clouds, water, trees, hills, that at times enter into a relationship with the formal object, the architecture.

The history of architecture in the sixteenth century in the Venice area is generally studied as the progressive refining and ultimate dissolving of classic architectural form in natural light and atmosphere. If it were that, this architecture would embody a first step toward the "open" forms of the Baroque, whereas on the contrary it is known how Venetian architecture resisted Baroque infiltration, entrenching itself in a rigorous formality lasting up to Longhena (who could accept whimsical form but not loosened form). Its development must be understood instead in another way, which will also explain its literal-minded attachment to individual classic forms, for it is clear that the use of logic to fix architectural form and to correlate the forms excludes emphasis on form and on correlation. In the Olym-

34. Palazzo Bevilacqua, Verona, Michele Sammicheli.
Courtesy of Art Reference Bureau

35. Palazzo Chiericati, Vicenza, Andrea Palladio.
Courtesy of Art Reference Bureau

pian Theater Palladio makes a point of demonstrating that
perspective is not a system, but a method, process, or technique,
and, if a law at all, a law of illusion and not of reality.

Since the path leading to this systematic breakup of the
perspective network of relationships is, in fact, the path along
which Palladio's formation as an artist moved, then the essential
experience in that formation is undoubtedly the architecture of
Sammicheli. He had been the first architect to effect a dissocia-
tion of the spatial homogeneity of Roman architecture, thus
managing to isolate the elements as pure and finite forms and
then putting them back together, with a syntax that does sug-
gest the rhythm of classical antiquity but cannot be considered
spatial or perspective in any sense.

It is known that Sammicheli was formed in Rome in the
inner circle of Bramante and Giuliano da Sangallo, that he was
interested in fortifications from the first, that about 1530 he had
already conceived the defensive system at Verona as a broad
track in city-planning style, and that already toward 1530 his
style appeared in its stable form in the Pompei, Canossa, and
Bevilacqua mansions (fig. 34). In the development of Renais-
sance architecture, military architecture represented a side cur-
rent that diverged, in which space was not an a priori geometric
structure but simply a datum. It no longer had a constant
proportional pattern but was an assemblage of objective cir-
cumstances; above all it was "ground," undulating levels, a
matter of accesses and refuges, possibilities of movement and
maneuver. The new means of war had now made obsolete the
closed system still tied to the system of the ideal city; the city's
defensive system spread out into the surrounding country and
enfolded nearby villages, networks of roads, watercourses, and
natural elevations. This elastic conception of space deeply influ-
enced architectural form, so that it could not retain a spatial
and perspective principle, it stood opposed to fortification as the
citizen did to the rustic, it formed the heart (the political heart,
too) of the city that the bastions defended. Sammicheli at
Verona worked out what Palladio a little later would work out
at Vicenza: he constructed mansions for the great families, but
with the aim (already involving city planning) of making them

be the adornment of the city, just as these families were considered the adornment and the focus of the community of citizens.

Now all of Sammicheli's buildings, and especially those around 1530 that could influence Palladio's development most, derived from Bramante's system (as in Palazzo Caprini), which was also to remain the system at the basis of Palladio's mansions, but they altered its proportional relationships away from balance, in such a way that every element was drawn toward the surface, detached from perspective connections, could boast of a design of its own or its own formal quality, repeated but never articulated; even the linking elements acquired full independence of form. In Palazzo Bevilacqua, Sammicheli went so far as to alternate openings of different width on the same plane within the same structural framing system and to alternate columns with straight fluting and columns with spiral fluting so that the light, vibrating on them differently, would distinguish their differing materials and colors within their identical form and location. By this route Sammicheli reached an architecture whose classicism was simultaneously severe and fanciful, a classicism more of speech and gesture than of substance or structure, which can be readily tied to the revaluation of the concept of "rhetoric" going on in those years.

Palladio's great step beyond Sammicheli consisted precisely in overcoming that literary, evocative classicism, in creating a new structural syntax, and in intuiting a new space which did not generate the architectural form but was generated from it and thus preserved in the form its value of being an idea-object, and of being, finally, a mere "term," which could be inserted into the context of ever different statements yet lose none of its own original, philological purity.

Part IV

The End of Italian Renaissance Painting

9

Maniera as an Aesthetic Ideal

by JOHN SHEARMAN

EDITORIAL NOTE: *The two distinct parts of this essay both drastically change the conventions in our ideas about mannerism, the more strikingly in that these are conventions of the chic or avant-garde. The usual ideas refer to Pontormo and a group of artists about 1520, whose new style is in revolt, is called mannerism, and works with unbalance, disproportion, and pressure. The author's first point is that the term is really the name of a different group of artists, who did not revolt but evolved from their predecessors and who were more graceful than tense. This will be added knowledge, but not surprising, to readers of a classic early study of the Pontormo group by Walter Friedlaender (available in paperback). Though it is now published under the name* Two Essays on Mannerism, *Friedlaender, for the reason pointed out by Shearman, avoided calling these artists mannerists, called them anticlassicists instead, and used the term* maniera *for the later group around Salviati mentioned here. Most other writers, however, were less careful, so that Shearman's first point is a corrective of received ideas. Its truly original point is its second, tracing the graceful style of the*

maniera *to painters working at the same time that Pontormo was developing his style, and emphasizing its status as a major current in the art of its century.*

IF WE SURVEY, from a distance, recent concepts of mannerism, we must admit that the situation is fluid and in certain areas chaotic. I suppose that students of no other period that has a name—Romanesque, baroque, postimpressionist—are so haunted by, or so much in disagreement over, the meaning of that name. There need be no hesitation in thinking again about the problem, even on the grounds of convenience, since there is no unanimity in the way the term mannerism is used—what qualities in a work it exemplifies, to what groups of works it applies. I suggest that there is a reason for this situation. In this century, definitions have been fabricated by historians, rightly intent on dispelling earlier prejudices against so much of six-teenth-century art, and each historian has felt free to make his own definition and to choose whatever works he would like to apply it to. No wonder that definitions vary so widely, for most are, in my view, arbitrary.[1]

When quite recently historians looked again at the cinque-cento, they found in it vital currents of style to which prejudice had taught them to be blind. By an accident—the clear sym-pathy established by early-twentieth-century tastes—the current that aroused most enthusiasm embraced the early work of Rosso, Pontormo, Beccafumi, and Parmigianino, and since mannerism, a term they inherited, applied to the cinquecento, many of them freely applied it to this current. With infinitely varying emphasis, detail, and choice of personalities, and with bewildering attempts to account for this phenomenon by out-side events, this technique has in general been followed. What is its validity? If one can imagine this technique let loose upon

1. The best survey of the historiography of mannerism, which gives a good idea of current differences in interpretation, is Eugenio Battisti's "Sfortune del Manierismo," in *Rinascimento e Barocco* (Milan, 1960), pp. 216 ff., which supersedes G. N. Fasola's less complete and less impartial "Storio-grafia del Manierismo," in *Scritti . . . in onore di Lionello Venturi* (Rome, 1956), I, pp. 429 ff.

the nineteenth century, one might begin impressionism with, say, Delacroix.[2]

The arbitrary approach accounts for the present fluidity, but its disadvantages do not stop at the inconvenience and contentiousness of chaos. If we allow definitions without controls, they become unarguable and virtually useless, for in a situation where each of us makes his own definition of mannerism, then, once our position is stated, no further discussion is possible. Secondly, the situation has in the last forty years had another unfortunate result: it has erected a new set of prejudices to replace the old ones. If the origin of mannerism is to be seen in such works as Pontormo's Certosa frescoes, or Rosso's Volterra *Deposition,* and since so many analyses, brilliant and entirely valid in themselves, have underlined the aesthetic violence, the expressiveness, and the spiritual intensity of these works, then it follows that these are the qualities of pure mannerism. Parenthetically, I never understand how this includes Parmigianino, or conversely why Dürer and the late Donatello are not mannerists. But if this much is granted, then a work such as Salviati's *Pace,* because it has none of these qualities, is a watered-down, anemic example of mannerism. In general, the result has been to throw the emphasis of interest, and so of research, upon the second and third decades of central Italian art, to the detriment of the rest of the century. This situation is at last changing. I believe that Salviati was not only, quite possibly, a greater artist than Pontormo, but that most of his work stands for something utterly foreign to the early work of Rosso and Pontormo. Thirdly, since it has become so common to identify mannerism with shock, tension, and violent expression, such analyses have too often been forced indiscriminately upon almost any cinquecento object, frequently in cases where they seem to me to be inappropriate. I have never found support for such interpretations deduced from the relevant literary material.

I should like to suggest that there is another way in which we

2. Many style labels can be defined only according to common usage. Impressionism, and mannerism even more, are unusual in that they may be traced back to ideas written down in the period in question.

can arrive at a meaning and a set of values for mannerism; it
can be drawn out of the material, and not imposed upon it; it
need not be arbitrary, but can be controlled and argued at every
stage. Let us take it as axiomatic, as history entitles us to do, that
every mannerist work must exemplify the quality *maniera*.

I must here make a semantic digression, because in the best-
known and very useful study of this word,[3] it is denied that
maniera is commonly used as an absolute quality (thus con-
tradicting the Accademia della Crusca).[4] In almost all cases the
word *maniera* can be rendered by the English word "style." We
use style in two different ways. First, and most usually, we
qualify it: we talk of good and bad style, Byzantine style,
Albertinelli imitating the style of Fra Bartolommeo, and so on
(corresponding to *buona maniera, maniera greca, la maniera di
Fra Bartolommeo*). But there is also what is known as the
absolute usage: we say that a person or a thing "has style," and
this needs no qualification by an article or an adjective; simi-
larly in Italian, since at least the quattrocento: "It is right for
the ladies to gossip, *ma con maniera*."[5] I think we all mean the
same thing when the word style is used in this way. The positive
qualities of style are surely a certain poise, cultured elegance,
refinement, and perfection of performance; the negative qual-
ities are unnaturalness, affectation, self-consciousness, and
ostentation. This corresponds precisely enough to the original
meaning of *maniera*. Georg Weise, in a recent exemplary study
of the entry of this word into the Italian language,[6] traced both

3. M. Treves, "*Maniera*, the History of a Word," *Marsyas*, 1, 1941, p. 69.
4. *Vocabolario degli Accademici della Crusca*, ix, 1905, pp. 819–20, nos. vii,
viii, xix, and especially xx, which includes some of the texts from Vasari and
Borghini quoted here. Treves, *op. cit.*, p. 81 (but contrast p. 74), dismisses
this usage as an occasional trope.
5. "Tuttavia d'eccezion soffre la regola: Dee la donna ciarlar, ma con
maniera"—Guadagni, *Poes.* i, 95, quoted in *Accademia della Crusca*.
6. Georg Weise, "La doppia origine del concetto di Manierismo," in *Studi
Vasariani* [Atti del Convegno internazionale per il iv Centenario della
prima Edizione delle "Vite" del Vasari, Firenze—Palazzo Strozzi, 16–19
Settembre 1950] (Florence, 1952), pp. 181 ff. On only one point do I
believe that Weise, if I understand him correctly, is in error. Because
Castiglione counseled the avoidance of *affettazione* at all costs, Weise
concludes (p. 184) that he is, so to speak, against *maniera*. But *affettazione*

its history and its meaning to the French courtly literature of the thirteenth to the fifteenth centuries. Here, *manière* is a wholly desirable quality of people, and corresponds roughly to *savoir-faire,* or sophistication; it is a part of an artificial code of behavior. So much is it an absolute quality that it can be personified in allegories of the virtues of the perfect courtier: *La Dame Manière.* Weise then showed how the word and its meaning came to be used by Italian authors of the first half of the quattrocento, like Giusto dei Conti (d. 1449) who praises *le virtù, la beltà, la maniera* of his lady. In a *canzone a ballo* Lorenzo de' Medici writes: "Whether you are walking, standing, or sitting, do it always with *maniera.*" Because of the great vogue for the literature of manners in the cinquecento, Weise naturally found examples more frequently in the literature of that period.

One constant factor in the development of art criticism is the borrowing of techniques of analysis and terms of reference from other fields of criticism. For example Vasari, in formulating the first definition of color harmony, took his formula and vocabulary directly from musical theory;[7] this is a familiar process, which of course also happens in reverse. The borrowing takes place when one field of criticism is less mature or articulate than another; one of the most articulate studies in the Renaissance was that of manners. It has been shown, for example, that Vasari's way of using the term *grazia* is borrowed from Castiglione,[8] and that his concept *facilità* is based upon the latter's

in this case is not to be translated as "affectation" with its modern meaning. Castiglione defines the term (*Cortegiano* I, 28 and 40) as the vice opposite to *sprezzatura:* it is the application of too much effort, and corresponds to Vasari's *fatica di stento.* See below nn. 10 and 11.

7. In the chapter *How Colors Should Be Harmonized* from Vasari's *Treatise on Painting, unione* is defined thus: "a discord of different colors brought into accord" and "a discord made most concordant," which may be compared with "Harmony is discord concordant" (for example, on the title page of Franchino Gafori's *De harmonia musicorum instrumentorum,* Venice, 1508). Vasari also uses the analogy *musica unita* when talking about color.

8. A. F. Blunt, *Artistic Theory in Italy, 1450–1600,* 2d ed., 1956, p. 97.

sprezzatura,[9] the effortless resolution of all difficulties. Dolce actually retains Castiglione's polarities *sprezzatura* and *affettazione*.[10] I suspect that Castiglione was a much more general source of inspiration than this, and one reason was that the *Cortegiano* made its own bridge to the arts. Not only was an artist present at the discussions, but Castiglione often quotes an example from the history of art to illustrate a general point of human behavior.[11]

It was with these conditions that *maniera*, from being an attribute of people, became applied to a similar quality desirable in works of art. I think it is significant that the earliest examples I have been able to find of *maniera* being used in this way occur in the work of courtier writers. The first is a sonnet in praise of Pisanello by Agnolo Galli, 1442 (almost as soon as the word appears anywhere) :

> Art, measure, air, design,
> *Maniera*, perspective and naturalness
> Heaven has given him. . . .[12]

9. R. J. Clements, "Michelangelo on Effort and Rapidity in Art," *Journal of the Warburg and Courtauld Institutes,* XVII, 1954, pp. 308–10. For the origins of Castiglione's *sprezzatura* (especially *Cortegiano* I, 27) in antique theory (Cicero, Pliny's *venustas,* the Greek *charis*) , see S. H. Monk, "A Grace Beyond the Reach of Art," *Journal of the History of Ideas,* V, 1944, p. 131.
10. ". . . a certain appropriate carelessness is wanted. . . . For where labor can be detected, there must needs be hardness and fussiness. . . ." [L. Dolce, *Dialogo della pittura* (Venice, 1557) .]
11. E.g., illustrating the virtue *sprezzatura* against *affettazione* (*Cortegiano* I, 28) : "Apelles found this fault with Protogenes, that he did not know how to take his hand away from the panel." Protogenes' fault was "being fussy in his works." Later in the same passage *sprezzatura* is illustrated in terms of a painter's technique.
12. G. Vasari, *Le vite* . . . , I: *Gentile da Fabriano e il Pisanello*, ed. A. Venturi, (Florence, 1896) , p. 49. I have followed Venturi's attribution of the poem. J. Dennistoun [*Memoirs of the Dukes of Urbino* (London, 1851) , I, p. 416], who first published the poem, gave it to the courtier Ottaviano Ubaldini, and Mrs. Marilyn Lavin tells me there are reasons why this attribution is to be preferred. In any case, it is not in doubt that the poem was written in 1442 at the court of Urbino. I believe this text has not been quoted in this connection; however, the greater part of those which follow have been noted many times in these discussions.

This may be compared with Lorenzo de' Medici's list of the virtues of women: "great intelligence, polished and modest ways and habits, elegant *maniera* and gestures."[13] The second example is from the 1519 letter to Leo X on the architecture of Rome, where the matter is Raphael's but the syntax is Castiglione's; after praising the antique architects, they say that the buildings of the Goths were "wanting in every grace, without any *maniera* whatever."[14] The construction is a favorite of Castiglione's, and there is no question that *maniera* is a quality equated grammatically with *gratia*;[15] the term is therefore used absolutely, as in Galli's poem. Let us notice in passing that it is clear from the context that grace and style are qualities of modern and antique architecture.

The letters of Aretino forge this link between the two fields of criticism in a slightly different way. I know of no case where he uses *maniera* absolutely as an attribute of a work of art, though he does so, for example, when making an evocative appreciation of Tasso's poetry, linking *maniera* as Castiglione does with grace.[16] But there are cases where he talks of the manners of, say, a piece of decoration, exactly as if he were talking of a person; he describes the rooms in Duke Cosimo's palace, "having such artfully made *maniere*," and praises a relief by Raffaello da Montelupo, 1536, "having such delicate *maniere*."[17]

13. Weise, *op. cit.,* p. 183.
14. V. Golzio, *Raffaello nei documenti* (Vatican City, 1936), p. 85.
15. See, from the same letter, "entirely without art or design" (of the reliefs on the Arch of Constantine) and "entirely without art, measure, or grace." The whole sketch of the history of architecture in Rome has a remarkable similarity to Castiglione's brief history of the Latin tongue in the *Cortegiano* I, 32. The description of the period of barbarian architecture has this analogy: "Since Italy had not only been preyed upon and devastated, but long inhabited by barbarians, the Latin language was corrupted and spoilt by contact with those nations. . . . Hence it has long been unregulated and various among us, having had none who cared for it or wrote in it or tried to give it any splendor or grace at all. . . ."
16. ". . . with angelic grace in style and heavenly *maniera* in harmony . . ." [Pietro Aretino, *Lettere sull'arte,* ed. F. Pertile e E. Camesasca (Milan, 1957), II, no. 77, October, 1549].
17. *Ibid.,* II, no. D (February, 1549) and I, no. XI (June 7, 1536); cf., "philosophers, lordly and full of noble *maniere*," I, no. 57 (November 26, 1537).

Vasari, of course, uses *maniera* in a multitude of different ways; the absolute one is common, and again it is as a desirable quality. The crucial text occurs in the *Proemio* to the third part of the *Vite,* where the familiar list of five qualities, of which the artists of the second section were still deficient, ends with *maniera.*[18] There are two points about this. The first four qualities, rule, order, measure, design, are all to some extent technical terms that need to be defined for the ordinary reader, and he defines them. But he does not define *maniera.*[19] This is because the term comes from everyday use and from the literature that his readers would know: there was no need to define it. Secondly, almost immediately afterward he repeats the list, applying these qualities to Leonardo, but he replaces *maniera* with *grazia;*[20] again, *maniera* is not the same as *grazia,* but it must be analogous grammatically, and must also be a positive quality. Then he says that Ghiberti, in his bronze doors, showed invention, order, *maniera,* and design, and Maso da San Friano invention, design, *maniera,* grace, and harmony in coloring.[21] There are other cases of *maniera* used in this way in the *Vite,* and at least one in the letters, describing a wax head by Michelangelo.[22] Using it in different contexts, he naturally

18. G. Vasari, *Le vite* . . . , ed. G. Milanesi, Florence, 1879, IV, p. 7.
19. He only says (p. 8) what makes it perfect: *"Maniera* then became most beautiful of all by the practice of frequently copying the most beautiful things, and using the most beautiful element of each, hands or heads or bodies or legs, in combination, and making one figure of all those beauties as well as one could, and using it for all one's figures, which therefore is called beautiful *maniera."* He then discusses (p. 9) the shortcomings of the artists of the second age: ". . . as to rule, a freedom. . . . As to drawing . . . not that soft and graceful facility. . . . As to maniera . . . gracefulness in making all the figures slim and charming . . . by the design and judgment used in executing them."
20. Vasari-Milanesi, IV, p. 11.
21. Vasari-Milanesi, II, p. 106, and VII, p. 612.
22. Vasari-Milanesi, VII, p. 421: (of Barbara de' Longhi) "she has begun to paint a few things with quite good grace and *maniera";* and II, p. 288, (*Life of Masaccio*) : "the figures that stood on tiptoe were not good at all and had no *maniera* in essential parts." In the letter to Aretino, September 7, 1536, sent with the wax head, Vasari praises its "liveliness . . . mixed with profound design, topped off by such an abstracted and wonderful

gives it subtly varied shades of meaning, but in general the
original concept, of accomplishment and cultured refinement,
makes perfect sense. In one well-known passage on sculpture,
for example, he stresses its antinaturalism, or rather its con-
scious abstraction from and idealization of nature.[23] Similarly,
Giorgione followed the "ensign of living things, and no imita-
tion of *maniera* whatever."[24]

Vasari and his generation were not conscious of periods in the
history of art with contrary stylistic characteristics, but only of a
greater or lesser approximation to an absolute standard of
perfection. Therefore, he does not use the term *maniera* with

maniera" (VIII, p. 266). Problems of interpretation of Vasari's usage
frequently arise. Paradoxically, *maniera* can still be meant absolutely, as a
universal quality and not a particular style, even when it is qualified.
There is an example in the Vita of Polidoro and Maturino (V, p. 144)
". . . because of the fine *maniera* and fine facility they had . . .," which
does not seem ambiguous, since *maniera* is the syntactical analogue of
facility. Other cases are more questionable; for example, talking of the
soldiers in Francesco Salviati's *Anima Resurrection,* ". . . in various
attitudes, shown in foreshortening forcefully and with a fine *maniera,*" and
again, after discussing the Udienza frescoes: ". . . everything he did always
had great judgment, with copious and varied invention; and what is more,
he had a command of drawing, and had finer *maniera* than anyone else in
Florence" (VII, p. 27). In the last, the omission of the article *a* before
finer maniera makes the sense most probably absolute. In a similar way,
Vasari expands *design* to *good design* (e.g., I, p. 49). Cf. Giovanni della
Casa's definition of the content of his *Il Galatheo* (Venice, 1562, p. 3):
"what I consider it proper to do, so as to be well bred and pleasant and of
fine *maniera* in communicating and dealing with people."
23. Vasari-Milanesi, I, p. 149.
24. Of the Fondaco dei Tedeschi frescoes: "he made it a point in all he
did to hold to the ensign of living things, and no imitation of *maniera*
whatever; and this work is celebrated and famous in Venice." (Vasari-
Milanesi, IV, p. 97). This text is usually interpreted differently: Giorgione
followed nature rather than the style of other artists. He seems rather to
talk of a general contrast of methods of work, following a naturalistic and
not an idealistic process (the latter would certainly be related to the Neo-
Platonic theory of imitation of an ideal form in the artist's mind). If this
is so, the passage is interesting for the surprisingly objective distinction
between Venetian art and his own ideas; nevertheless, in the last sentence
a sly bias is implied—Vasari held that the best painting in Venice was by
Francesco Salviati.

historical discrimination, restricting it to his own century, but wherever he, in his own subjective vision, feels it appropriate. It seems to me to make perfect sense that he sees the quality in Ghiberti's reliefs, just as Galli recognized it in Pisanello a century before. With the same logic, Cellini found *maniera* in an antique torso.[25] In fact, the expression is used *critically* before it is associated with a limited stylistic phase. Two authors of the eighties, Borghini and Armenini, weighed it in the balance and at times found it wanting. The former suggests that it is not necessary to "hold to *maniera*,"[26] and the latter, using it often as an ordinary term of praise, like Vasari, is worried about its artificiality.[27] It is out of this critical usage that the

25. Talking of the newly discovered antique torso which he later turned into the *Ganymede:* "Then I showed His Illustrious Excellency, with the best means I knew, that I would make it absorb such beauty and gifts of intelligence and rare *maniera.* . . ." (*Vita di Benvenuto Cellini . . . scritta di sua mano . . .*, Milan, 1821, II, p. 311.

26. Of Jacopo Sansovino's *St. James* in the Duomo: "Although the head is unanimously considered beautiful, and is, it seems that the professionals wish it had more *maniera* . . . to me it seems one could not ask for it to be more beautiful, and a good master is not always obligated to hold to *maniera,* and sometimes may show his knowledge of how to make things finished and delicate." (Borghini, *Il Riposo,* Florence, 1584, p. 159; for Borghini, and some others, *di maniera* must be very close in meaning to *sprezzante*). This text is doubly valuable for the expressed wish of the contemporary sculptors for more *maniera*. Thus, an ideal that had surely begun as something more or less subsconscious had, by the end of the century and at the moment of its demise, become a subject for discussion.

27. G. B. Armenini, *De' veri precetti della pittura,* Ravenna, 1587. Positively in I, p. 50: ". . . with *maniera* and with judgment, they, the good painters) have robbed the best of all colors . . ."; for the association of *maniera* with *giuditio,* see the Vasari text quoted above, n. 19. Another passage (II, p. 89) also corresponds closely with Vasari's expansion of maniera: "If Zeuxis had not had *maniera* remarkable in itself, besides his great diligence, he would never have harmonized the beautiful separate limbs that he took from many girls, nor would that perfection he had imagined beforehand have come to be." A passage expressing reservations (III, p. 223) seems already to turn toward Bellori's point of view (on the dangers of too much facility): "therefore be assured that *maniera* alone cannot replace everything, or ever suffice for all aspects. . . . Countless youths can be seen today growing set in their errors by relying too much on their own idea and procedure, since without setting up any example to imitate or at least to make things clear to oneself . . ."

historical one grows, first in the familiar letter of Vincenzo Giustiniani,[28] where it is applied to a group of painters, and then fully formulated in Bellori's famous purple passage in the *Vita* of Annibale Carracci, 1672.[29] There is no difference in *meaning* between Bellori's and Vasari's use of the word, but by a mutation in prejudices it becomes a term of abuse rather than of praise; now, however, it is seen as something that distinguishes a period, and he conceives virtually a movement, begun by Raphael, among others, "who were the beginners of *maniera;*" the first praiseworthy reaction came with the work of Rubens and Barocci. Although, in general, later writers followed Bellori, this is not always so; there are those who continue to use the expression without *historical* intent, as a general term of praise or abuse.

It is at this point that derivative words become important. They existed from the beginning. The French *enmaniéré,* and the Italian *manieroso,* meant stylish, polished, refined.[30] Vasari and Firenzuola[31] use the Italian form for elegant people, and later writers apply it, without change of meaning, to works of

28. Bottari and Ticozzi, Raccolta di lettere . . . , Milan, 1822 ff, VI, p. 125 (the letter was first published in Rome in 1675) .
29. Talking of the decline in the sixteenth century: "Craftsmen, abandoning the study of nature, spoiled art with *maniera* or in other words a fanciful idea based on day to day procedure and not on imitation. This vice destructive of painting first sprouted up in masters of honored reputation, and took root in the schools that followed after, whence it is unbelievable in the telling how much they degenerated, not only from Raphael, but from the others who gave *maniera* its start"; (G. P. Bellori, *Le vite* . . . , Rome, 1672, p. 20) . It is likely that *maniera* is to be interpreted in this sense, and absolutely, in the following comment of Bellori's on Annibale's praiseworthy reaction to Michelangelo: "Turning from *maniera* and from the anatomies of the *Last Judgment,* he transformed himself, and looked again at the wonderful nudes in the units of the ceiling above. . . ." He seems in fact to be contradicting Vasari, who stated that in the *Last Judgment* Michelangelo had demonstrated "the way to the grand *maniera* and nudes and how much he knows of the difficulties of design."
30. Weise, *op. cit.,* p. 182.
31. Vasari-Milanesi, V, p. 173, of Rosso: ". . . good at everything, and *manieroso* and courteous in all his actions." Agnolo Firenzuola (d. 1543) : "She was beautiful and manierosa . . ." (quoted, with several other examples, in N. Tommaseo and B. Bellini, *Nuovo dizionario della lingua italiana,* Turin, 1929, III, I, p. 82) .

art. Ottonelli and Pietro da Cortona (1652)[32] contrast the
naturalist Caravaggio with the Cavaliere d'Arpino, with his *stile
manieroso e gratioso*, and it is a very popular expression with
Malvasia (1673) who, associating it with adjectives like af-
fected, dashing, willful, shows not only his prejudice but also
his retention of the original concept.[33] He restricts it to the art
of a certain period, roughly to the contemporaries of Salviati.
Baldinucci's alternative is *manierato*,[34] used with the vicious-
ness of Bellori, but it is still used objectively by others; a few
years later Richardson, in the Uffizi, made this revealing note
on an antique bust of Plautilla: "very young, and a natural
pretty air: This is not common in the Antique, which is
generally *Manierato*."[35]

32. P. Ottonelli and Pietro da Cortona, *Trattato di pittura*, Florence,
1652, p. 26: "the former, Michelangelo, kept to nature. . . . The latter,
the Cavaliere, follows his own genius in painting and worked up to the
excellence of a *manieroso* and graceful style. . . ." Quoted after Nicola
Ivanoff, "Stile e maniera," *Saggi e Memorie di Storia dell'Arte*, I, 1957, pp.
115–16; this very comprehensive study deals with a different meaning of
the word which is not the root of mannerism: *maniera* as personal style,
like handwriting. Vasari and others frequently use the word in this way.
33. *Felsina pittrice*, I, pp. 253, 276, 358. In I, p. 276, he compares Camillo
Procaccini with his father; Camillo is "bolder, larger, more wilful, more of
an inventor, though at times too *manieroso* and not too correct . . .";
comparing Camillo to Giulio (I, p. 288) : "the one moderately *manieroso*
and resolute, the other very natural and studied." The text of I, p. 358, is
the famous one on the Bolognese contemporaries of Salviati quoted by
W. Friedlaender in "Der antimanieristische Stil um 1590 und sein
Verhältnis zum Übersinnlichen," *Vorträge de Bibliothek Warburg*, 1928–29,
p. 216, n. 2.
34. F. Baldinucci, *Vocabolario toscano dell'arte del disegno* . . . , Flor-
ence, 1681, p. 88, and *Lezione di F.B., nell'Accademia della Crusca Illus-
trato*, Florence, 1692 (". . . that defect that is called *maniera* or
manierato, which means weakness of the mind and still more of the hand
in following the truth") . In his *Vita* of Giambologna (II, p. 122) Baldi-
nucci characterizes the *Samson* then in the Giardino de' Semplici and now
in London: "In this statute of Samson Giambologna seemed to surpass
himself, in that he succeeded in keeping it somewhat further away from a
certain *manierato* that some of his works have, and as a result closer to
nature and truth." Lanzi quoted Bottari's remark on Michelangelo: "there
is a little of the *manierato*, covered with such art that you don't see it."
35. J. Richardson, *An Account of the Statues* . . . *and Pictures in Italy,
France, etc., with Remarks*, London, 1722, p. 52.

The term mannerist appears first, as is well known, in French; Fréart de Chambray coins *maniériste* for a group, including the Cavaliere d'Arpino and Lanfranco, whom he wishes to abuse: he uses it critically, not historically.[36] The earliest Italian example I know—of 1785—is already historical in sense.[37] Lanzi's frequent use of the term from 1792 onward is well known, but I must underline two points: first, he states that his *manieristi* are precisely those, in the epoch succeeding Leo X, whom Bellori described as painting *di maniera*,[38] and second, their mannerism is opposed, as it should be if the meaning is indeed continuous, to the early work of Rosso as well as to the High Renaissance.[39]

36. R. Fréart de Chambray, *Idée de la perfection de la peinture,* Le Mans, 1662, p. 120, see Treves, *op. cit.,* p. 80. In John Evelyn's translation (London, 1668, p. 122) the term is *Manierist.*

37. The anonymous panegyric on David's *Oath of the Horatii,* written 1785, in *Memorie per le belle arti,* Rome, 1787–88 1, p, cxxxviii: the *colorito* is contrasted favorably with "quell'affettata vaghezza di tinte, che forma la delizia dei manieristi." Treves (*op. cit.,* p. 80), overlooking this and Lanzi's first edition, gives the first appearance in Italian as Salvini's translation of Fréart, 1809.

38. L. Lanzi, *La storia pittorica della Italia inferiore . . . compendiata e ridotta a metodo . . .,* Florence, 1792 [I vol.] p. 246 (in the expanded Bassano edition, *La storia pittorica dell'Italia,* 1809, I, p. 186): "painting . . . became a labor of day-to-day application, almost a mechanism, an imitation not of nature, which was not looked at, but of the willful ideas that arose in artists' minds. (1) . . . These are the mannerists." The footnote (1) refers to the Bellori passage quoted here n. 29. Cf. also, in the 1809 edition, the new introduction to Vol. II, p. 3. Further, his remarks on Federigo Zuccaro, "more *manierato* than Taddeo, more willful in decorating, more crowded in composing . . .," seem to be based on Malvasia's distinction between the two Procaccini (see above, n. 33).

39. Lanzi's longest passage on mannerism concerns the contemporaries of Vasari (1792 ed., pp. 94–96; 1809 ed., I, pp. 186–89, expanded); in this passage he describes a decadence (following Baldinucci) relative to the "strength of Michelangelo, gracefulness of Andrea, wittiness of Rosso, trying to make colors and folds like Fra Bartolommeo and shadow like Leonardo" (1792 ed., p. 92). Lanzi was familiar with less of Rosso's work than we know today, and formed his impressions mainly on the Pitti *Pala Dei* of 1522, which is well defined as *spiritoso.* On the other hand, he also knew the Città di Castello *Ascension* (so-called) which to him had *alquanto di stravagante* (1792 ed., p. 91) which, in his terms means *manierismo.* Was he not right?

The word *manierista* reaches the general currency of guide book usage by 1807.[40]

Lanzi also seems to have invented the term *manierismo* in 1792,[41] and his critical analysis, of excessive virtuosity and capriciousness, links his meaning directly with that of Burckhardt, or even of an early article by Gamba.[42] These would have been intelligible to the cinquecento—except that they, naturally, would have pleaded a positive interpretation against the negative legacy of the intervening centuries. It is only in this century that an abrupt change of direction occurs in the development of the term.

I have traced briefly this course of events to suggest two things. The first is that the expression mannerism has a continuous history, and this history shows that the word already has a meaning; this seems to me a good enough reason for not inventing new ones. The second is that if we are willing to revert to the tradition of this concept, we have a term that is not only historically justified and not arbitrary, but also one that can be controlled and argued: research can sharpen the weapon. Taking again the axiom that mannerism must embrace, among other things, *maniera,* I want now to suggest how we, as historians, can make use of the term on these conditions.

No *historical* concept of mannerism exists in the cinquecento, but it is then that *maniera* was most appreciated in works of art. *Manierismo* was never a movement, in the post-Romantic sense, and I think we must fix its limits by asking ourselves at what points *maniera* begins and ceases to characterize a style. The nature of stylistic changes in the pre-Romantic period is never violent or reactionary, but is a complex, gradual process: at a certain point one feels that the ingredients and objectives have changed in their relative proportion, so that a new set of values predominates. *Maniera,* in small proportion, is present in many

40. E.g., Moschini, *Guida per l'Isola di Murano* [1st ed., 1807]; 2nd ed., 1808, p. 3: "a bold and felicitous Venetian mannerist, Andrea Vicentino . . ."; and p. 4: "Antonio Foler, who lived at the time of the mannerists . . ." The lack of prejudice here is rare.
41. ". . . manierismo; o sia alterazione dal vero" (1792 ed., p. 96) .
42. E.g., Conte Gamba, "Un disegno e un chiaroscuro di Pierin del Vaga," *Rivista d'Arte,* v, 1907, pp. 89 ff, especially p. 93.

periods, especially in some parts of the quattrocento; when was it present in greatest proportion?

When in the seventeenth and eighteenth centuries a term was fashioned to characterize the Romano-Tuscan period from (roughly) Raphael's school to the Zuccari and the Cavaliere d'Arpino, I think the derivatives of *maniera* were chosen because this was its most typical, communicable feature. I feel it is legitimate to associate in our definition those qualities which are constantly bracketed with it, are sympathetic to it, and in the appropriate cultural *ambiente* were as highly valued: I mean *sprezzatura,* the effortless resolution of all difficulties—difficulty is a hypnotic concept in Renaissance theory,[43] hence the positive value attached to *facility.*[44] The conquest of difficulty naturally places a premium on complexity of form, fantasy, invention, and caprice. *Grace* is an ideal that is frequently exchanged for *maniera,* though it is more restricted in meaning.

In the French courts passion was inimical to *manière,* as it

43. In the Renaissance argument, the *Paragone,* the relative difficulty of the two arts is given a prominence that now seems irrelevant and even absurd; cf. already Manetti on Brunelleschi's relief for the bronze doors: "Everyone was startled and amazed at the difficulties he had set before himself . . . how difficult those figures are, and how well they perform their functions. . . ." (A. Manetti, *Vita di Brunellesco,* ed. E. Toesca, Rome, 1927, p. 16).

44. Again, without a mental readjustment, this often seems absurd: ". . . in this art perfection consisted in nothing other than in trying to become rich in invention early, studying nudes much, and reducing the difficulties of execution to facility" (Life of Lappoli, Vasari-Milanesi, VI, p. 15; "facility is the chief touchstone of the excellence of any art, and the most difficult to achieve" (L. Dolce, *Dialogo della pittura* [Venice, 1557], ed. P. Barocchi, Bari, 1960, p. 149). It is in these terms that Vasari expresses the advance made by his own generation. In the *Proemio* to the third part in the 1550 edition, he reviews only those artists up to the generation of Rosso, Sebastiano del Piombo, Giulio Romano, and Perino del Vaga (p. 560). In the edition of 1568 he interpolates a passage in which he sums up the progress since then (IV, p. 13): "But what matters to the exclusion of all else in this art is that they (the living) have made it so perfect and easy today for all who have a command of drawing, invention, and color, that whereas previously our teachers made a panel in six years, now these make six in one year, and I can vouch for it unquestionably by what I have seen and done: and many more turn out finished and perfect than those made previously by the other reputable masters."

was also to Castiglione's *sprezzatura*.[45] So, mannerism should speak a language that is articulate, intricate, and sophisticated, it should speak a silver-tongued language of beauty and caprice, not one of violence, incoherence, and despair.

I feel very strongly that this argument cannot lead us to the art of the second decade in Tuscany, but that it leads us to Rome; I believe we can even say at what later point the new language was brought to Florence. Mannerism was not a reaction against the High Renaissance, but was latent in it, like the baroque. It became something different and individual by taking a part of the High Renaissance and subjecting that part to special development; characteristically, it came to birth easily, not in a crisis.

The Sistine ceiling is a work as vast in scale stylistically as physically. There are parts that were not understood until Rubens, others have rightly been compared to Pontormo, and yet others inspired Correggio; but there are some parts, especially some of the Ignudi (fig. 36), that contain such a high proportion of elegance and grace, both of form and posture—at the expense, as always, of physical and emotional energy—that in them lies the germ of mannerism. I do not suggest that it necessarily starts here; it is arguable that *maniera* is conspicuously present in the Doni tondo, or even in Leonardo. But it was in developing in the following decade this cultured and refined style that Michelangelo gave the essential impulse; it is important that this new style first became known in Rome. The opposing concepts, of Energy and Grace, of Passion and *maniera,* can be seen quite evidently in the sculpture of the second decade, between the Slaves and the Christ of the Minerva. Perhaps even more striking, because more highly developed, is the Flagellation design of 1516 made for Sebastiano; only a copy of the final design survives, so I show one of the preparatory studies (fig. 37).[46] This is a subject which

45. Weise, *op. cit.,* and *Cortegiano,* ed. Florence, 1889, p. 34. Passion was also inimical to Giovanni della Casa's *bella maniera: Il Galatheo,* Venice, 1562, p. 47.

46. For the copy of the *modello,* see A. E. Popham and J. Wilde, *Italian Drawings at Windsor Castle,* London, 1949, no. 451, fig. 100; for the preparatory study, see J. Wilde, *Italian Drawings in the British Museum, Michelangelo and His Studio,* London, 1953, no. 15.

earlier would have drawn out all that was most expressive in Michelangelo, for it lends itself to violence, yet it is interpreted now with an unreal, ballet-like beauty, and reserve. The form is as graceful, and as idealized, as the action.

Simultaneously a similar development took place in Raphael's style. Between the second Stanza and the Cartoons, and the late works, a new direction is indicated; the situation is very complex, and it is more accurate to speak of one of a number of new directions. The *St. Michael* (fig. 38) has again a subject that a few years earlier would have led Raphael to a dynamic, explosive interpretation; now, in 1517, he expresses not so much the subject as an ideal of beauty, and a harmony of color and formal composition. The exquisite poise is as remarkable as the grace of form and the intense idealism of the head; here one sees perhaps the most surprising development in Raphael, the stillness of the emotion, almost to the point of abstraction. Raphael's style a few years before had been (in direction, not in intention) protobaroque; it was the portraits of Julius II and Castiglione that meant most to Rubens and Rembrandt, the Chigi Chapel in Sta. Maria del Popolo takes a blind step toward Bernini, the Cartoons were a springboard for Poussin.[47] Some of the late works, the *St. Cecilia* (fig. 39), the *St. Michael,* the portraits of Joanna of Aragon and La Fornarina,[48] prepare the way for Roman art of the immediately succeeding decade.

47. These points are argued at greater length in my article "The Chigi Chapel in S. Maria del Popolo," *Journal of the Warburg and Courtauld Institutes,* 1961, p. 129.
48. The *St. Cecilia* is normally dated around 1514, which seems to me too early. I know of no direct documentation for the painting, and there are conflicting statements that it was ordered in 1513 and 1514; the evidence about the chapel in S. Giovanni in Monte is also confusing: it is variously stated that it was begun in 1510 and finished August, 1515, or begun in 1514—the act of endowment is dated September 9, 1516, and it seems not to have been consecrated before August 24, 1520 (to the evidence and sources quoted in Golzio, *op. cit.,* p. 28, should be added: Orazio Pucci [a descendant of the Antonio Pucci who consecrated the chapel and ordered the picture], "La Santa Cecilia di Raffaello," *Rivista Fiorentina,* June, 1908, pp. 5 ff). If any use is to be made of Vasari's anecdote that Francia set up the altarpiece, it must also be concluded that it arrived in Bologna shortly before the latter's death in 1517. My own feeling is that Marc-

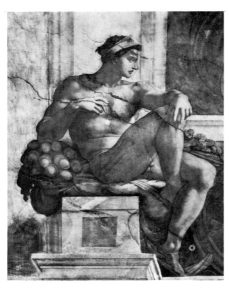

36. **Nude, Michelangelo. Vatican, Sistine Chapel**
Courtesy of Art Reference Bureau

37. **Flagellation,** Michelangelo. London, British Museum
Courtesy of the Trustees of the British Museum

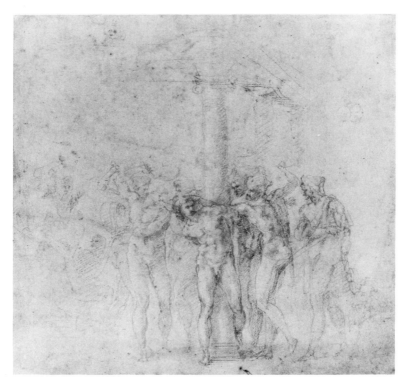

Neither in Michelangelo's case nor in Raphael's is this idealization a development toward empty superficiality. In the poetry of the former, and in the literary circle of the latter, beauty and grace have their own expressive and spiritual value. Even in extreme cases the emotional stillness in their works is not lack of feeling but a change in the means of its communication.

Raphael perhaps preceded Michelangelo in the subconscious search for the ideal of *maniera* in architecture. In the letter to Leo X we have his criticism of Bramante, whose too-austere style still fell short of the antique standard in richness of motifs and costliness of materials.[49] There is no sign that Raphael used the inventive license toward the antique which Vasari so acutely appreciated in Michelangelo[50]—his contribution is complementary: grace of detail, lightness, and surface complexity. His façade of the Palazzo Branconio dell'Aquila repeats the criticism of Bramante, replacing the latter's structurally expressive system with an intricate mask of stucco, so lavishly distributed that it draws window tabernacles and niches into its decorative purpose (fig. 40). It is a little capricious, and its wit, variety, and beauty ask to be admired; the way to the Casino of Pius IV is opened here.[51]

antonio's engraving (Bartsch XIV, 116) follows, like others, a rejected preliminary design, in the style of the Cartoons and therefore datable about 1515, and that the completed altarpiece is in a different, later style, and should be dated a year or two later. Those figures which were most modified (e.g., the Magdalen) show the stylistic changes most clearly. The unity of the emotion in the first design, stemming from the essential subject, is absent in the painting, which has in compensation a higher saturation in the quality of beauty.

The *St. Michael* I accept, with Frederick Hartt, as an autograph work of Raphael's. The *Joanna of Aragon* is known to be largely pupils' work, but there is evidence that the design, and perhaps the execution of the head, are Raphael's. *La Fornarina* (Palazzo Barberini) is bound to be a controversial work; I cannot agree with those estimates of its quality which make it into a follower's work—it has a grasp of form beyond any of them, and I think it represents one facet of Raphael's latest, personal style.

49. Golzio, *op. cit.,* p. 85.

50. Vasari-Milanesi, I, p. 135, VII, p. 233.

51. Most of these points were first made by W. Friedlaender, *Das Kasino Pius des Vierten* (Leipzig, 1912), pp. 17 ff.

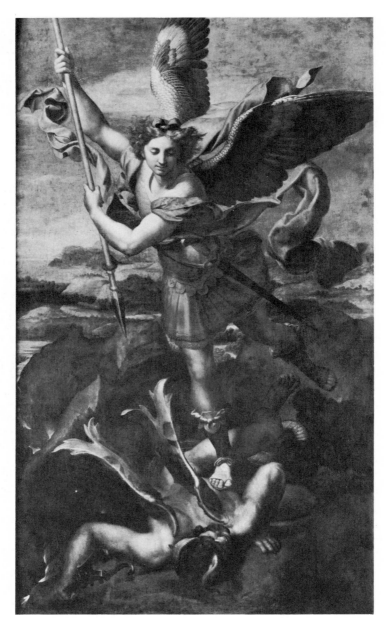

38. **St. Michael,** Raphael. Paris, Louvre
Courtesy of Agraci—Art Reference Bureau

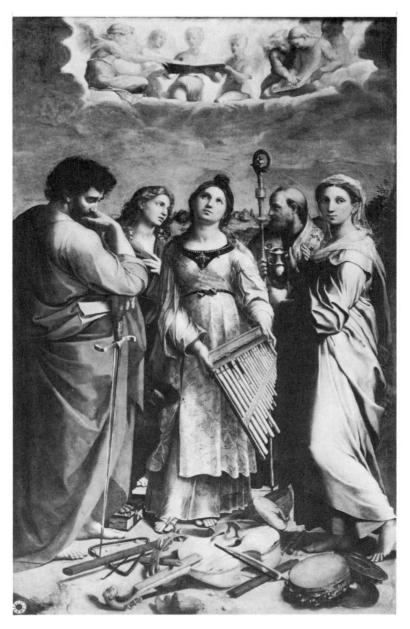

39. **St. Cecelia,** Raphael. Bologna, Pinacoteca
Courtesy of Art Reference Bureau

40. Drawing after Raphael's Palazzo Branconio dell'Aquila, Parmigianino.
Florence, Uffizi
Courtesy of Soprintendenza, Florence

If the germ of mannerism exists in the High Renaissance, and the seeds were sown in the second decade, the vital place of its growth is in Rome between the death of Raphael and the Sack. There was then in Rome, by chance, a brilliant group of young men, headed by Perino, Polidoro, Rosso, and Parmigianino, and it was in their hands that mannerism was shaped into a style of universal significance.[52] Of these, the most difficult to study is Polidoro, yet it is clear that in these few years his productivity was enormous and his style very influential. The maturity of the quality *maniera* in his work is astonishing. He was a master of fantastic ornament (for example, of vases and trophies) and he evolved from Raphael a figure style of svelte and extravagant plasticity (fig. 41). His enormous output depended upon a true genius, composed of an unlimited imagination (in a restricted field) and a genuine cerebral facility.

Perino's early Roman period is still almost as difficult to study. Paradoxically one of his most advanced compositions was produced in Florence in 1522/23, and this was an artistic event of the first importance: it was here that the new Roman style was introduced to Florence. Vasari arrived shortly afterward and he recorded the enthusiasm with which it was received both by artists and connoisseurs.[53] The cartoon Perino made for a fresco in the church of the Camaldoli was so novel that it became a second school for young painters,[54] after Michelangelo's *Battle of Cascina,* by which, incidentally, it was influenced. The subject was the Massacre of the 10,000, and a

52. In this discussion I am forced to be selective; there are certainly others in Rome whose contribution to the new current must be remembered, especially Sebastiano del Piombo (e.g., the Louvre *Visitation* of 1521), Giulio Romano (the *Madonna and Saints* in Sta. Maria dell' Anima, rather than the Genoa *Stoning of St. Stephen*), Bandinelli, and perhaps Cellini. Beccafumi is also clearly moving, around 1520, in a parallel direction, though as yet down a private path.

53. Vasari-Milanesi, v, pp. 606 ff.

54. "When artists and other well-versed wits saw this cartoon, they judged that they had not seen equal beauty or good design since the one Michelangelo Buonarotti had made for the hall of the Council" (Vasari-Milanesi, v, p. 606).

number of drawings record its design (fig. 42).[55] The figure
groups are complex developments of Raphael's themes, but
their movements are antidynamic: not really movements at all,
but torsions, poses, and ritualistic gestures, each silently obeying
a rarefied code, abstracted from natural, passionate human
behavior. Similarly, every form is shaped by an ideal, and
fundamentally by the same set of values. To the evidence of
these drawings we must add a feature of the cartoon mentioned
by Vasari: a wealth of bizarre and fantastic detail on things like
helmets and shields.[56]

The Camaldoli cartoon also gives us a unique opportunity to
contrast a representative young Roman with a Florentine of his
own generation, for it seems that Pontormo produced a design
for the same commission (fig. 43).[57] His drawing comes, there-
fore, at the beginning of his work in the Certosa, and it is
evident how, from a position basically similar around 1510,
Florentine and Roman art had pursued divergent paths in the
intervening decade. This may partly be due to the very differ-
ent characters of the two dominating personalities, Raphael in
Rome and Andrea del Sarto in Florence. Pontormo's *Massacre*
is full of passion, dynamic sequences of form, and explosive
movements. The contrasting treatments of the same iconog-
raphy at the top of each design are characteristic: Pontormo's is

55. These drawings were first connected with Vasari's text by Conte
Gamba; for one version (perhaps none of those now known is the
original) see Agnes Mongan and Paul J. Sachs, *Drawings in the Fogg
Museum of Art,* Cambridge, Massachusetts, 1946, I, p. 101; II, fig. 101
(here fig. 42).
56. ". . . cuirasses in the antique manner and many decorative and
bizarre habiliments, and hose, shoes, helmets, shields and other arms made
with the greatest wealth of beautiful decoration possible to use and
imitate and add to antiquity, drawn with that love and skill and finish that
the last touches of art can induce" (Vasari-Milanesi, v, p. 607).
57. This has been pointed out only by Mr. Popham, and seems to have
gone unnoticed: A. E. Popham, "On Some Works by Perino del Vaga,"
Burlington Magazine, 86 (1945) : 59, n. 3, and *idem,* "Drawings in the
Fogg Museum," *Burlington Magazine,* 90 (1948) : 179 (review of the book
by Agnes Mongan and Paul Sachs). Pontormo's design also recalls
Michelangelo's cartoon, but in a totally different way, not following the
bellezza e bontà di disegno.

41. Façade decoration of Palazzo Milesi, Rome, after Polidoro da Cara-
vaggio.

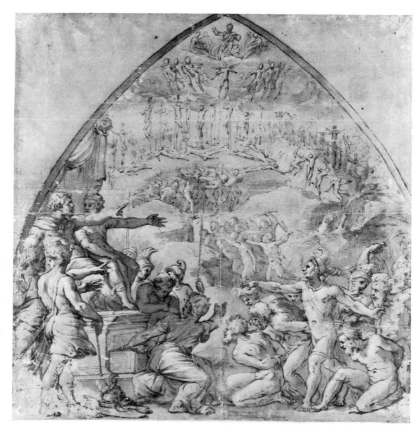

42. **Massacre of the Ten Thousand,** copy after Perino del Vaga. Cam-
bridge, Fogg Art Museum
Courtesy of Fogg Art Museum, Harvard University, Charles Alexander
Loeser Bequest

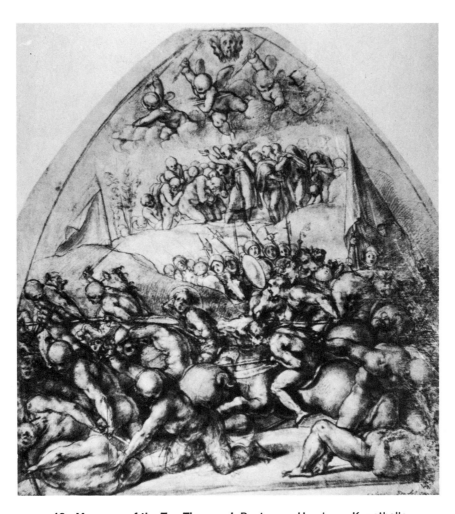

43. **Massacre of the Ten Thousand,** Pontormo. Hamburg, Kunsthalle

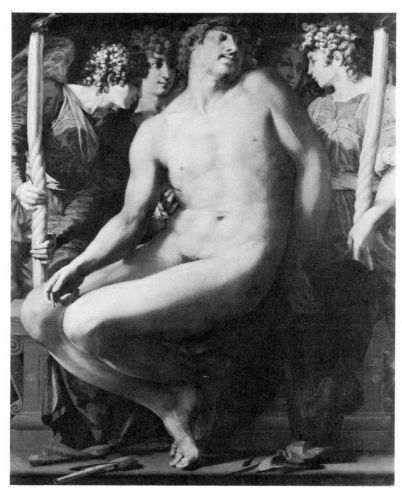

44. **Dead Christ with Angels,** Rosso. Boston, Museum of Fine Arts
Courtesy of Museum of Fine Arts, Boston

an energetic, ecstatic symbol, ignoring rational relationships of space and form, Perino's belongs to some Olympian ballet. There seems to have been a competition, and it is significant that Perino won it;[58] I think the whole incident was a turning point in Florentine art.

Rosso's latest works in Florence seem to take this new direction,[59] but there is no doubt that in Rome he did so wholeheartedly. The newly discovered *Dead Christ* in Boston (fig. 44) allows us now to appreciate his stature in Rome.[60] In some ways this work makes a parallel with Polidoro's style, but above all it reinterprets, and is profoundly inspired by, the Sistine ceiling. It shows us most clearly that even rampant mannerism is not a reaction against the High Renaissance. Rosso's rediscovery of Michelangelo took place in general and in detail; the figure of Christ is based on the prophet Isaiah and one of the Ignudi, and the angel heads are derived from Michelangelo's (figs. 45, 46) and through Michelangelo from classicism, in a particular sense.[61] He modifies the expressive linear, chiseled, style that he had individually developed in Florence from the late works of Donatello,[62] and being led by Michelangelo back

58. The hypothesis that seems most plausible, that the designs were produced in competition, was also produced by Popham, "Drawings . . .," p. 179.
59. Especially the two Moses compositions of 1523.
60. Painted about 1526, in Rome, for Bishop Tornabuoni; in 1568 in the collection of Giovanni della Casa (Vasari-Milanesi, v, p. 162).
61. As Johannes Wilde has pointed out to me, the whole plastic composition, with the highest relief in the central figure, is derived from the pendentive system in the Sistine Chapel. It is only with Rosso's move to Rome that the Antique becomes a significant source for his style; in this case the right-hand angel must be related, however distantly, to the figure of Persephone holding a torch in the Triptolemos relief in the National Museum, Athens (Alinari 24236). This may be more than a formal connection.
62. One of the important consequences of Leo X's visit to Florence in 1515 was that then, for the first time, Donatello's late pulpit reliefs were set up and became visible to other artists, and certainly Rosso and Bandinelli were among those who admired them and whose style was influenced by them. In Rosso's work quotations from them may be found in the Skeletons drawing of 1517, and several early drawings by Bandinelli copy them exactly. The more general stylistic response in the two artists

to a continuous plasticity, this becomes, like that of his contemporaries, mellifluous and *soigné*. This picture should also remind us of the *intensity* possible within the admitted inhibitions of mannerism. The impact of Roman *maniera* on Rosso can clearly be seen if we compare the head of Christ with that from the masterpiece of his Florentine period, the Volterra *Deposition* (figs. 47, 48). The new intensity lies more in the expression of a set of aesthetic values than of emotion.

Parmigianino came to Rome with a predisposition toward the grace of Raphael, and the direct experience of the latter's work had upon him an effect similar to Michelangelo's upon Rosso. On his arrival it was said that in this young man was reborn the spirit of Raphael;[63] this is a remark that makes a lot of sense if we think of those works which the Romans would have remembered as Raphael's last, most authoritative statement. It is also significant in that it underlines the point that Parmigianino's work was not seen by his contemporaries as either anticlassical or a reaction against Raphael, but rather as a continuation (figs. 49, 50). It is indeed a continuation of a part of Raphael.[64] Two

was very similar; in Rosso's case this response may be seen most sharply in the *Madonna and Saints* of 1517–18 now in the Uffizi. Pontormo's fresco *Christ Before Pilate,* from the Certosa cycle, is also closely based on one of those reliefs (this was pointed out independently by Irving Lavin, "An Observation on 'Mediaevalism' in Early Sixteenth Century Style," *Gazette des Beaux-Arts,* VI/L, 1957, p. 113, and by myself in a thesis presented earlier in the same year; we were both preceded by Antal). It seems that what these artists found in this new source was an alternative, in some ways more acceptable and more readily assimilated, to the urgent expressiveness of Dürer.

63. "Raphael's spirit was said to have passed afterwards into the body of Francesco, since that youth was noticed to be as rare in art and as courteous and graceful in his ways as Raphael was, and, what is more, because it was felt how much he made a point of imitating him in every way, but especially in painting" (Vasari-Milanesi, V, pp. 223–24).

64. The sources of the figure of the Madonna in the altarpiece from the Roman period now in London illustrate this point. The prototype for the whole figure is Raphael's *Madonna del Cardellino,* and the ideal of the head is equally certainly Raphaelesque. In turn, Raphael's Madonna was derived directly from the St. Anne, in reverse, from Leonardo's cartoon exhibited in Florence in 1501: this design, an earlier version of the Louvre *St. Anne,* is recorded in several copies (one reproduced in H. Bodmer,

decades later, Aretino complimented Salviati on a composition of the Conversion of Saul by remarking that it had the *venustà* of Raphael and the plasticity of Michelangelo.[65]

In the twenties, Michelangelo made further contributions to this new language, most obviously in architecture. But at the same time he gave it, so to speak, some of its most popular figures of speech. First, the *Teste divine* (fig. 51), which are *dimostrazioni* of hyperclassical idealism and of imaginative fantasy;[66] these instantly passed into the syntax of Rosso, and later of Salviati and Bronzino.[67] It is significant that Michelangelo also invented an entirely new technique, itself *manieroso,* for these drawings. Second, he invented the *figura serpentinata,* a characteristic exercise of mannerist artists, since it poses the purely aesthetic problem of incorporating the maximum of torsion and variety in the human figure within a limited space; Gianbologna's *Rape of the Sabines* answers this problem, among others: the *figura serpentinata* in triplicate.

The Roman developments of the twenties, and Michelangelo's work in the same period, began to affect Florentine art generally by the end of the decade, and the work of the artists I have mentioned was the foundation of the mature style of Cellini, Salviati, and Bronzino in the forties, the great decade of Florentine mannerism (figs. 52, 53). I have tried to show that there exists a—so to speak—documentary basis for the application of the word to these works and this current. I feel that its use on these lines would make sense to a cinquecento connois-

Leonardo, Klassiker der Kunst, 37, Stuttgart, 1931, fig. 62). Parmigianino's response to Raphael is not more of a "reaction" than is Raphael's to Leonardo. Parmigianino's Christ Child, while in His position following Michelangelo's Bruges *Madonna,* is actually derived, as is clear from the drawings, from antique figures of Ganymede.

65. Aretino, *op. cit.,* II, no. 147 (August, 1545). Aretino pays a similar compliment to Vasari (I, no. 107 December, 1540).

66. See Popham and Wilde, *op. cit.,* no. 453.

67. Most immediately in Rosso's Moses compositions of 1523; cf. also Salviati's *Visitation* of 1538 in S. Giovanni Decollato, Rome, or the *Charity* in the Uffizi, and Bronzino's frescoes in the Chapel of Eleonora of Toledo, now known, through the researches of Craig Smyth and Edward Sanchez, to have been painted in the 1540's.

45. Detail of fig. 44.
 Courtesy of Museum of Fine Arts, Boston

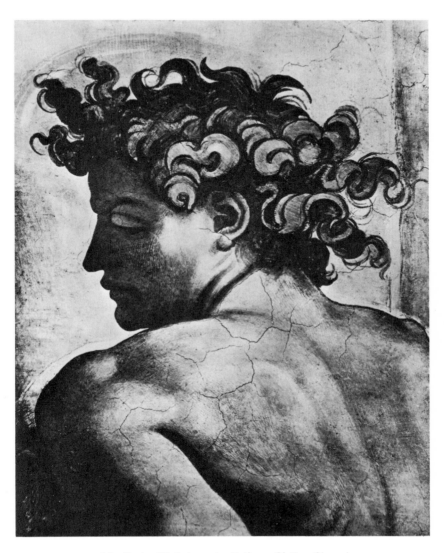

46. Nude, Michelangelo. Vatican, Sistine Chapel

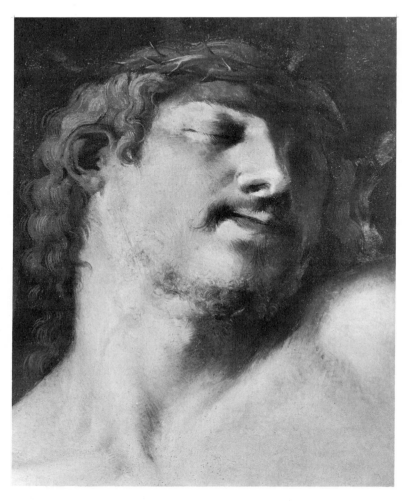

47. Detail of fig. 44.
 Courtesy of Museum of Fine Arts, Boston

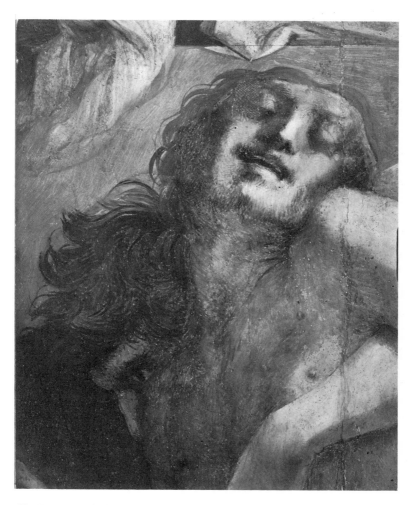

48. Head of Christ, detail of **Deposition,** Rosso. Volterra, Pinacoteca Comunale
Courtesy of Soprintendenza alle gallerie, Florence

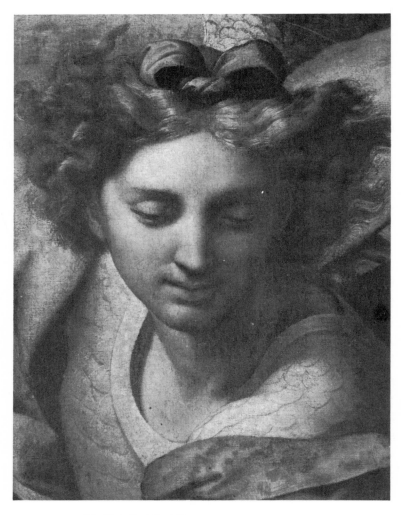

49. Detail of fig. 38.
Courtesy of Agraci——Art Reference Bureau

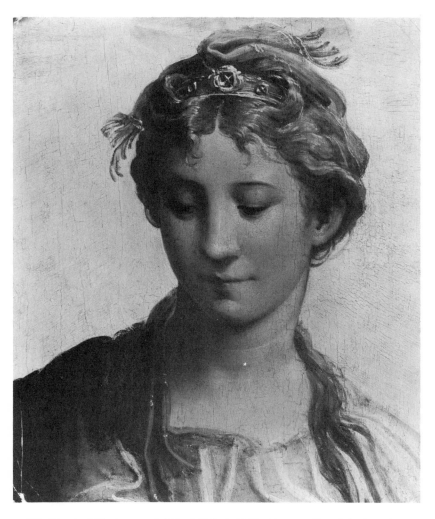

50. Head of Madonna, detail of **Vision of St. Jerome,** Parmigianino. London, National Gallery
Courtesy of the Trustees, National Gallery, London

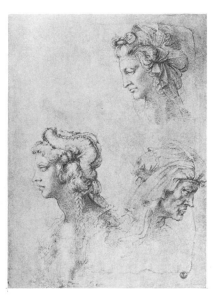

51. **Teste Divine,** Michelan-
gelo. Florence, Uffizi
Courtesy of Soprinten-
denza alle gallerie, Flor-
ence

52. Base of the Perseus, Ben-
venuto Cellini. Florence,
Piazza della Signoria
Courtesy of Art Reference
Bureau

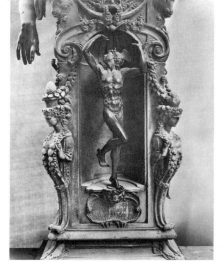

53. Peace, detail of decoration of the Sala d'Udienza, Francesco Salviati.
Florence, Palazzo Vecchio
Courtesy of Art Reference Bureau

seur, who would be astonished if we called Pontormo's Certosa frescoes *manierosi*. Unless I am wrong, mannerism is a label that came down to us firmly attached to something, and the label loses all meaning if we attach it to something else.[68] Moreover, I believe that the approach I have suggested could be useful to the modern historian: *maniera* and its associated qualities and ideals isolate an important current in cinquecento art, and one that begins in the right place, is vigorous and productive, inventive and intensely beautiful (if we miss that point we miss its *raison d'être*). I think we should return to the old meaning for mannerism, keeping, however, the gain in historical imagination in this century, which allows once more an unprejudiced, positive interpretation of the style on its own terms.

Mannerism is perhaps the most vulnerable, of all stylistic phenomena, to changes of taste; it asks to be admired, and it rests upon many reversible convictions, for example, that there is an ideal beauty, that facility is something positive to express, that prolixity of form and ornament gives pleasure to the eye and stimulates the mind. Naturally, it was meaningless to the seventeenth, eighteenth, and nineteenth centuries, and could only be seen as a perversion and a decadence. Early twentieth-century prejudices not only led, in my view, to the misapplication of the term, but delayed still further the appreciation of

68. This crux has been the subject of an acute comment by Coletti ("Intorno alla storia del concetto di manierismo," *Convivium,* 1948, p. 801) who, discussing at one point seventeenth- and eighteenth-century definitions, queried more modern usages: "for Vasari . . . Pontormo's fault (in the Certosa frescoes) is that he did not use enough *maniera,* that he was not enough of a mannerist. Whereas on the contrary precisely Pontormo is the type of mannerism for modern criticism, *basing itself on his anticlassicism.* Thus words lose their meaning or even reverse them [italics mine]." The author did not commit himself further on this dilemma.

M. Rosci ("Manierismo e accademismo nel pensiero critico del Cinquecento," *Acme,* IX, 1956, p. 66) also acknowledges this conflict between the *manierismo* of the literary tradition and what he calls the *primo, vero manierismo,* but then insists that the traditional *manierismo* is *il puro e semplice accademismo del secondo Cinquecento,* and that the *vero manierismo* lasts from early Pontormo, Rosso, and Beccafumi, to Bronzino and Ammanati: a conclusion that seems to me entirely arbitrary.

true mannerism. Perhaps today we are in a more fortunate position. The functionalist heresy, for instance, has been exhausted, and our present prejudices may enable us to admit that the premises of mannerism are as legitimate as any others; and that, with all its inhibitions and while the current was vital, it produced works of the greatest beauty.

10

Jacopo Bassano: 1568–69

by W. R. REARICK

EDITORIAL NOTE: *During Titian's old age, in the decades after 1550, there were three equally great Venetian painters of a younger age group, Tintoretto, Veronese, and Bassano, whose real name was Jacopo da Ponte. Bassano is not famous like the other two because he never set up shop in Venice, but from his headquarters in his native small town of Bassano (which gave him his nickname) he furnished altarpieces for the surrounding villages. This has made it hard to settle what he did, as have other reasons suggested in the following essay, one of various recent studies dedicated to clarifying his personality. His deep color technique makes him more modern and more influential on younger artists than Tintoretto, and he is more modern and influential than either Tintoretto or Veronese in his choice of unpretentious realistic themes. His most remarkable influence was on a young artist who spent the years 1567 to 1570 in Venice, El Greco.*

FORTUNE HAS contrived an almost unique combination of problems in the establishment of the authenticity and the chronology of the works of Jacopo Bassano. In the years when there is external evidence for the chronological arrangement of the paintings, Jacopo's share in the actual execution of the works is frequently in doubt; whereas in the periods during which it is reasonably clear that he worked alone, we are left with almost no firm basis for a chronology. It is not difficult to summarize

the periods of Jacopo's career for which we have reliable documentation. Having begun his independent activity in the paternal workshop about 1530, he executed a series of surviving dated or datable works from 1534 to 1541, which provide a firm basis for a precise chronology. However, in the long and complex evolution of his style from 1541 until 1568 only two dates, 1558 for the *St. John the Baptist* (Museo Civico, Bassano) and 1562 for the Treviso *Crucifixion*, serve as points of reference for his stylistic development. Beginning in 1568 we have again a proliferation of datable paintings which carry us to 1592, the year of his death. While there is some evidence of the presence of a second hand in the execution of several works from the early period, the middle period is rich in masterpieces entirely by Jacopo. The question of the autograph character of documented paintings becomes crucial after 1568 when, one by one, his four sons gradually took over the execution of commissions accorded the family workshop. While it is not for the moment possible to enrich the documentation for the middle period of Jacopo's activity, we can enlarge our view of both his chronology and his style by a closer look at the crucial years 1568–69.[1] Although in almost no instance in Jacopo's career can more than one commission be located in a single year, we have for these two years no fewer than two datable paintings and five dated drawings, to which we may add two paintings and a drawing which are closely related to them. This list includes not only one of Jacopo's most famous masterpieces, the *Adoration of the Shepherds* (Museo Civico, Bassano), but also several works which are either totally unknown, misunderstood, or only casually mentioned in the literature. The present study is limited to a discussion of only those works by Jacopo Bassano that are securely datable in these two years, leaving for a later, more extensive study several other paintings and drawings

1. The Bassano family account book, *Libro secondo di dare ed avere dalla famiglia Dal Ponte con Diversi per pitture fatte,* was announced for publication in 1957. See M. Muraro, "The Jacopo Bassano Exhibition," *The Burlington Magazine* 99 (1957) : 291. It is to be hoped that its eventual publication will clarify the confused sequence of the commissions between 1512 and 1592, the period covered by the entries.

which can be associated with them exclusively on the basis of style.

Before taking up the paintings and drawings of 1568–69 in an approximate chronological sequence, it is essential to note the specific conditions in the Bassano studio in those years. Although Jacopo had probably worked alone during most of his middle years, he had inherited the workshop from his father and, in the well-established Venetian tradition, planned to train his sons to carry it on after his own death. In 1568 he was about fifty-four years old,[2] and his eldest son Francesco (b. 1549) at nineteen must have been well enough advanced to collaborate fully with his father and even to do some independent work of his own. His earliest participation in the shop probably dated from about 1564 when he was fifteen. Giambattista (b. 1553) was the least talented of the sons and at fifteen could not have progressed much beyond the mechanical rudiments of his craft. Leandro (b. 1557) was only eleven, and Gerolamo (b. 1566) but two years old. While all eventually entered the family workshop, only Francesco need be considered in discussing collaboration in Jacopo's works of 1568–69.

The earliest of the dated works of these years is the large drawing in colored chalks for a *Scourging of Christ* (fig. 55) in the collection of Hans Calmann in London, which bears the black-chalk inscription '1568/da agost 1°' at the top left center of the sheet.[3] It is the earliest compositional study which we have from the hand of Jacopo, but not the first of his drawings in which he used that remarkable colored-chalk technique which is his special contribution to Renaissance draftsmanship.[4]

2. The year of Jacopo's birth is not yet known, but most authors place it about 1517. However, since he was working independently in 1530, a date closer to 1512 is to be preferred.
3. Many colored chalks on blue paper, 407 by 535 mm. See H. and E. Tietze, *Drawings of the Venetian Painters in the 15th and 16th Centuries* (New York, 1944), p. 52, No. 163.
4. The earliest surviving drawing by Jacopo Bassano in this abbreviated style is in Frankfort, Städel Institut 15216 (many colored chalks on tan paper, 269 by 328 mm.) See H. and E. Tietze, *op. cit.*, p. 51, No. 148. Here Jacopo revised his motif of a recumbent shepherd with a flute from the *Adoration of the Shepherds* (Borghese Gallery, Rome) in preparation for reversing it for his *Annunciation to the Shepherds* (National Gallery, Washington), a painting of ca. 1557.

The setting of the scene is a terraced staircase in Pilate's palace; behind the three steps which descend to the left the architecture is suggested with rapid and, in certain areas, unclear slashes of charcoal and white chalk, creating a warped space of solid vertical projections and gliding diagonal recessions into shadowy depths. The eight figures echo the movement of the setting. At the right a boy sits on the step blowing a hunting horn, his curved back closing the composition and directing the eye to the arm of the half-draped tormentor, whose potential movement toward the right accentuates the violent backward stress of the soldier behind Christ. In turn, a turbaned figure below him redirects the impetus to the ruffian who rises from below and turns inward toward Christ, whose blurred, contained form is a pivotal axis which sways gently to the rotary movement of His tormentors. A red-hatted mameluke and a shadowy official close the left of the composition with a strong vertical, while the familiar Bassano dog curls with callous unconcern at Christ's feet.

The extemporaneous brilliance of the invention is matched by the brevity and energy of the execution, a personal shorthand which bears but faint resemblance to the orderly discipline of sixteenth-century draftsmanship. Later, in a letter of May 25, 1581, to the Florentine collector Niccolò Gaddi, Francesco wrote: ". . . we have never drawn much or made that our specialty, but have put all our effort in seeking to make works that would turn out the best possible."[5] In this drawing and in a half-dozen others of its type, one finds the confirmation of this anti-Tuscan, or better anti-Renaissance, point of view. For Jacopo the varicolored chalks served as a rapid, tractable substitute for paint. Color areas and form-defining detail are applied and chiaroscuro and plasticity suggested with the improvisational fondness for expressive effect and sensuously tactile surface which characterizes his painting. In this first compositional experiment he evokes the total impression of a completed painting.

This highly individual use of his materials, whether paint,

5. See G. Bottari, *Raccolta di Lettere etc.,* III (Milan, 1882), pp. 265–66.

chalk, or charcoal, as interchangeable vehicles for the inventions of his fervid imagination accords well with the traditional appraisal of Jacopo as an isolated experimenter. However, he was not in any sense a self-contained provincial. His awareness of the art not only of nearby Venice but also of developments in Emilia, Tuscany, and even beyond the Dolomites created a spur, a constant tension and attraction for exotic and more sophisticated forms which is at the base of his restless and convoluted experimentation. In this instance, for example, he could not merely proceed from his summary, yet complete, vision of the *Scourging of Christ* embodied in the sketch to a duplication of it in paint. Instead, in the process of revision, the powerful magnetism of Titian intervened, as it had with increasing frequency in Jacopo's work since the early sixties. Jacopo often went not to the contemporary Titian, but to earlier works, usually by means of reproductive prints rather than by firsthand contact with the painting. However, in this case he went directly to Titian's *St. Peter Martyr* altar in SS. Giovanni e Paolo in Venice and sketched the figure of the executioner in a drawing that is now in the collection of Mrs. Charles Goldman in New York (fig. 57).[6] That he worked from the painting and not a print is evident from colored chalk touches which correspond to the colors in the painting, and from similarities in detail to the painting and not to the engraving by Martino Rota, which in any event dates from 1569 or later. The massive, heavily chiaroscuroed forms of Titian's painting are transformed by a nervous outline and a summary, high-keyed pictorialism. Compared to the Calmann compositional study, the use of the chalks is here more contained, as one might expect of a copy. However, the stylistic connections between this drawing and the compositional study are numerous: the blurred features of the executioner and those of the soldiers behind Christ, the solid bulk of the lower torso of the executioner and that of the figure in front of Christ, the definition of rounded form through sashes, belts, etc., and the

6. Colored chalks on tan paper, 272 by 310 mm. See *Bassano Drawings,* Seiferheld Gallery (New York, 1961), No. 1.

sensuous luminosity of the colored chalks. This study after Titian is unique in Jacopo's *oeuvre,* but his frequent references to the paintings of other Venetian artists suggest that drawings of this type may once have been numerous.

In spite of their similarities, it would not have been possible to associate the Goldman drawing with the Calmann compositional study were it not for the existence of the painting for which they are preparatory. Although the *Scourging of Christ* (fig. 54) has been in the depot of the Accademia for the entire span of modern Bassano scholarship, it has been almost totally ignored in the literature.[7] In every aspect of the painting there is a softening and relaxation of the vigor and intensity of the compositional sketch. Expanded to a long horizontal, the setting is less insistently related to the figures, whose closely integrated swing toward the left now progresses in easy sequence to the right. Each figure is studied with a refinement of detail which makes of it an isolated form, related to the passionate theme more by psychology than by movement or gesture. Pictorial unity is achieved through a warm harmony of rich browns, gold, pale lavender, and olive green, set off by accents of red, ice blue, and the yellow-rust of the curtain. The components of the compositional sketch have been partly redistributed in the painting. The setting is simplified and the directional impetus reversed toward the right, where a sudden drop creates the effect of a dais on which Christ is revealed by the drawn curtain, an unusual device suggesting the *trompe l'oeil* effects of the Dutch masters of the next century. This intermediate level of reality serves in addition to place the spectator in the role of a participant, separated from, yet directly involved in, the scene. The boy with the horn and the dog are now to the left of the picture, the mameluke reclines, and the soldier behind Christ moves toward the right as if to drag Him into the view of a mob that is suggested by the addition of an armored soldier and two shadowy figures at the extreme lower right of the composition. The soldier's place is taken by the half-draped tormentor, the figure that provides the clue to the relationship between this

7. Accademia, Venice, No. 412, canvas, 53 by 111 cm. See W. Arslan, *I Bassano,* 1 (Milan, 1960), p. 375.

painting and the drawing after Titian. The motif of the drawing has been turned completely around and reversed, but the derivation of the painted figure from the Titian painting is clear in numerous details as well as in the general pose. Indeed, in the painting, it is precisely this figure which gives the impression of an almost overstudied, rhetorical manner. For in spite of the resurgence of his interest in Titian in these years, Jacopo's personal idiom had taken a direction of intimacy and gentle pathos in which context the grander gestures of Titian found an uneasy place. The implied violence of the upraised arm ill accords with the sad trepidation with which the others fulfill their duties.

The date of the Accademia painting is easily determined by its close connection with the two preparatory drawings. The Calmann study is dated August 1, 1568, and the study after Titian may follow it directly or it may have been part of Jacopo's workshop reference material. In any case, its stylistic proximity to the compositional drawing permits an anticipation of its date by only a very short time. The completed painting must have left the workshop in the autumn of 1568.

Additional evidence for the dating of the *Scourging of Christ* is found with another work of our group: the *Adoration of the Shepherds with SS. Corona and Victor* (fig. 58), now in the Museo Civico, Bassano.[8] It was installed in the church of S. Giuseppe, Bassano, on December 18, 1568, or just four months

8. Museo Civico, Bassano, No. 17, canvas, 240 by 151 cm. Signed on the step at the centre 'JACs. A. PONTE/BASSANs P.' The drawing in the National Gallery of Scotland, Edinburgh (No. 2232, black and red chalk on blue paper, 235 by 328 mm.) has been associated with the 1568 *Adoration* by H. and E. Tietze, *op. cit.,* p. 50, No. 133. It is part of a series of drawings including Fitzwilliam Museum No. 2868, British Museum 1920–11 –16–1, British Museum 1895–9–15–858 etc., all early works of Leandro Bassano. In the Edinburgh drawing Leandro copied the 1568 painting, omitting the donor and piecing it out at the sides preparatory to adapting it to a horizontal format in a painted replica, not yet identified. He followed the same process with British Museum 1895–9–15–858, which is copied from Jacopo's *Adoration* in the Bode Museum, East Berlin, or from its replica, formerly in Dresden (see note 11), in preparation for his own version, of which the best of many examples is in the National Gallery of Scotland No. 1511.

and eighteen days after the date of the Calmann drawing.[9] Although local legend had it that the *Adoration* stood on Jacopo's easel for four years while he labored to perfect it,[10] its fresh and spontaneous breadth of brushstroke suggests a brief and concentrated period of execution and its style marks a significant step beyond the *Scourging of Christ.* While Jacopo went to his own previous treatments of the *Adoration* for some elements of the composition,[11] the lower part of the 1568 altar contains several adaptations of motifs from the *Scourging of Christ:* the St. Corona and the St. Victor recall the woman at the left of the earlier painting and the tormentor behind Christ, while the shepherd who looks toward the right has the same expression of pathos as the soldier to the right of Christ. The differences, however, are more significant than the derivations. The love of jewel-like color accents, the attenuated and graceful figures, and the episodic composition of the earlier painting are transformed onto a plane at once simpler and more solid. The axial focus of the inturned figures on the sleeping Child and the architectural accent specifically recall the Calmann drawing, but movement is arrested, transfixed by a quiet reticence of expression and a more massive physical bulk. The drapery no longer flows in delicate tubular folds, as from Christ's knees; rather, in the patriarchal figure of St. Joseph it spreads in flat bands, broken and angular with crisp edges, to define form in terms of relatively smooth surfaces. Even the gray clouds above take on a tangibly volumetric substance which calls forth a

9. G. Gerola, "Catologo dei Dipinti del Museo. Sezione Bassanese," *Bollettino del Museo Civico di Bassano,* 3 (1906) : 110.
10. G. B. Verci, *Notizie Intorno alla Vita, e alle Opere de' Pittori, Scultori, e Intagliatori della Città di Bassano* (Venice, 1775) , p. 80.
11. The immediate prototype for the 1568 *Adoration* is the painting of the same subject now in the Bode Museum, East Berlin, No. 2176. Previously unrecorded in the literature, it is a splendid work entirely by Jacopo, of which a replica, perhaps autograph, was in Dresden (No. 278, burned in 1945) . In style the Berlin *Adoration* is very close to the Accademia *Scourging of Christ,* and it may date from the first half of 1568. In the Berlin composition the basic triangular group of the Virgin, St. Joseph, and the kneeling shepherd evolved from the *Adoration* in the Galleria Nazionale, Palazzo Barberini, Rome, No. 649, and was reversed for the 1568 altar.

strenuous effort from the *putti* who separate them for the radiance. The color has shifted to a more marked blue-green tonality, softly grayed in certain areas such as the Child's flesh. Sharp color accents are muted, and the liquid translucence of the paint substance in the *Scourging of Christ* has become thinner, incorporating the heavy weave of the canvas into its texture and softening into feathery effects in the *putti*'s hair, Joseph's beard, and the dog at the right. This *Adoration* is the first work in which Jacopo translated his elegant and picturesque genre figures into a sober colloquy of quietly dignified rustics. It is the first in a series of monumental genre altars in which the remnants of Emilian mannerism disappear almost entirely; a fundamental step toward the characteristic Bassano genre painting of the mid-seventies.

Unlike the works belonging to 1568, the two paintings and four drawings which can be placed in 1569 are in no instance inscribed or documented with more than the year itself. Moreover, the diversity of medium and subject makes a month-to-month sequence impossible. We will, therefore, begin with the largest and most ambitious altar: the *St. Jerome in the Wilderness with an Apparition of the Virgin* (fig. 59) (Accademia, Venice) .[12] This work is problematic on several counts. It is inscribed on the rock in the center foreground: "1569/G⁰.A.Pᵗ.Pᵗ." This form is in itself unusual, since the dates on all the later altars are in Roman rather than Arabic numerals, and since the initial for Jacopo is consistently "J." rather than "G." for Giacomo. The rest of the abbreviated "a Ponte Pinxit Bassanensis" appears in no other work in precisely this form or order. However, the paint of the inscription seems to be part of the original surface, the numbers are paleographically very close to those which appear on drawings of the same year, and no reasonable alternative can be suggested as a reading of the inscription. Thus, in spite of its irregularity, the signature and date must be accepted as authentic. The execution of this altar presents a more crucial problem. In the 1568 *Adoration* only minor areas of the paint surface suggest a hand other than Jacopo's, but in

12. Accademia, Venice, No. 920, canvas, 222 by 162 cm. Originally in the church of the Riformati in Asolo.

the St. Jerome most recent critics have sensed a decline in quality, which they attribute to Francesco's greater or lesser share in its execution.[13] Certain areas, namely the middle and distant landscape, the hut, and the rocky hill at the left, seem clearly by Jacopo. The Saint himself is in heavy impasto, the paint layer thick and with little of Jacopo's characteristic transparency; but the forms, so secure in their definition of muscle, sinew, and bone, are entirely worthy of Jacopo. The saintly paraphernalia which litters the foreground is not on the same plane in either concept or execution, while the Virgin and *putti* above are commonplace in type and quite without the master's freshness of brushwork. These questionable areas present analogies with several paintings which may be considered to be among Francesco's most youthful efforts in his father's workshop. The Saint, a distant relation of Jacopo's anguished hermit of about 1560, also in the Accademia, descends from the Treviso *Crucifixion* of 1562 by way of at least two replicas executed by Francesco, the earlier one in Munich and a slightly later version in the Fitzwilliam Museum, Cambridge.[14] In the 1569 altar the variations in pose are surely due to Jacopo, but the basic laying-in of the paint must have been left to Francesco, with the master returning only for corrections and the final glazing with its finishing details. The still life, introduced originally by Francesco in his replicas of the Treviso Saint, was entrusted entirely to him here as well. The Virgin is a free variant, reversed, of the woman with a child to the right of Francesco's

13. The low critical esteem for the 1569 *St. Jerome* is due in part to its poor state of preservation. The entire paint surface has suffered from rubbing, especially the left side, and the surface glazes are gone in most areas. A vertical tear the entire height of the canvas to the right of St. Jerome's head was repaired in the eighteenth century. Most authors have attributed the evident collaboration in this painting to Francesco, noting his hand especially in the top half of the picture, and usually limiting Jacopo's contribution to the figure of the Saint. W. Arslan, *op. cit.,* I, p. 376, suggested that Leandro completed all but the figure of the Saint, an idea that is contradicted by the fact that Leandro was eleven years old in 1569.
14. Both the Munich and Cambridge versions are usually given to Jacopo. See W. Arslan, *op. cit.,* I, pp. 171–72, and B. Berenson, *Italian Pictures of the Renaissance, Venetian School,* I (London, 1957), p. 17.

54. **Scourging of Christ,** Jacopo Bassano. Venice, Accademia
Courtesy of Soprintendenza alle galleria, Venice

55. **Scourging of Christ,** Jacopo Bassano. London, H. M. Calmann
Courtesy of Mr. Calmann

56. **Presentation of the Virgin,** Jacopo Bassano. Ottawa, National Gallery of Canada Courtesy of the National Gallery of Canada

57. Study after Titian's **St. Peter Martyr,** Jacopo Bassano. New York, Mrs. Charles Goldman Courtesy of Mrs. Goldman

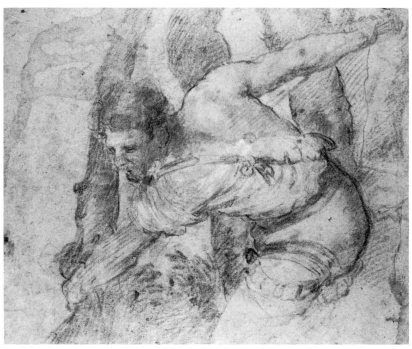

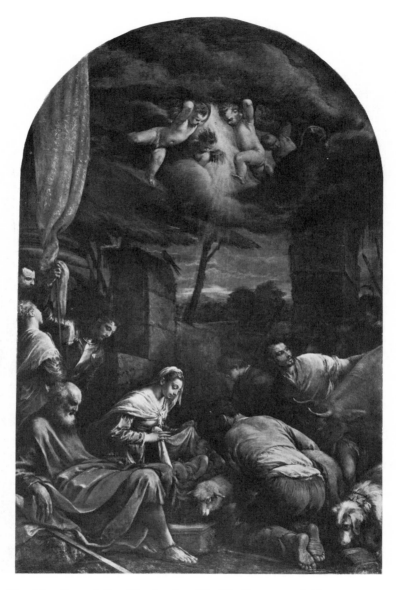

58. **Adoration of the Shepherds with SS. Corona and Victor,** Jacopo
Bassano. Bassano, Museo Civico
Courtesy of Museo-Biblioteca e Archivio di Bassano del Grappa

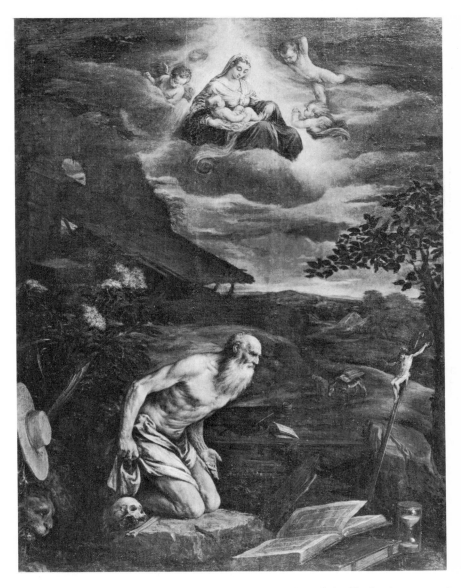

59. St. Jerome in the Wilderness with an Apparition of the Virgin, Jacopo
Bassano. Venice, Academia
Courtesy of Soprintendenza alle Gallerie, Venice

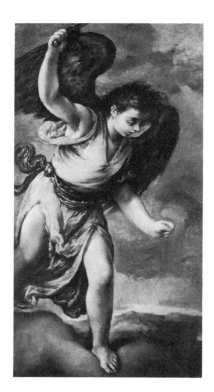

60. **Archangel Gabriel,** Jacopo Bassano. Lugano, private collection

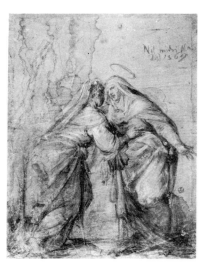

61. **Visitation,** Jacopo Bassano. Florence, Uffizi
Courtesy of Soprintendenza Alle Gallerie, Florence

own signed *Miracle of the Quails* (ex-Caspari Collection, Munich),[15] and two of her attendant *putti* are lifted, one reversed, from Jacopo's 1568 *Adoration*. Thus, the entire upper half of the picture may be given to Francesco in design and in execution. In spite of Jacopo's only partial responsibility for the design and his very limited share in its execution, the *St. Jerome* altar accords well with developments seen in the *Adoration*. A solitary figure kneels in rapt immobility before the tiny crucifix, immersed in the dusky quietude of the evening landscape. Only the Virgin intrudes, and then ineffectually—almost as an afterthought added to satisfy some rustic iconographer. Having established a mood of expansive serenity in the dense grouping of the *Adoration*, Jacopo now in this St. Jerome depopulated his scene in anticipation of the characteristic Bassano genre picture which, again in collaboration with Francesco, was to evolve in the next decade.

The *Presentation of the Virgin* drawing (fig. 56) (National Gallery of Canada, Ottawa) bears the date 1569 twice and is a rough compositional study exactly analogous to the Calmann drawing in style and in intention.[16] Although it must have been a first experiment in the evolution of a monumental altarpiece, we have no documentation for such a commission, nor does a painting of that date exist. While the space suggested in this drawing is disjointed and shows several isolated areas of experimentation, it is clear that the action takes place on a

15. W. Arslan, *op. cit.,* I, p. 219, Figs. 126 and 207. Signed "FRANC. A. PÓTE/BASSANO/FE. . . ." Arslan sees the hand of Jacopo in the execution of the head of the boy looking out from the right center of the composition.

16. National Gallery of Canada, Ottawa, No. 4431, charcoal and many colored chalks on blue paper, 518 by 304 mm. Inscribed in charcoal at the upper left "de l'ano 1569" and on the step at the center "del 1569." The *Circumcision* in the Museo Civico, Bassano (No. 21), signed and dated 1577 by Jacopo and Francesco, is closely based on this design, but the Ottawa drawing is not a preliminary study for this later painting. The drawing in the National Museum, Warsaw (see M. Mrozinska, *Disegni Veneti in Polonia* [Venice, 1958], No. 2) is a compilation in which almost every figure derives from one of the major altars from the period 1572–74. A date of ca. 1575 for the Warsaw study is confirmed by its compositional similarity to several paintings of about that date, such as the Prado *Expulsion of the Moneychangers from the Temple* (No. 28).

62. **Archangel Gabriel,** Jacopo Bassano. Oxford, Christ Church
Library
Courtesy of the Governing Body of Christ Church, Oxford

63. **Virgin Annunciate,** Jacopo Bassano. Florence, Uffizi
Courtesy of Soprintendenza alle gallerie, Florence

sharply rising diagonal plane: the stairs on which the eagerly inclined figure of the young Virgin approaches the two priests behind the altar at the upper right. In the right foreground the hopeful gestures of the five "heathen" reinforce the upward thrust of the diagonal. The use of the brightly colored chalks is here even more abrupt and energetic than in the 1568 drawings. Details of expression and costume are ignored; only effects of mass and color area emerge from Jacopo's aggressive shorthand. The charcoal outlines splinter with a ferocious vitality unique in the sixteenth century. Although the finished altar, if it existed, may have been more stable in design, this drawing is a rare instance in which Jacopo betrayed an interest in one of Tintoretto's powerfully *mouvementé* compositions. Jacopo incorporated into his drawing certain motifs, such as the sharp rise of the stairs (reversed) and the beggars, from Tintoretto's *Presentation of the Virgin* in S.M. dell'Orto, which was completed before 1556. Since in most respects Jacopo had nothing in common with the volcanic showman of Venice and his art does not owe him any appreciable debt, we may possibly find an explanation for this exception in the attention given the Tintoretto *Presentation* by Vasari, who saw it in 1566 and praised it highly in his 1568 *Vita,* published the year before Jacopo executed this drawing.

Jacopo's graphic experiments in these years were not all so individual. The *Visitation* (fig. 61) (Uffizi, Florence), inscribed 1569, shows him in search of a greater clarity and continuity of form.[17] The figure of the Virgin is modeled in charcoal heightened with white which only occasionally displays the force which emanates from the *Presentation*. Instead, the bulk of the graceful, slow-curving form is defined in a sensuous chiaroscuro. For the most expressive foci of emotion the charcoal was abandoned and the head and hand brushed in with a delicate wash. As Jacopo proceeded to the St. Elizabeth he indicated only the lower drapery in charcoal, executing the rest of the figure in bistre wash over only the faintest traces of charcoal outline. Jacopo's restless search for a medium which would exactly convey his peculiar combination of boldness and

17. Florence, Uffizi No. 13953 F, bistre wash over charcoal and black chalk heightened with white on blue-green paper, 529 by 398 mm.

intimacy here elicits his brief but poignant comment at the top of the sheet: *"Nil mihi placit/Del 1569."*

Like the *Presentation* study, the *Visitation* drawing of 1569 may have been preparatory to a painting, but none is now known.[18] However, we have evidence of the existence of this composition in the family workshop. The *Madonna del Rosario* at Cavaso del Tomba was commissioned from Jacopo in 1587, but its execution was due entirely to his son Gerolamo.[19] The medallion series which surrounds the central apparition of the Virgin contains fifteen scenes from her life, most of them based on known or probable designs from earlier in Jacopo's career. The *Visitation* medallion repeats the Uffizi drawing with only slight variations. Later versions of the *Visitation* motif in the *Madonna del Rosario* altars at Paderno del Grappa, Asolo, and Verbosca diverge more notably from Jacopo's design and illustrate the academic disintegration of the workshop at Bassano after 1592. In its sensitivity the execution of the Uffizi drawing parallels Jacopo's painting style of 1569, and it is probable that it served as a *modello,* a finished guide to the transfer from wash on paper to paint on canvas. The possibility that the transfer was left to Francesco is not to be excluded, especially since no drawings by Jacopo of such a completed type survive from the period before his sons entered into active collaboration in the shop.

The remaining two drawings dated 1569 pose even a further problem. The *Archangel Gabriel* (fig. 62) , which until now has been unnoticed and unattributed in Christ Church Library, Oxford,[20] bears the date 1569 in the same hand as that of the

18. Verci, *op. cit.,* p. 106, lists a *Visitation* among the now lost frescoes by Jacopo at Fieta. Their date is not yet known.
19. L. Magnagnato, *Mostra di Dipinti dei Bassano* (Venice, 1952) , pp. 55–6, No. 44. For the Verbosca altar see W. Arslan, *op. cit.,* I, p. 291.
20. Christ Church Library, Oxford, No. add. 10, bistre wash over black chalk heightened with white on light-brown paper, 535 by 327 mm. The date "1569" in wash is at the lower left corner. There is an inscription in a seventeenth-century hand on the mount: "Bassano langelo de la famosa anonziata di Milano," and, in an eighteenth-century hand, "Copia." It has not been possible to find any record of a Bassano *Annunciation* at Milan, and the notation may be an erroneous transcription of an earlier note. The drawing is indeed a copy, but not in the sense implied by the second inscription.

same date on its pendant, the *Virgin Annunciate* (fig. 63) in the Uffizi.[21] Both drawings are in bistre wash heightened with white over a faint design in charcoal or black chalk, a combination of media closely resembling that of the *Visitation,* although in execution there is a notable diminution in spontaneity. The few authors who have mentioned this drawing have noted its somewhat academic tendency and have relegated the *Virgin Annunciate* to a workshop status without regard for the problems raised by the date.[22] Instead, the distinction in quality between these pendant drawings and the *Visitation* is due to a difference of purpose rather than of hand. In contrast to a normal preparatory study such as the *Visitation,* in the *Archangel Gabriel* both figure and cloudy setting stop abruptly about two centimeters short of the left margin, and in the *Virgin Annunciate* a similar limitation is found at the right side. This suggests that Jacopo was not formulating a composition, but, rather, recording it. The status of this sort of drawing is clearly defined in the graphic tradition of sixteenth-century Venice: it is a *ricordo* done after a painting to preserve the motif for future reference and repetition.[23]

Unexpected confirmation of the status of these two drawings may be found in the fact that one of the pendant paintings which made up this *Annunciation* still exists. The *Archangel Gabriel* (fig. 60), now in a private collection in Lugano, was

21. Florence, Uffizi, No. 13061 F, bistre wash over black chalk heightened with white on faded-blue paper, 539 by 375 mm. The date "1569" is inscribed in wash at the lower left corner.
22. H. and E. Tietze, *op. cit.,* p. 56, No. 216; and W. Arslan, *op. cit.,* I, p. 342, as workshop of Leandro.
23. The practice of making a *ricordo* of a composition for reference in the workshop is an ancient tradition in Italian draftsmanship (*cf.* H. and E. Tietze, *op. cit.,* p. 15). Later instances of *ricordi* by Jacopo Bassano include the drawing (Uffizi 13065 F) done after the 1571 *Martyrdom of S. Lorenzo* in the Duomo at Belluno. While numerous others survive, by the mid-seventies Jacopo merely indicated the major forms in chalk, turning the *ricordo* over to one of his sons for the addition of the bistre wash. The *ricordo* of the Brera *St. Roch Ministering to the Plague Victims* of 1575 (Uffizi 13063 F) was sketched briefly in chalk by Jacopo and washed and heightened with white by Francesco. The *Martyrdom of St. Sebastian ricordo* at Windsor Castle (Popham and Wilde, Cat. No. 122), which is dated 1574, falls into the same category.

separated from its pendant, possibly during the Napoleonic spoliation, and some early collector sought to make it into an independent picture by the addition of a scales and sword, thus transforming it into an *Archangel Michael*.[24] The Christ Church drawing reproduces the painting in an identical format, and it is the same in the solid physical type of the angel, the fall of the drapery, and the complex play of the highlights. The closest parallel to the *Archangel* in Jacopo's works of this time is found in the *Adoration,* and its fullness of form, energetic pose, fluidity of texture in the blown hair, and golden luminosity of the almost monochromatic yellow-green-brown color closely recall the two *putti* at the left of the radiance in the 1568 altar. The Virgin in that picture has been reversed and only slightly modified for the *Virgin Annunciate.*

In the *Archangel Gabriel* Jacopo went to sources outside his own work just as he had in the *Scourging of Christ*. In this instance, it was Giuseppe Salviati who served as a point of reference. Salviati painted his *Annunciation* altar for the church of the Incurabili, now in San Lazzaro dei Mendicanti, probably shortly before he left Venice for Rome in 1565. Salviati's Archangel Gabriel is almost identical in pose and in numerous details to Jacopo's Angel, and the Virgin of the Uffizi *ricordo* shows a clear, if less specific, awareness of the Salviati altar. The influence of Salviati may even have been operative in the technique of the *ricordi,* since he was one of the first to introduce into Venice the central Italian technique of executing *ricordi* in a fluid bistre wash with white heightening.

It is not now possible to determine the provenance or the original disposition of this *Annunciation*. Verci describes an *Annunciation* with two Saints below among the lost frescoes at Enego: "dietro l'altare, da un lato si vede l'Angelo Gabriele, e dall'altro M. Vergine Annunziata."[25] However, these canvases must either have been the top lateral parts of a polyptych (an

24. Canvas, 91 by 48 cm. First published by L. Fröhlich-Bum, "Unbekannte Gemälde des Jacopo Bassano," *Belvedere,* 10 (1931) : 123. A restoration undertaken at the author's suggestion has confirmed that the sword and scales are additions, probably of the nineteenth century.
25. Verci, *op. cit.,* p. 105.

improbably archaic form) or the shutters of a small organ. The date 1569 inscribed on both *ricordi* is a *terminus ante quem* for the paintings, which, because of their affinities with the *Adoration* of December 1568, may be dated late in 1568 or early in 1569.[26]

The extreme paucity of dated or datable works in the years prior to 1568 raises the question: why did Jacopo begin at this time to date so many paintings and, in particular, why did he actually inscribe the date on so many drawings of 1568–69? An explanation for the sudden attention to date in the case of the drawings may be found in the fact that Jacopo must at this time have foreseen a remunerative system of duplication in his workshop, a program which did indeed accelerate to mass-productive dimensions after 1568. Francesco had begun to take a larger part in the shop production, and his three younger brothers were all destined to follow him in the reproduction of the paternal designs. There survive, in fact, at least a dozen shop replicas of the *Adoration* painted in that year. This expansion, not to say eventual explosion, of the family enterprise necessitated some more orderly method of preserving Jacopo's inventions in a compendium on which the succession of sons, sons-in-law, nephews, and mere hack assistants could draw. A dated drawing could be correlated with an entry in the family account books and a particular invention thus located in time and place. Eventually, the operations of the shop assumed such massive proportions—spilling over into the subsidiary studio of Francesco in Venice after 1579 while Jacopo's personal contribution was diminished by his blindness—that such orderliness was no longer possible. In 1568, however, the careful notation of the date on a sketch or *ricordo* must have seemed a prudent start toward assembling the working material which traditionally formed the basis for a family *bottega*.

The material which went into this stockpile of motifs and

26. Jacopo's very small *Annunciation* pendants in the Museo Civico, Vicenza (No. A46) strongly resemble the 1569 *Annunciation* pair, especially the Archangel. For later derivations of the motif, see the *Madonna del Rosario* altars (see n. 19) and Leandro's lunettes in the sacristy of SS. Giovanni e Paolo, Venice.

compositions must have been varied. In addition to the seventy-odd *abbozzo* listed in the inventory of the shop after Jacopo's death in 1592, painted sketches which may have been largely assistants' *ricordi* rather than *modelli* by Jacopo, brief note is taken in the inventory of "Two cartons of various drawings and thirteen rolls of various drawings."[27] The cartons must have been portfolios containing large *ricordi* such as the one Jacopo did after his *Martyrdom of St. Lawrence* of 1571. The *rodoli* or *ruotoli* would have been canvas rolls on which miscellaneous drawings were pasted. Indeed, several among the drawings which can be dated 1568–69, most notably the *Virgin Annunciate* and the *Visitation*, still bear the imprint of the canvas roll on the remnant of the glue which once covered their *versos*. Of the numerous drawings which once made up these rolls, the greater part must have been *ricordi* done by one or another of the sons. In 1568–69, however, it is likely that Jacopo undertook this type of drawing for the first time in his career, and that these earlier examples are his own demonstration pieces from which Francesco and the others learned the technique.

27. Verci, *op. cit.,* p. 100.

Sources and Acknowledgments

The essays are reprinted with the kind permission of all the authors, and of the following copyright holders: Alfieri Edizioni d'Arte (for those by Rigoni and Argan), the *Journal of the Warburg and Courtauld Institutes* (for Wilde's), and the Princeton University Press (for Shearman's). They originally appeared as follows: Erwin Panofsky's in *The Burlington Magazine*, 64 (1934): 117–27; Meyer Schapiro's in *The Art Bulletin*, 27 (1945): 182–87, and 41 (1959): 327–28; Millard Meiss's in *The Art Bulletin*, 27 (1945): 175–81; Erice Rigoni's in *Arte Veneta*, 2 (1948): 141–47; Johannes Wilde's in *The Journal of the Warburg and Courtauld Institutes*, 7 (1944): 65–81; Henry Millon's in *The Art Bulletin*, 40 (1958): 257–61; James S. Ackerman's in *The Journal of the Society of Architectural Historians*, 13 (1954): 3–11; Giulio Carlo Argan's in *Venezia e l'Europa: Atti del XVIII Congresso Internazionale di Storia dell'Arte* (Venice, 1955), pp. 387–89; John Shearman's in *Studies in Western Art: Acts of the Twentieth International Congress of the History of Art* (Princeton, 1963), pp. 200–21; Rearick's in *The Burlington Magazine*, 104 (1962): 524–31. The following modifications have been made from the original versions: small revisions have been made in Schapiro's and Meiss's articles by the authors. The editor has translated the articles by Rigoni and Argan and all quotations in foreign languages in the other articles, except where the context appeared to supply a translation. Rigoni's source references to shelf locations of manuscripts in archives have been omitted as only useful to readers who would need the original-language version. A small additional number of illustrations has been provided. In all other ways the essays appear exactly as they did originally.

Icon Editions